Watercolor
Your Way

Watercolor Your Way

By Carl Schmalz

WATSON-GUPTILL PUBLICATIONS/NEW YORK
PITMAN PUBLISHING/LONDON

To my mother and father

Edited by Connie Buckley
Designed by Bob Fillie

Copyright © 1978 by Watson-Guptill Publications

First published 1978 in the United States and Canada by Watson-Guptill Publications,
a division of Billboard Publications, Inc.,
1515 Broadway, New York, N.Y. 10036

Published in Great Britain by Pitman Publishing Ltd.,
39 Parker Street, London WC2B 5PB
ISBN 0-273-01207

Library of Congress Cataloging in Publication Data
Schmalz, Carl.
 Watercolor your way.
 Bibliography: p.
 Includes index.
 1. Water-color painting—Technique. I. Title.
ND2420.S36 1978 751.4'22 78-644
ISBN 0-8230-5686-6

Manufactured in U.S.A.

First Printing, 1978

Contents

Acknowledgments

No book is written, perhaps no human achievement is accomplished, except by building on the works of others. This book owes, first, a great debt to the late Professor Arthur Pope of Harvard University and his predecessor Professor Denman Ross. It also is based on the special knowledge and pedagogical gifts of Professor James M. Carpenter of Colby College as well as many others of my teachers and colleagues.

I have tried, in an abbreviated and sometimes awkward way, to adapt what I learned from Professors Pope and Carpenter about the great art of the world to the special nature of transparent watercolor in America. I trust that what I have said will be useful. It is not, however, all that either of those distinguished mentors could have said.

A book of this sort requires illustrations. I have tried to present a good cross-section of contemporary watercolors, together with a few fine examples from the past. I have also tried to include as many paintings as possible by people from all parts of this country, paintings by both women and men, and by people of different races, backgrounds, and different degrees of fame. I feel only partially successful in this, although I believe that the variety of illustrations achieved is still unusual.

I am deeply obliged to many people for the illustrations that appear here. Owners, artists, dealers, and museum staffs were particularly helpful. Among them, I single out the staffs of the Boston Museum of Fine Arts, the Fogg Museum, the Bowdoin College Museum, and Colby College Museum. I am particularly grateful to Dr. William C. Landwehr, Director of the Springfield Art Museum in Springfield, Missouri, who lent me a wealth of photographs of works awarded purchase prizes in the splendid Watercolor U.S.A. Exhibitions run by that institution for the last decade and a half. Equally, I salute Susan E. Meyer, Editor of *American Artist* magazine. She permitted me to use the collected photographs in her files, many of which appear in this book. I am especially indebted to Robert E. Kingman, Amherst College photographer, who is responsible for all black-and-white photographs not otherwise credited, and to David Stansbury, whose skill and care produced the color photographs that are not individually acknowledged.

Finally, I owe an obligation to Professor Joel M. Upton of Amherst College, whose critical reading of my text aided and sustained me; to his wife, Sara W. Upton, who typed it; to my wife, who not only made the initial typescript but protected me from unnecessary intrusion and bore with me through the long days of labor; and to all of my students from whom I learned something of how to talk about these matters.

Introduction

There are many excellent books that introduce the beginner to transparent watercolor painting, but few that deal with concerns encountered by painters at the intermediate level. This book addresses some of those concerns. Although it is directed primarily to those of you who have had some experience with watercolor, I hope that it may prove helpful to beginners and more advanced painters as well.

Once you have acquired basic skills in watercolor, your primary need becomes regular, informed criticism. Except in certain areas of our country, this can be difficult to find; in many places there are still few watercolorists. Lessons and workshops arranged by art societies, galleries, and museums are extremely valuable, but usually less frequent than one would wish, and not everyone has the time or money for painting trips that would introduce him or her to new experts.

Were these the only reasons to indicate the importance of learning to criticize your own work they would be sufficient. But there are other reasons, too. How often have you attended a solo exhibition and wondered at the variation in the quality of the works shown? Too few artists are able to make the solid, ruthless judgments that produce a really fine, high-level show. Artists may include a weaker work because they "like something about it" and thus diminish the quality of their presentation, not because they cannot paint well, but because they cannot judge their work well.

How do you select a group of pictures with which to introduce yourself to a gallery owner or dealer? Here again, you want to show only the very best. As with choosing pictures for an exhibition, it is wise to get help—the most expert you can find—but often, and finally, the decisions must be your own.

The last reason for learning to criticize your own work is the most vital of all: painting is not a mechanical affair; it is a human event. As you put paint on your paper, you constantly assess your progress, are alert to new possibilities, and are wary of things that require change or refinement. You make continuous critical judgments. For an artist, making and judging are aspects of the same process. Learning to see pictures with some sophistication is, therefore, just as central to your task as is learning to paint with competence and facility.

This book differs from most how-to-do-it books because it tries principally to answer questions about how to see pictures, rather than how to make them. But since seeing and making are interwoven in the act of painting, the questions related to both become entangled at some points. Nevertheless, helping you to see pictures—especially your own—clearly and objectively is the primary aim of this book.

Watercolor Your Way is based on two fundamental assumptions. The first is that quality in painting is not basically a matter of "beauty" or even "meaning," for neither can exist without order. Just as a statement in language or numbers must be appropriately structured to be comprehensible, so a painting must be structurally ordered in ways appropriate to visual language. There is no hard and fast grammar of visual language, as every painting represents a dialect of its own. Nevertheless, artists develop individual dialects that they use with slight variations in all of their mature work; hence, just as we say that *Madame Bovary* is written in French—indeed, "in" Flaubert—we can say that the *Polish Rider* is painted "in" Rembrandt.

Pictorial order is created by the interplay among the artist, his subject, and his materials. It is recognizable as what I will call here *pictorial coherence* or *integrity*—the wholeness and consistency that result from a marriage of singleness of vision (whether trivial or profound) and well-used materials.

When you make a painting, you do a very special thing: you make a completely newborn world. Like a god, you *create* it. You alone are responsible for its life and laws, which is why that white sheet can be so frightening. The order of your painted world emerges from your response to

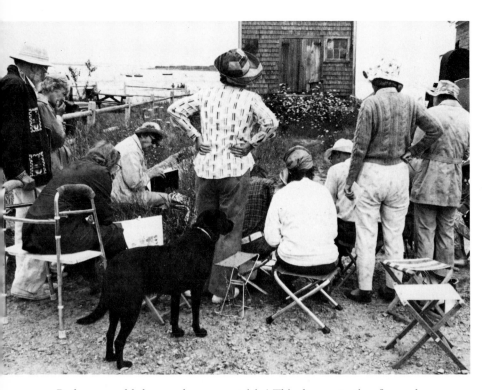

Perhaps an old dog *can* learn new tricks! This demonstration focused on reserving small lights to indicate the Queen Anne's Lace in front of the shack. Apart from that, it is basically an "easy" picture, a type which I describe in Chapter 1. Photo by Alice Moulton.

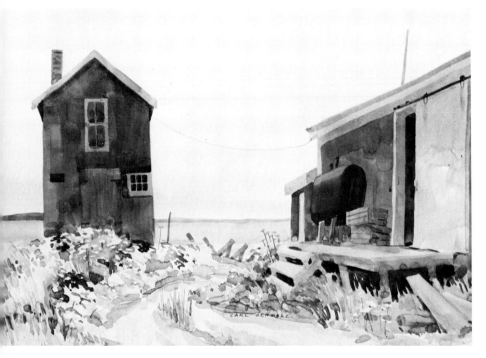

Shack at Biddeford Pool by Carl Schmalz, 1974, 15″ x 21″ (38 x 53 cm), 140 lb. hot pressed paper, collection of the author. Color variation helps to articulate the sky in this painting. Without it, pictorial coherence would be jeopardized, for the intricacy of the foreground flowers and weeds might be too different from the sky, making them appear to belong to quite distinct picture worlds. I made the technical process easier for myself in this picture by painting a basic wash on both buildings and reserving the trim when I set in the color for shingles, windows, and shadows.

the world you experience, translated by your vision and skill into the terms watercolor paint will permit. When you are finished, you have made a personal statement about your understanding of the human experience. This statement reflects your strengths and weaknesses, your sympathies and dislikes. All this you have to accept, for it is a consequence of the responsibility you took on when you gave life and order to the blank paper.

This "world" you make must be coherent: that is our first assumption.

The second assumption is that you can best grow as an artist by building on your strengths rather than concentrating on your weaknesses. I do not mean that you can or should ignore your weaknesses; but because they are, in general, easier to see than strengths, it is tempting to focus on them. Unfortunately, this may mean that you overlook your strengths, and that is folly, since it is chiefly in what you do best that you can most easily see yourself as a painting personality. Weaknesses, especially if you have not been painting very long, are more apt to be gaps than flaws in your *persona* as a painter, and you can't begin to find your personality as a painter by looking at gaps. In the chapters that follow, therefore, even though I will talk about faults often enough, I want you to remind yourself constantly to see faults in the context of what you are doing well.

How to Use This Book
Since this book is primarily about how to *see*, and most especially about how *you* see and work, there is no special list of materials. What we are interested in are your working habits, your subject selection, your palette, and your way of producing coherent pictures.

This is an introduction to criticism, not to painting itself. The

only thing you need, therefore, apart from some of the things listed on page 39 in Chapter 4, is your usual gear. Among other things, you are going to look through your materials and ask yourself why you have them and what they will do.

The principal thing you will do is look hard and analytically at your own work. Select from your work twelve to fifteen pictures, although as few as eight will be sufficient if you can't or don't want to include more. Ideally these pictures will represent a total cross section of your work. The group may include a few pictures done as long as five or six, even ten, years ago, but it would be best if most of them were done during the last couple of years.

They should be varied. Include all possible shapes, sizes, subjects and treatments. But don't include anything you feel is not quite good. You are going to spend a lot of hours examining these pictures from many points of view. Few may come through the scrutiny unharmed; don't make the results any harder on yourself than you must. Put your best pictures into your collection.

One more word of caution—fifteen pictures is the top limit. More than that will prolong your exercises beyond tolerance and clutter your analysis beyond usefulness.

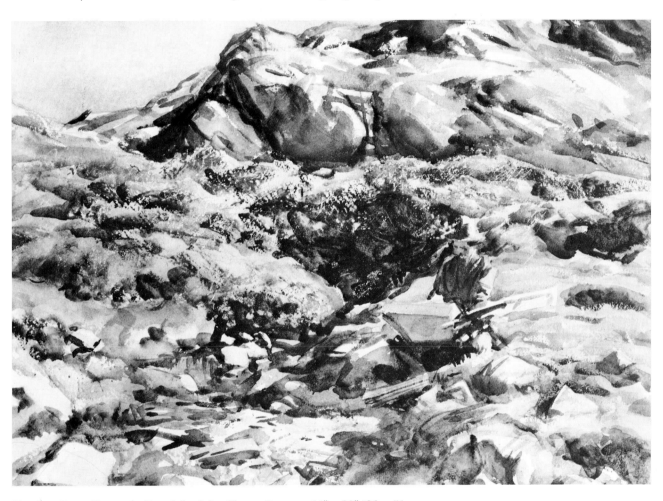

Simplon Pass: Mountain Brook by John Singer Sargent, 14″ x 20″ (36 x 51 cm), courtesy Museum of Fine Arts, Boston. Sargent's painting is based on strokes of essentially similar size and shape. He differentiates them to enhance the description of rocks, shrubbery, and water, but pictorial coherence is so strong that in black and white it is difficult at first to make out the watercolorist at work at center right.

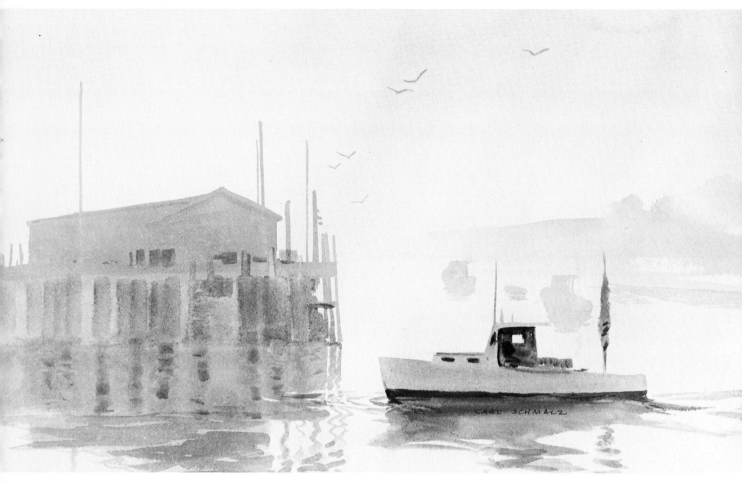

Figure 1
Morning Fog, by Carl Schmalz, 1969, 12½″ x 21¾″ (32 x 55 cm), 140 lb. rough paper, collection of the author. The easy progression of values from light to dark, background to foreground is especially evident in a black-and-white illustration; but without the play of yellow and violet, and red, green, and blue in the more distant objects, the dark boat at lower right demands too much attention, creating disequilibrium in the design. Photograph by David Stansbury.

The "Easy" Picture

Is the light-to-dark painting procedure, essential to transparent watercolor, helping or hindering you?

Critical Concern

You may find the title of this chapter misleading, since no good watercolor is really "easy." Yet in some transparent watercolors, the relationship between technique and representation is so close that it creates an effect of great simplicity and economy.

As commonly defined, a transparent watercolor is one in which no opaque white pigment is used. Rather than whites or lights being added as positive, active marks that *cover* darks, all light tones depend on the white paper and the pale-valued areas being reserved, or left visible. This means you must normally paint the lighter colors in your picture before you apply the darker areas that abut, overlap, or surround the lighter ones. In other words, the transparent nature of your paint dictates the sequence in which you paint the various parts of your picture. You might prefer to paint your picture in a particular sequence but be forced to alter this sequence because of the technical requirements of transparent watercolor. For example, you may not be able to concentrate first on the central features of your picture if they are dark. There are some obvious advantages to this procedure, of course; among them is an obligation to work the paper all over so that you keep the entire surface in mind from start to finish. Nevertheless, the natural sequence of your creative responses must frequently be ignored because you must always place a light on the paper before you add a dark next to it.

There are, however, situations in which the process of painting from light to dark is admirably suited to your subject. This is true when you are painting darker foreground objects against a lighter background, and it occurs often when your subject is in indirect light (see Chapter 13), such as in fog or on an overcast day. In such cases, the need for reserved lights is greatly reduced, and the painting sequence follows the spatial "logic" of the subject. It becomes easiest to lay down your distant, pale tones first and your near, dark tones last.

You still do not generally have the choice (as does the oil painter) of painting your center of interest first, but you can achieve a natural pictorial coherence because the order in which you paint corresponds to the order of the spatial planes. This is the "easy" picture for you and for the viewer, who responds appreciatively to the ease with which the picture is organized.

Illustrations

Morning Fog (figure 1) is an example of an "easy" picture. I began this painting with a sky wash in which wet blended brushloads of orange-violet streaked the area, suggesting veils of drifting fog. When this lightest and most distant tone was dry, I added the shoreline to the right. While it was still wet, I lifted out a few strokes with a wrung-out brush to suggest wisps of fog. The silhouetted boats and their reflections went in next in the middleground, and then I put in the slightly darker, warm grays of the wharf and shack to the left. In the same drying time, I added some slightly darker tones, reserving the pilings and ladders, and painted the greenish reflection of the dock. Last, I set the lobster boat and its reflection in the foreground. I had to wait for these colors to dry before painting the darkest values in the painting—the boat's interior, portholes, and other descriptive details.

There are two aspects of this procedure that bear thinking about. One purely technical factor is that direct light-to-dark painting generally yields the dividend of fewer and more easily organized drying times. *Morning Fog* required only three drying periods. The other point is that the light-to-dark painting sequence corresponds almost exactly to the sequential process by which the illusion of space is es-

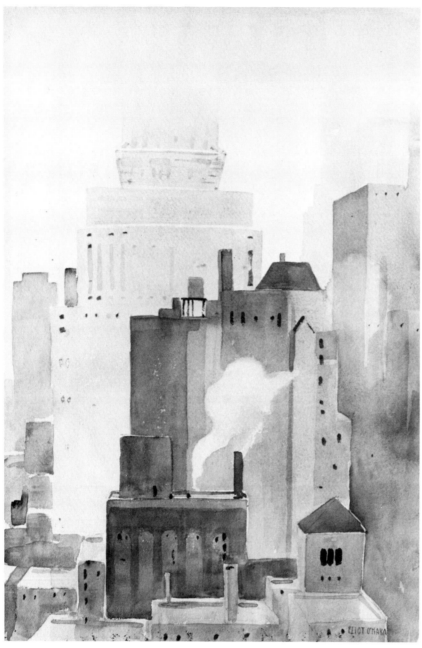

Figure 2
Above Lexington Ave. by Eliot O'Hara, 1931, 21½″ x 14½″ (55 x 37 cm), 90 lb. rough paper, courtesy O'Hara Picture Trust. Notice that here O'Hara—usually so attentive to consistency of light effects—uses darks arbitrarily to clarify spatial relationships. At right, the left sides of the buildings are shadowed, while at the bottom, their left sides are lighter. A few pale "seams" at the edges of the building washes help to create a feeling of rainy wetness.

tablished in the painting. Painting from background to foreground creates both a technical and representational order that is immediately (if subconsciously) perceived by the viewer.

In practice, of course, most "easy" pictures are not quite that simple. Look at *Above Lexington Ave.* (figure 2) by Eliot O'Hara. Like *Morning Fog*, it is procedurally uncomplicated. The sky wash went on first at the top of the page, and before it dried, the light washes of the buildings at center and right were added against the still dry white paper. When the light washes were quite dry, middle values were added in the nearer buildings. Up to this point, except for the reserved steam, this is an "easy" picture. But the middle-value buildings at left, which set off the central tower, as well as the middle-value structures in the foreground, interrupt the backward-to-forward, light-to-dark movements. Even so, we feel the economy of technique and the clarity of space in this painting. Note also that the drying times cannot have exceeded four, including the darkest accents. O'Hara was able to apply his paint in a fairly sustained rhythm and to think over his next steps between applications of paint.

Despite the fact that the painting procedure is not perfectly "pure," the picture projects a satisfying simplicity that stems largely from the viewer's sense of the logical link between the technical means and the pictorial illusion. As in *Morning Fog* (figure 1), or William Preston's lucid *Snowbound* (figure 3), the observer feels and appreciates the way in which the subject has been translated into terms appropriate to the process of transparent watercolor.

Exercises
The essential problem posed by this chapter can be divided into two parts; the first is more or less

mechanical, the second is more critical. Let's begin by dealing with the mechanical part.

Get out the fifteen or so paintings you selected after you read the Introduction. Set them up where you can see and compare them easily. Make yourself comfortable and, looking thoughtfully at your work, ask yourself the following questions.

1. Are any of these paintings pure "easy" pictures? None of them may be. In that case, are any of them modified "easy" pictures, such as O'Hara's *Above Lexington Ave.*? Look carefully and try to recall your exact painting procedure as you mull over these questions. If there are three or four such pictures among the group, you are probably employing transparent watercolor economically and effectively.

On the other hand, there are obviously a host of reasons why you may have no "easy" pictures in your study collection: for example, your subject preference may preclude this type of handling. It is important to recognize these reasons so you can ask yourself whether they are valid, given your artistic aims. For instance, if you work in a highly detailed fashion and think this makes the light-to-dark procedure impossible or undesirable, consider Loring W. Coleman's *Quiet Afternoon* (figure 4). Coleman faithfully records architectural details and nuances of light, but the ease of the process is still felt by the observer. Also note the relatively few and simple reserved lights.

Before you go on to try to specify why you have no "easy" pictures among your study paintings, it may be helpful for you to make one. You can do this by adapting one of the pictures you are looking at. Simply get out a fresh sheet of paper; draw in the main areas broadly; imagine that the entire scene is in thick fog; and then paint from light to

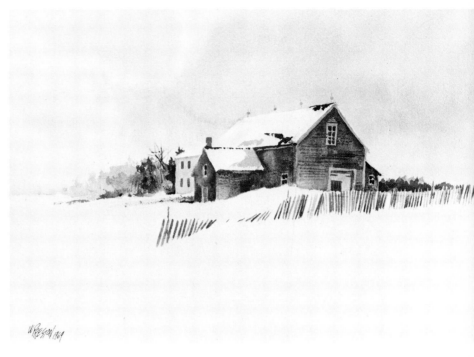

Figure 3
Snowbound, by William Preston, 1969, 21″ x 28″ (53 x 71 cm), courtesy Shore Gallery, Boston. Preston reserved the snow-covered roofs of the buildings and the window frames and trim on the barn. He accented the house with dark trees behind it, but otherwise, this is a fairly straightforward light-to-dark/ background-to-foreground painting. The procedure is especially evident in the trees at left. Photo by George M. Cushing.

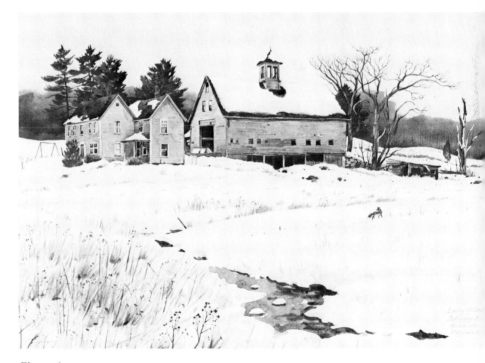

Figure 4
Quiet Afternoon, by Loring W. Coleman, A. W. S., 1974, 7¾″ x 11¼″ (20 x 29 cm), courtesy Shore Gallery, Boston. This small picture is packed with telling detail, yet it gives no impression of having been tedious to paint. This is partly because the reserved areas were so well planned. The painting hardly qualifies as an "easy" picture, of course, because the background trees are among the darkest elements in the picture. But within each spatial plane Coleman uses the light-to-dark logic to create spatial clarity.

dark, background to foreground. Increase intensities and value contrasts as you come forward (see Chapter 9 for a discussion of intensities and values). The resulting image may not look like your usual painting, but it will give you an eye-hand understanding of the simplicity of this process, its utility, and the technical/pictorial coherence it produces.

Now let's continue asking some further questions.

2. Do you *normally* work light to dark, if only in certain sections of your picture?

A "no" to this question almost certainly means that you are not availing yourself of the simplest transparent watercolor procedure—and you may be making the technical part of painting a good deal more difficult for yourself than necessary.

The most common reason for not working light to dark is an artist's greater familiarity with the opaque media, usually oil. In opaque painting, the procedure is

generally to work from the middle values toward both light and dark. The overall value pattern begins to emerge early and can be developed along with the representation. In oil painting, since lights are more opaque than darks, they can usually be placed adjacent to darks more satisfactorily than the other way around. If you are not normally working from light to dark in watercolor, it may be because you feel uncomfortable about carrying your picture forward—past the halfway point—without clear signs of the emerging value pattern.

There are several common ways to deal with this problem. Many watercolorists habitually make one or more value sketches before beginning their actual painting (figure 5). This might be a good practice for you as well. You can also plan to set in one or two small darks relatively early in the painting to help you gauge your final value range. Another good cure for those "value shakes" is to number the broad value areas from light to dark on

a scale of 1 to 9 (see Chapter 9) or 1 to 10 (see Chapter 2 in my book *Watercolor Lessons from Eliot O'Hara*, Watson-Guptill, 1974). These numbers go right on the drawing just before you start to paint; they serve the double purpose of reminding you to study your value relations carefully while providing a ready reference during the painting process. You can remove the most obvious numbers later with a soft eraser.

3. Do your pictures seem to include a large number of overlapped or blurred edges?

The presence of many edges of this sort can give an appearance of awkwardness to a picture and usually indicates insufficient attention to the light-to-dark procedure. A darker area can overlap a paler one with little sign of the double edge, but a light value set next to a medium or dark one will frequently show the "seam" or blur the edge by picking up some of the dark. We will discuss such seams further in Chapter 3.

4. Do your pictures reveal that you often resort to washing or sponging out, scraping, sanding, erasing, or other devices for lightening areas after your work is "complete"?

Excessive use of these perfectly legitimate techniques is usually a sign of value problems. Once again, you may be failing to appreciate the effectiveness of the light-to-dark painting procedure.

These first four questions—and their answers—will give you a pretty clear idea as to whether the absence of "easy" pictures among your works is a result of some rational decision on your part or a consequence of one or more technical problems. Painting an "easy" picture as suggested at the end of exercise 1 should also show you why the easiest technical procedure can help you produce a painting that impresses the viewer with its sureness and grace—for the appearance of hesitation and insecurity destroys

Figure 5
Sketch for **Kitchen Ell**, by Carl Schmalz, 1970, 5″ x 7″ (13 x 18 cm), collection of the author. A simple notation from the sketch book I always carry with me, this served not only as a memory aid, but also as an initial value plan. Although I sketched the idea as a horizontal, in painting *Kitchen Ell* (figure 32) I chose to emphasize verticality and to focus in much closer so that I could make the ell window the prominent center of the picture (see the discussion in Chapter 5). Photograph by David Stansbury.

any picture. Now look again at your collection of paintings and ask yourself these different, though related, questions.

5. Do any of your pictures exploit, even to some limited extent, the inherent correspondence between the light-to-dark painting procedure and the spatial planes in nature—lighter tones in the distance, darker ones in the foreground? If so, how many pictures, and which ones?

You will probably find that you have organized specific areas in some of your paintings according to the light-to-dark principle. In O'Hara's *Oregon Shore* (figure 6), for example, the entire area behind the big rock is structured on this principle. In front of the rock, however, the lights and darks are frequently reversed. Lights are needed in the foam, and the dark strokes low on the center rock define the slope of the wave. In the eddying surf itself, lights and darks are employed largely to create linear patterns suggesting the water's movement.

6. Where you *have* used the light-to-dark procedure, were you consciously taking advantage of its technical ease and the pictorial coherence it creates?

You may have been unaware of what you were doing, but you have probably achieved a sense of ease and coherence in these sections of your picture anyhow. As we shall see, it is often in those parts of a picture you painted least consciously that you can discover your most personal tendencies as an artist.

Summary
This chapter has introduced the basic problem addressed by this book: what are the simplest ways to integrate your technique with your subject to realize a coherent statement of your expressive aim?

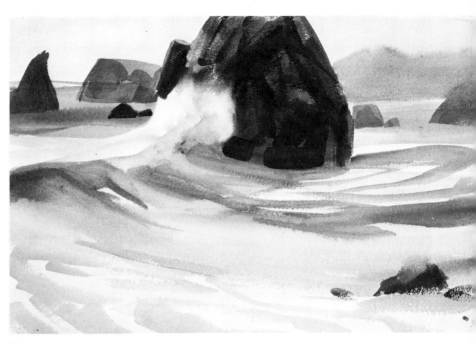

Figure 6
Oregon Shore by Eliot O'Hara, 1962, 15″ x 22″ (38 x 56 cm), smooth paper. Here O'Hara treats surf and rocks very broadly, accenting the vigorous movement of the water in contrast to the solid, immovable character of the rocks. The distance behind the central rock is organized by the light-to-dark/background-to-foreground principle. Nearer than the rock, light and dark are needed to create the contrasts that produce visual excitement suggesting motion. Photo by Woltz.

This chapter considers only one aspect of this complex matter, unique—but essential—to transparent watercolor. The light-to-dark procedure can yield an almost automatic correspondence between the painting sequence and the spatial illusion of the finished picture. We have also observed that this orderly correspondence, or basic coherence, is normally achieved only when particular subjects are represented. In its purest form, the method is unsuitable for many watercolors. Nevertheless, it can be employed in parts of most pictures. Its use will contribute both coherence and—because it is the "natural" way to apply transparent watercolor—an air of ease and sureness to a painting.

The light-to-dark procedure has a drawback that may have dissuaded you from using it. It *seems* to prevent early realization of your picture's value pattern. The half-done picture tends to look anemic, as though it could never come to a strong and healthy maturity. Have faith in the procedure—and in yourself—and remind yourself that you *will* introduce some stronger darks soon! Also try to avoid this situation by making preliminary value sketches, by introducing a few darks deliberately out of sequence, and by numbering your values.

In any case, you can increase the pictorial coherence in your work by thinking through your painting sequence before you set brush to paper. Keep the following aims in mind as you do so: (1) wherever possible, reduce the complexity of the painting procedure; (2) minimize the number of drying times; (3) avoid awkward edges, so far as you can, by eliminating the need to juxtapose lighter tones against darker ones already on the paper; and (4) include reserved lights in your light-to-dark plan.

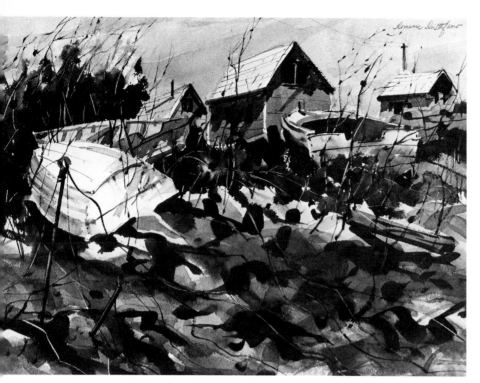

Figure 9
Up for Repairs by Domenic DiStefano, c. 1974, 22″ x 30″ (56 x 76 cm), rough paper, collection of the Springfield Art Museum, Springfield, Missouri. Watercolor U.S.A. Purchase Award, 1974. A stroke painting need not be tight and detailed. Notice the breezy open character of this picture. Observe also that in addition to keeping his strokes similar in size, DiStefano also tends to keep them similar in shape and direction. This gives the picture surface a strongly felt coherence.

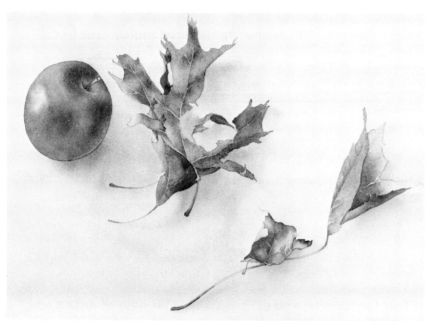

Figure 10
Apple and Five Leaves by DeWitt Hardy, 1975, 10″ x 12″ (25 x 30 cm) (sight), courtesy Frank Rehn Gallery, New York. This painting owes its delicacy partly to linear precision and partly to the uniformly soft merging of color typical of washes. A strong sense of three-dimensionality is less important to Hardy than clarity of two-dimensional pattern. The consistent handling of the washes, by its coherence, helps to emphasize this surface interest. Photo by Geoffrey Clements.

more freely into each other during the extended time made available by slower drying. O'Hara maintains a consistent surface by treating the monoliths themselves as washes, smaller in scale than those that define the sky and ground. Rather than building the stones with individual brushstrokes, as I did, he permits most colors within the stones to merge into each other. The dark strokes that indicate hedgerows in the background are kept broad and undetailed; they do not interfere with his unified surface. O'Hara's world, too, seems whole and complete, although the total statement is very different from mine.

These two examples should not mislead you into thinking that a stroke painting must be relatively "tight" and a wash painting relatively "loose." Look at *Up for Repairs* (figure 9), a bold, splashy painting by Domenic DiStefano giving an impression of generosity and vitality; there is scarcely a washed area on the paper. In contrast, DeWitt Hardy's *Apple and Five Leaves* (figure 10) is done entirely with washes, evoking a sense of serene precision. Both pictures display the surface consistency that is so significant a part of pictorial coherence.

A method frequently used to integrate the stroke and the wash is to intersperse them more or less uniformly over the paper surface. *The End of the Hunt* (figure 11) illustrates Winslow Homer's mastery of this type of surface unity. He manages it partly by using strokes to indicate areas where the contours are rather incidental, instead of drawing descriptive shapes or lines. At the top right, for instance, generalized strokes indicate clouds; in the foreground, the white ripples are separated by darker, broken strokes. The more distant water and the background hillside are composed of relatively large washes that Homer manipulated

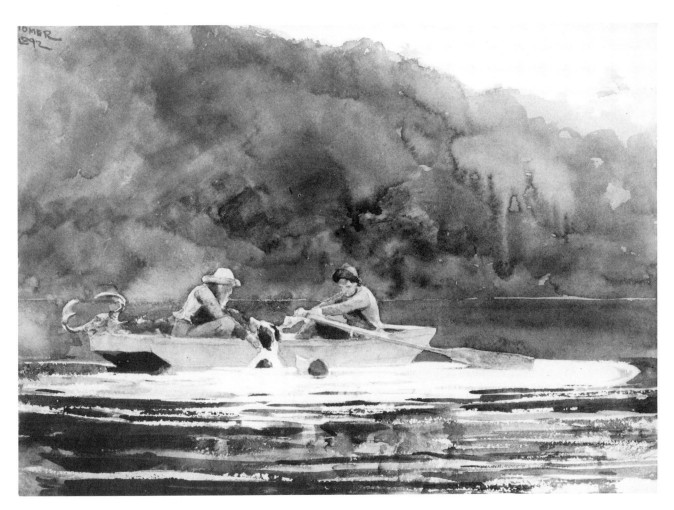

while they were wholly or partially wet. Modulations of the values within these areas, especially the soft edges left by irregular drying, vary the washes sufficiently to suggest foliage and reflections while preserving the appearance of a worked surface. Because neither pure wash nor pure stroke appears in emphatic form, the pictorial surface is both tightly knit and handsomely varied. The world Homer creates is coherent, full, and forceful.

Finally, you can achieve surface consistency by utilizing some logical sequence from wash to strokes. For example, you might treat all background areas with washes, gradually using more strokes as you develop the foreground. This would establish a logic in which wash means "distant" and stroke means "near." Something similar to this occurs when you paint wet-in-wet. An example is Judy Richardson

Gard's *The Covey* (figure 12), where wet blending gradually decreases from the picture's edges toward the upper center. The weedy habitat of the birds is thus played down; the quail blend with their landscape at the edges of the picture and are more visible at its center. The gradual drying of the paper allowed the artist to increase descriptive detail and to focus our attention by means of strokes.

But wet blending is not the only way to obtain a coherent surface by establishing a sequence from wash to stroke. Look back, for instance, to my *Stonehenge* (figure 7). Although the sky is painted wet-in-wet, I made sure that the brush marks remained on the dried surface. Hence it is clear that the area is painted in strokes. But these strokes (like those in the grass) are much broader and less defined than those in the monoliths in the

Figure 11
The End of the Hunt by Winslow Homer, 1892, 15¼" x 21½" (39 x 55 cm), rough paper, courtesy Bowdoin College Museum of Art. Large wash areas may be modified by playing with the drying time to create effects similar to those produced by strokes. Here, especially in the foliage at the right, you can see how Homer interweaves genuine strokes and apparent strokes that articulate his washes. In addition, there is some use of sequential organization as strokes become clearer and more frequent in the foreground.

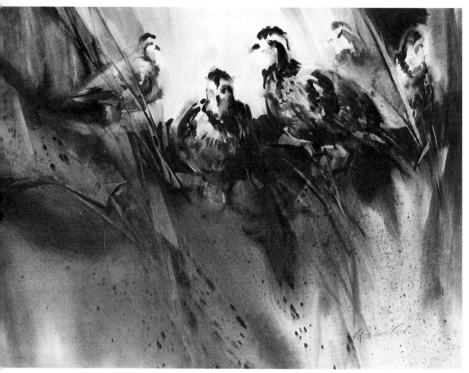

Figure 12
The Covey by Judy Richardson Gard, c. 1973, 21″ x 29″ (53 x 74 cm), rough paper, collection of the Mercantile Bank of Springfield, Springfield, Missouri. Gard creates a coherent surface by working with the natural order of drying. Soft, broad strokes at the periphery of her picture give way sequentially to sharper, smaller, more descriptive ones in the birds at center. Added accents of spatter help to keep the wetter parts of the surface visually interesting.

near foreground. So broader strokes correspond to the areas of lesser emphasis, while more specialized and descriptive strokes correspond to areas of focus, creating the heart of the subject.

Exercises

Now look again at your picture collection and think about your surface consistency. How are you achieving an orderly and coherent surface, and how well are you doing it?

1. Do your pictures demonstrate any form of surface coherence? If so, which method for obtaining that coherence do you seem to favor?

Consider these questions with care. At first you may not be able to identify your form of surface consistency, and there may appear to be none at all. This is rarely the case. It is more likely

you are using one of the four methods described, but realizing it imperfectly. So look for a dominance of (1) large and small washes, (2) all-over strokes, (3) uniform interweaving of strokes and washes, or (4) a sequence or gradation from wash to stroke (or wet to dry).

If you have persistent difficulty identifying the kind of surface consistency you prefer, perhaps you actually haven't any, or you are just not sure what you are supposed to be looking for. In either case, it will be helpful for you to try a small picture using each method. It will take a little time, but it will be worth it.

Tear up some used paper (with one clean side) into four quarters, each about 11″ x 15″ (28 x 38 cm). From your paintings or sketches select a subject that is not too complex, something with mostly large areas. Using each of your four sheets in turn, make a

painting that is done all in washes; one that is all in separate, visually distinguishable strokes; one in which washes and strokes intermingle fairly equally over the whole paper surface; and one that moves from washes to strokes as you work from background to foreground. This will give you examples of the four primary methods of attaining surface coherence in your own "handwriting" and should make it easier for you to identify your personal preference. You will probably feel more comfortable working on one or another of these small pictures, and you should also be able to see which exercise is most like the paintings in your study collection.

When you think you have defined your tendency toward a particular mode of surface consistency, ask yourself the further questions listed below. These exercises will help you identify ways in which you may be realizing surface coherence incompletely. They will also suggest how you can improve.

2. If you have found that you are basically a wash painter, check your pictures as follows:

Are you using wet-blended areas for only one part of the picture surface, such as the sky? Since clouds, for example, are "soft," it is easy to assume that skies should be painted wet-in-wet. Unless other parts of the picture are also painted in this fashion, however, your sky may seem to belong to a different world from that of the rest of your picture. Too great a difference in technique, especially if the different technique corresponds to a single represented entity, can disrupt the surface and reduce the sense of the picture's unity.

Do you habitually rely on linear strokes for clarification—on leafless trees, for instance—or to liven up your washed areas, as in rocks or bushes? A similar dis-

ruption of the surface can arise from ill-digested linear accents. In a basically wash-organized picture, lines must either be scattered generally over the surface or be ordered so they build sequentially from related parts of the picture to the place where you need them. Many painters who use the wash method of surface organization avoid employing many lines.

3. If you lean toward the stroke method of surface unification, try the questions below.

Ask yourself the same question that appears in question 2 above: are you using wet blended areas for just one part of the picture? Then reread the comments in that section. Also ask yourself whether the sizes of your strokes are consistently varied. That is, are you working with fairly broad strokes all over your picture so that smaller strokes, by contrast, emphasize areas you intend to point up?

It is not necessary to keep all your strokes more or less the same size, as Prendergast did (color plate 4), but you should work out some system for the variations you adopt. For example, in *Gentle Surf* (figure 13), all the basic tones went on in broad strokes, although I included considerable variation in the sky and rocks. I was careful to reserve some hard-edged lights in the sky that resemble smaller, negative strokes of approximately the same shapes and sizes as those I used to define both rocks and water.

Always a hazard in transparent watercolor, overpainting is especially tempting for the stroke painter. Are you creating dead spots that break the consistency of your surface by overlaying too many strokes, particularly in the darker sections of your pictures? It will be no news to you that dead or muddy tones kill any part of the picture surface where they occur. But perhaps you have

Figure 13
Gentle Surf by Carl Schmalz, 1975, 15″ x 22″ (38 x 56 cm), 140 lb. hot pressed paper, collection of the author. The focus of this picture is the cluster of small strokes that suggest surf and ripples. I reserved similar shapes, somewhat negative strokes, in the sky so that it would not appear too different in surface treatment from the rest of the painting.

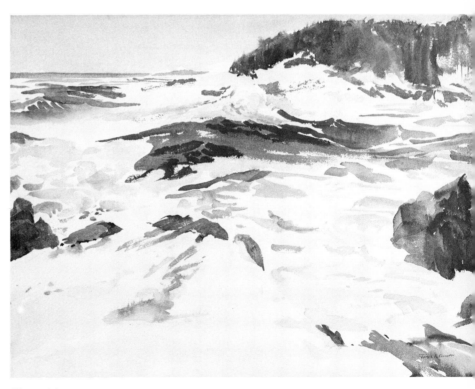

Figure 14
Winter Seas by James A. Elliott c. 1961, 21″ x 29″ (53 x 74 cm), rough paper, courtesy of the artist. In this picture Elliott organizes his surface in terms of evident strokes, though there is a slight move from background washes (the sky and distant promontory) toward foreground strokes. Snow-covered ledges in the immediate foreground are again treated quite broadly. Photo by Pierce.

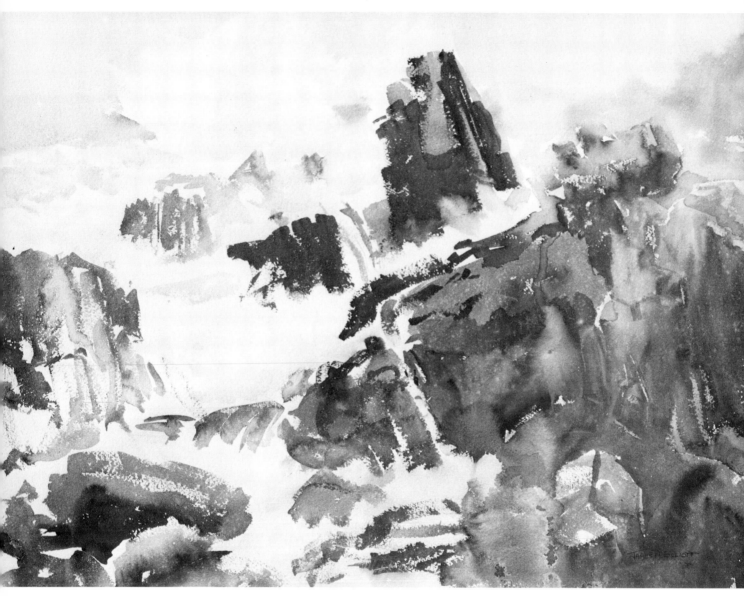

Figure 15
Force Nine James A. Elliott, c. 1963, 22″ x 30″ (56 x 76 cm), rough paper, courtesy Bowdoin College Museum of Art. Here Elliott modifies his usual stroke method to express the surf's power. Wet blending obscures some strokes in both the rocks and water. Areas throughout the picture surface verge on washes. But surface coherence is maintained because the mixed treatment occurs all over the paper. Photo by Pierce.

not thought of mud as a threat to surface coherence. Since the integrity of the illusion depends on coherence in the materials and their use, muddy color is simply inappropriate use of transparent watercolor.

4. If you prefer to organize your paintings by intermixing washes and strokes, ask yourself these questions:

Are you achieving a fairly even distribution of washes and strokes over the surface of the painting? If not, you may be slipping into one of the other systems of surface coherence. In any case, you are risking the unity of the method you are using.

Do your washes and strokes vary a great deal in size? Harmony of size, within a reasonable range, is usually necessary to surface coherence when you intermix washes and strokes. A large flat wash, for example, will look unrelated to areas treated with wash and stroke together. That same large area, modulated by wet-blended variations or by some defining strokes within it, will cohere with the rest of the surface, as in the sky in *Stonehenge* (figure 7).

5. Finally, ask these questions if you are inclined to order your picture surface by a gradation from wash to stroke.

Do you have a gradation system? If not, you may be the type of painter who works more naturally with a different system—a more even distribution of strokes and washes. On the other hand, your system may be right, but not fully matured. Look again at

your pictures; can you tell whether you are leaning toward a background-to-foreground organization or a periphery-to-center system? Observe whether you seem to care about distance and atmosphere; if so, you may want to adopt the distance-to-foreground system. If deep space is not one of your main concerns, then perhaps the periphery-to-center organization is more useful for you. Try to decide which of these organizational patterns best fits your past work and your present interests and then decide where you are weak in executing the system.

For example, is your transition from the washed background to the strokes of the middleground or foreground too abrupt? This might create a disruption in the order of your picture. Similarly, a too abrupt transition from washed periphery to stroked central focus can isolate the center from the rest of your painting.

Summary
Consistency in the treatment of the painted surface is one of your most important ways of achieving pictorial coherence. Without such coherence, your visual statement is hesitant, flawed, and incomplete.

The major cause of surface inconsistency in transparent watercolor arises out of the medium's very versatility—the variety of ways you can apply paint. Not only do you have the wash and stroke, but you can employ wet blending and many other surface treatments ranging from scraping to spattering. This

richness of choice can easily lead to too much variety of technique in a picture, thereby weakening its surface coherence.

The four basic methods of creating an organized surface dealt with in this chapter do not, of course, exhaust all the possibilities. They are meant, rather, to give you a handle on the problem, a sense of what surface coherence in watercolor involves, and a way of identifying it. You will probably find that like most painters you have one fundamental method, although you vary that method to suit your subject and your expressive needs in any given picture.

But these variations are probably related. For instance, you may find that you are a wash painter, but that you sometimes need to move toward wash and stroke. James A. Elliott is basically a stroke painter, although he often tends to work wash-to-stroke/background-to-foreground. His *Winter Seas* (figure 14) is quite true to the latter method. But *Force Nine* (figure 15) required a vigorous intermingling of wash and stroke, with generous wet blending over all sections of the paper. Elliott's personal stroke-touch remains visible throughout the surface, but strokes are subordinated to the free, open washes that help express the wild force of the waves against the rocks.

You can expect similar variations in your own work, and now might be a good time to take one last look at your study collection. You will probably find some range of related surface organization methods.

Figure 16
Bermuda by Andrew Wyeth, c. 1950, 21″ x 29″ (53 x 74 cm), courtesy Bowdoin College Museum of Art. Gift of Mr. and Mrs. Stephen Etnier, in Memory of S. Foster Yancey, 1930. Wyeth creates surface coherence by mixing many types of edges almost equally over the paper. Blended edges, crisp ones, rough ones—all appear in each section of the picture, so that the observer senses that all represented elements have been fully translated into the special watercolor language of the individual artist. The few reserved lights are skillfully done so that they also become a part of the pictorial world.

Edges and Reserved Lights

Are razor-sharp edges, unexpected edges, or messy edges reducing the surface coherence of your paintings?

Critical Concern

Edges present problems to painters in all media, chiefly because "there are no lines in nature." We identify what we call different objects by perceiving their contours, but these are actually only juxtapositions of color and value that vary from sharp to scarcely visible gradations. Our drawing conventions, however, render all these distinctions as lines, and the conventions necessarily carry over to painting, since the marks brushes make have distinct edges unless the artist deliberately modifies them.

For painters, then, the edge problem is generally less one of technique than one of either insufficient observation or inadequate thought. For the transparent watercolorist, however, edges can be especially troublesome because of technical complications. There is a potential for inconsistency in the contrast between the sharp, dry edges that watercolor seems to invite at the borders of both strokes and washes and the soft edges that wet blending produces. Also, there is a sneaky tendency for the edges of washes or a sequence of brush marks to add up to a totally unplanned linear element that can often prove very difficult to disguise or remove. Such unexpected "lines" can alter your composition and interfere with both illusion and surface integrity. Finally, there is the overlapped or blurred edge alluded to in the last chapter. Any of these can decrease surface coherence and cause the painting to look botched and incompetent.

Let's think briefly about each of these three problem areas. Few watercolor effects are as entrancing as the soft, wet-in-wet blending of color that is so special to the medium. But we seldom recognize that the clean, hard edge of a wash or stroke laid on dry paper is equally characteristic of watercolor. The capacity of the fully charged brush to form a precise, linear edge, although enhanced by the use of cold-pressed or hot-pressed paper, is fully evident in paintings on rough paper as well. The problem, then, is that even though both blurred and precise edges are natural to watercolor, they are extremely different visually. A coherent painting normally includes almost exclusively one or the other—or a fairly balanced mixture of both (see color plate 17, *Nursery* by Susan Heidemann).

Unexpected edges or undesirable linear elements can occur in all media. They are usually a result of an inclination to add more of anything that looks good. Unfortunately, we generally do almost the same thing the second, third, or fourth time. In transparent watercolor, unwanted edges or lines slip in easily, especially as dark touches are added in an attempt to enliven potentially dead areas. A sequence of such darks can become a fortuitous line if not carefully controlled. When painting seaweed on a beach, for example, I have to refrain quite consciously from overaccenting a sand slope with these "helpful" darks.

For the transparent watercolorist, however, the worst edge trouble arises directly from the light-to-dark procedure and the necessity of reserving lights. If you are not painting light to dark and reserving lights, you are asking for blurred edges. If you *are* reserving lights, you know that placing a deep dark against a very pale tone poses few difficulties because the coverage will normally be complete; but with middle tones you must *plan* in order to avoid overlaps, for here the darker of the two tones is likely to be quite transparent and result in an unwanted seam or blur.

Illustrations

When we speak of edges that are too sharp, we must speak relatively. The plethora of sharp edges in *The Ell* by Loring W. Coleman (color plate 5), for ex-

Figure 18 (right)
Flop (detail) by Carl Schmalz, 1976, 11″ x 8½″ (28 x 22 cm), 140 lb. hot pressed paper. Here I ruined an interesting painting by letting myself become overanxious. I wanted the cracks to stand out and, in the process, made the central crack in this detail into so powerful a line that it stays on the paper surface instead of lying in the rock surface. Compare this with the well handled cracks in Larry Webster's *Quarry Fragment* (figure 103). Photograph by David Stansbury.

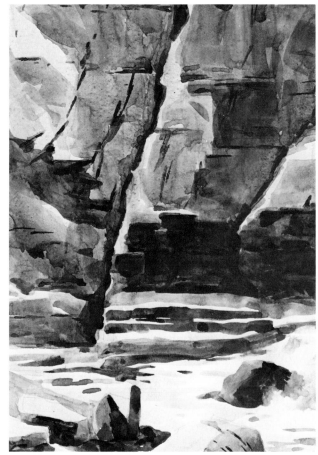

Figure 17 (above)
Flop (detail) by Carl Schmalz, 1975, 12″ x 19½″ (30 x 50 cm) 140 lb. hot pressed paper. Preoccupation with sharp edges creates an overemphasis on shapes in this non-picture. The luminosity of the shed and cottage at left is contradicted by over-precise detail in the house at right. There is also a problem in the lack of consistency between the rather loosely applied paint and the sharp edges of the shapes that further diminishes surface coherence. This paper is a candidate for the trash can! Photograph by David Stansbury.

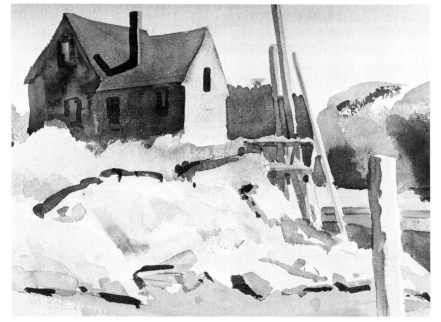

Figure 19
Flop (detail) by Carl Schmalz, 1974, 8½″ x 11″ (22 x 28 cm), 140 lb. rough paper. This probably was not going to be a painting anyway, but I made sure of it by losing interest and sticking in darks thoughtlessly. Not only is there an unpleasant line at the junction between ledge and shrubbery, but the shadow darks among the lower rocks are also insensitive as well. Photograph by David Stansbury.

ample, fits consistently with his entire picture surface, and the architectural detail of his subject lends itself to a wealth of descriptive edges.

A detail from one of my failures, on the other hand, illustrates how sharp edges can assist in the destruction of a picture (figure 17). I was initially interested here in effects of reflected light on the adjacent cottages. That feeling is finally overpowered, however, by an insistence upon architectural clarity, which I tried to accomplish through excessive attention to contours—of buildings, their details, and shadows. The pattern of shapes made prominent by these edges conflicts with the light effect, diminishing the power of both. The would-be-picture has a split personality and fails as a coherent statement of either pattern *or* light.

Although overemphasis on precision of edges occurs frequently in the architectural elements in a landscape, it can happen anywhere—in trees, clouds, and, of course, rocks. Another of my attempts flopped because of a rock crack that is too sharp (figure 18). Compare the central crack in this detail with the one at the right. Preoccupation with descriptive accuracy makes the edges of the center crack too dark and too visible, so the crack fails to take its place within the more general treatment of the rock face elsewhere on the paper's surface. Faulty observation and technical overkill violate the coherence of the painted surface and destroy the pictorial illusion.

Unexpected edges, which are generally lines or linear elements that appear by accident, can be controlled simply by remaining alert. You will find that they most frequently appear as darks, often where you are looking for shadow accents. An example is a detail (figure 19) in which I thoughtlessly outlined the top of an exposed ledge with shadows

from the foliage above it. The "line" thus formed seems to exist on the surface independent of light effect and illusion.

The obligation to paint from light to dark means that many light shapes must be "reserved"; that is, we have to paint darks around them. This involves the contradiction of making *active* marks that often serve a passive purpose. Where most positive marks stand for themselves, the function of these is to clarify and define a light. The other main medium in which this "upside-down" thinking is required is, of course, drawing (which may be why the English usually refer to watercolors as "drawings" and may further have contributed to the resistance, in some quarters, to accept watercolors as paintings on a par with those in other media). The need to reserve lights calls for watercolorists to think with special flexibility and a particular kind of planning.

Let's orient ourselves by reviewing a bit. We employ the light-to-dark procedure because the technical ease it allows emerges in the final picture as visible order (see Chapter 1). The procedure is simple, and it creates a natural coherence in the materials we are using. It follows that if we are to achieve the greatest economy of means, both in the process of painting and in the appearance of the final product, we must anticipate the location and tone of our lights. In this way, we can let a surprising number of lights do double duty, and we can also control the kinds of edges we desire.

Before looking at some classically masterful examples of reserved lights, let's consider the question, "Why not use commercially available masking fluid and save all of this nonsense?" The answer is that sometimes you can do this very successfully, but these times are the exception rather than the rule. You will be using reserved lights, at least in

modified form, for a major portion of almost any painting. When you mix the masking-fluid procedure with the reserved-lights procedure you tend to lose surface coherence. This is because the masking fluid goes on as a *positive* mark. Unless you modify the mark considerably after you remove the masking product, you will leave an incongruous *positive* light among your reserved lights. This is exactly the problem with using opaque white, and the reason for avoiding it except in special circumstances. In short, unless you need very small lights—for example, tiny flowers in a field or a glint of light along a wire or on an icicle—you will almost always find it technically easier to reserve, for if you mask or use opaque white, you will probably have to spend almost as much time fudging the marks to make them appear reserved as you would have spent reserving them in the first place. There will always be those special circumstances in which masking fluid or opaque white may be the only possible solution: in such a situation, by all means use it. But be alert to how it may diminish the surface coherence of your painting, and be prepared to disguise its use to restore that coherence.

A good illustration of superb economy in reserving lights is Winslow Homer's famous *Homosassa River* (color plate 6). Homer always made a careful pencil drawing before he began to apply his watercolor. He concentrated on the objects he wanted to stress, rarely setting down more than background notes. As a result, the more distant areas in his watercolors are frequently "ad-libbed" and most clearly reveal his economies. In this picture, Homer put in the grayed blue, still largely visible at the right, after the sky dried. Observe how the value varies within itself from right to left. He used a very similar value for the lighter tree

trunks, laying them over the gray-blue. After some of the lighter foliage had been added, he began to model the trunks and to darken their upper lengths against the sky. Some of these darks were also used to suggest other trunks and vines against the lighter jungle background. Finally, this value becomes darker at left where it defines a palm trunk and masses of Spanish moss. The effect of luxuriant growth, light, and distance is achieved by the judicious use of essentially three colors, some doing double duty.

Although the edges of these colors are all sharp, notice how Homer uses a variety of edges in the picture as a whole, including rough brushing in the palm fronds and reflection, wet blending in the background and water, and a blotted-out light in the immediate foreground. The observer recognizes in this variety an all-over ordering of edge types consistent with Homer's all-over balance of stroke and wash, as discussed in Chapter 2.

In *Maine Still Life* (color plate 7), I had many lights to reserve. In fact, the entire picture was virtually painted "backwards" by comparison with the "easy" picture. After a quick pencil drawing, I painted the palest tones of the lilies, stems, and weeds. As the light-middle value of the lobster pots went on next, I reserved the previously painted vegetation. This tone, which I deliberately varied to give a sense of texture to the oak slats, covered the part of the pots in shade as well as in light. I turned then to the modeling and detail of the lilies, finally setting in the deeper darks, which I also used to define details in the lobster pots. Wherever possible I let a lighter tone run under the edge that the darker surrounding colors would overlap. This gave me almost complete control over the edge I wanted. Here I used sharp edges almost exclusively, letting the

character of the smooth paper add to the visual crispness that unifies the surface.

Exercises

There are two parts to these exercises, the criticism and—for those of you who would like a bit more practical thinking about reserving lights—a painting section. To begin, set up your pictures and look at the way you treat edges.

If you are a wet-in-wet painter, you will have relatively few edges to check, since most will be softly blended. Nevertheless, a study of your use of edges, especially the relatively firm ones, will help you determine whether you are (1) relating edges to your main pictorial interest; (2) using edges effectively for representational focus and compositional emphasis; and (3) exploiting the possibilities of edges for surface coherence.

Concerning the first point, a little thought tells you that the sharpness of edges is a direct function of value contrast. For example, the bare branches of leafless trees make striking patterns against a light sky, but grouped together, as at the border of a meadow, the separate branches are scarcely distinguishable because their value is so nearly the same. So one of the first places to look for overstated edges is where tones close in value abut. From the standpoint of observation, these junctures offer one of your best bets for softening edges, which will tend to emphasize broad areas of value, and hence value pattern, in your painting. On the other hand, you may choose to make the edges of shapes close in value precise to clarify pictorially what is visually unclear. In this case, you may want to soften some strong contrast edges arbitrarily for balance. This increases the visibility of individual objects while minimizing value patterns. So consider: does your use of

edges work for or against your pictorial interests?

Concerning the second point, we have already seen that edges can help create visual emphasis or focus, both representationally and compositionally. In Judy Richardson Gard's *The Covey* (figure 12), we observed how a gradation from wash to stroke focuses attention on the center birds. This can also be seen as a gradation from softer to firmer edges. The same shift is commonly used to indicate a movement from far to near in the illusory space of a picture. Are you using edges to help define space in your pictures? Are you taking advantage of edges to focus your composition?

Finally, the properly controlled treatment of edges based on gradation yields a surface coherence. As with the stroke and wash, there are two other principal ways of achieving coherence of edges. One is through a consistent use of the same type of edge throughout the picture; the other is through an even mixture of edges. My *July 6, 1976* (color plate 8) is an example of the first. Crisp edges, typical of smooth paper, show everywhere except within the larger washed areas, such as the house at right, the distant foliage, and the shadowed trunks at center. In those areas I have sought variation by permitting colors to flow together.

Andrew Wyeth's *Bermuda* (figure 16) displays all types of edges without regard for distance. Surface coherence is maintained by distributing the variety of edges over the entire surface, so some clouds have hard or ragged edges, some rocks have soft ones, and the figure and the boat, the focal center, share the general spectrum of possibilities.

A consistent treatment of edges leads to *pictorial* coherence as well as surface coherence, in the same way that a consistent treatment of strokes and washes does. Again,

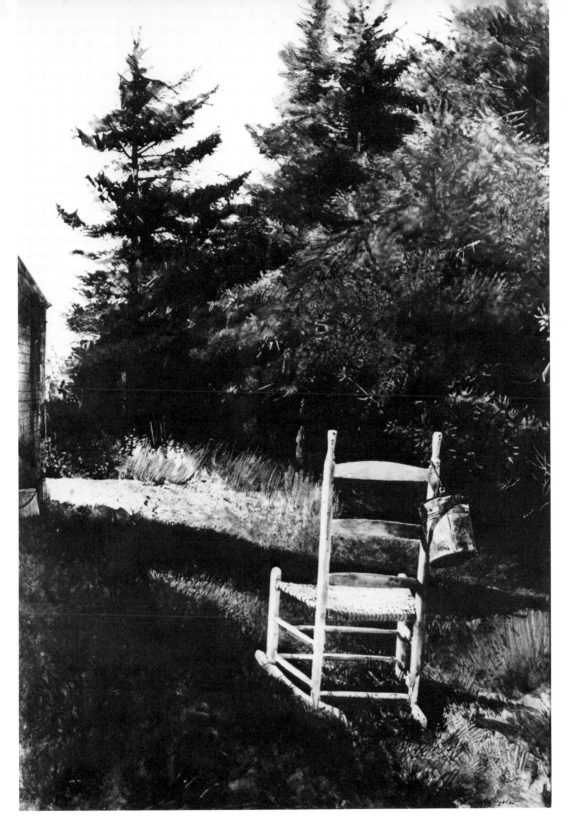

Figure 20
Lawn Chair by Andrew Wyeth, c. 1962, 22″ x 15″ (56 x 38 cm), smooth paper, courtesy of the Joan Whitney Payson Gallery of Art, Westbrook College. This later watercolor by Wyeth is done in the technique he calls "drybrush." It is much more detailed than *Bermuda*, but most of the lights are still reserved, despite their small size. A few lights, such as those in the right foreground, are scraped out of the wet paint. Notice that Wyeth makes these scraped marks look very much like the reserved areas. He uses the principle of sequence skillfully, building from less detailed areas of paint texture, such as the foliage at upper right, to more detailed areas of descriptive texture, such as the grass and chair itself. Photo by Tom Jones.

Figure 21
Small Point, Me. (detail) by Carl Schmalz, 1965, 8½″ x 11″ (22 x 28 cm). Finished painting 13″ x 31″ (33 x 79 cm) 140 lb. hot pressed paper, collection of the author. The lights of the dead spruce trunks and branches went on with the lights in the sky, the distance, and the grass. I reserved them when painting the darker foliage and later modified their color where appropriate. Photograph by David Stansbury.

Bermuda serves as an example. By means of edges, his personal combination of stroke and wash, and his patent economy, Wyeth constructs a compellingly unified picture world in which the viewer perceives a unique coherence between personal vision and materials as used by a single individual. When we say that this is a picture with both vitality and force, we are referring precisely to our comprehension of this complex and complete coherence.

Wyeth's painting makes a good starting point for further discussion of reserved lights. For the most part, *Bermuda* is a straightforward light-to-dark picture. The houses, their roofs, and the glint of light on the man's hat had to be reserved. As mentioned earlier, the trick in making this process easy is to plan ahead, especially to consider ways in which lights can be doubly used. Wyeth, for instance, allows some sky tones to slip down into the roof of the house at left where they become variations within the roof area (see also figure 20).

In another example, a detail from one of my pictures (figure 21), you can see how undertones in the trees function as fine branches above, and reserved lights become trunks and larger branches below. It is this kind of economy that is so often apparent in Winslow Homer's painting; it is also essential to the technique of many other artists.

If you would like to try reserving lights, select a subject (perhaps something you sometimes shy away from) with plenty of light-against-dark elements. This might be some birches or other light-trunked trees against evergreens; an architectural subject, possibly including a picket fence;

or dry, sunlit weeds in front of a shaded building. Remember that this is a technical exercise, not an attempt to make a painting, so don't undertake anything too complex.

Get out a half-sheet of your usual paper (the back of a used one will do fine). Even if you normally work on full sheets, a half-sheet will be large enough for this task. Set up your paints.

Now make a quick pencil sketch of your subject, trying not to be too detailed. Sit a few minutes to plan your attack: this is the most important part of the process. Keep in mind that your aim is to attain the desired effect using the simplest possible procedure. Check your birch trees, for example. They may be white against a hillside, but are they white against the sky? Could you afford to spill sky tone onto them, reserving only a few scraps of white paper, thus making painting the sky easier for yourself? A few darker tones might then accent the branches against the sky, and you have your effect with minimal effort. Or, where your fence is in shadow, could you let that tone run under the building behind it to avoid having to paint the pickets twice— once to put on the shadow and once to relieve the fence against a darker background?

Study the subject for every possible opportunity to economize your procedure. Remember that value is nearly always more telling than hue: often a hue tells the viewer more than is required and may contribute to a lessening of color coherence (see Chapter 12 for more information about color coherence). A color that is not fully descriptive of the object it represents may increase color coherence and, if the value is

right, will not detract from your illusion. For example, the shadow on your picket fence may really be a neutral blue, but it will work just as well if you paint it the same warm gray as the trim on the building behind it, thus saving one whole tedious operation.

Having determined where you can simplify your reserved lights, consider what kinds of edges will be appropriate for them. You want to consider two aspects of your painting—the actual variety of edges in the objects you are representing and the relationships among them required for surface coherence.

Now paint your picture, keeping your decisions in mind and trying to complete it in as few steps as possible. This will give you a good sense of how the reserved light problem has most satisfactorily (and most often) been solved by transparent watercolorists.

Summary
A coherent painting requires edges that are consistent and compatible with the subject. As with strokes and washes, edges in a picture may be similar or dissimilar, though equally distributed over the paper surface, or they may be organized sequentially, such as soft edges in the distance that shift to increasingly crisp ones in the foreground.

You can avoid unexpected edges chiefly by staying alert to their presence, especially when you are painting things that call for a series of similar brushstrokes.

Blurred or messy edges are best controlled by planning your painting process to take maximum advantage of the economies offered by reserving lights.

Figure 23 (right)
Striped Leaves by Susan Heidemann, 1976, 22″ x 30″ (56 x 76 cm), cold pressed paper, collection of the artist. This is fundamentally a stroke painting. The strokes vary in size within a controlled range, and all share a similar fluid texture deriving from their initially wet application. Heidemann does not tamper with her stroke once it is set down, so the drying often tends to be a little uneven; this gives both the strokes and the surface a sense of loose aliveness.

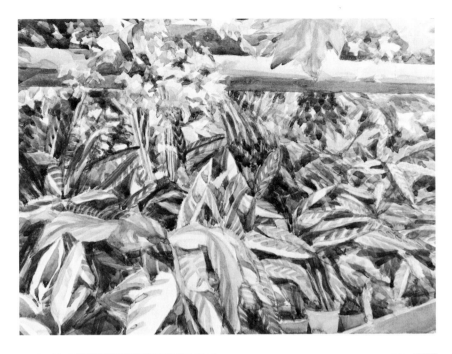

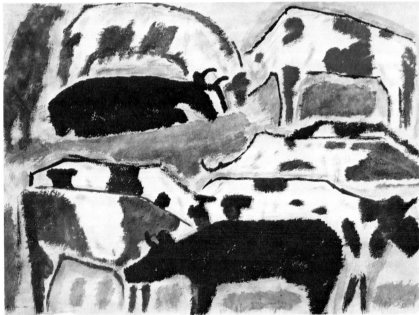
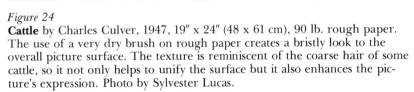

Figure 24
Cattle by Charles Culver, 1947, 19″ x 24″ (48 x 61 cm), 90 lb. rough paper. The use of a very dry brush on rough paper creates a bristly look to the overall picture surface. The texture is reminiscent of the coarse hair of some cattle, so it not only helps to unify the surface but it also enhances the picture's expression. Photo by Sylvester Lucas.

Figure 25
Texture Sample by Carl Schmalz, 140 lb. rough paper. Utterly different textures tend to contrast so greatly that they disrupt surface coherence. Note that it is virtually impossible to read the spatters and rough brushing as behind the wet-blended strokes. This is because they must *actually* overlap the earlier washes due to the light-to-dark procedure of transparent watercolor. But the sharpness of their edges also instructs us to read them as near, as in the light, rough-brushed marks at lower right. The differences are so visible that we cannot read a coherent paint surface at all. Photograph by David Stansbury.

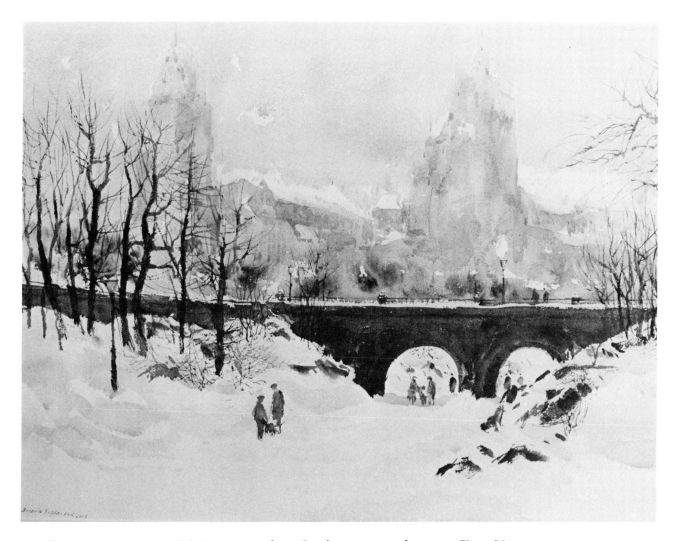

overall appearance, Gene Klebe's *Wet Float* (figure 27) illustrates a similar system. There is a background-to-foreground shift from wet to dry texture that corresponds to a shift from generalized to specific *descriptive* texture as well. Note that the background water and much of the wet float are treated quite broadly, as are unessential details such as the ropes at left and the lower section of the lobster pot at right. Dry textures are largely used to render more precisely the surface textures of the baskets, rusted anchors, barnacle-covered pot buoys, and other bits that characterize the locale.

Most dangerous to pictorial coherence is adding textures not typically obtained with the normal materials and tools of transparent watercolor. I do not wish to suggest that such textures

are taboo. On the contrary, they can be very effectively used, as in Samuel Kamen's *Berries* (figure 28). This small black-and-white picture relies on crayon or pencil lines to augment and vary the relatively homogeneous texture of student-grade, machine-embossed paper; and partly because of the prominence of the pencil textures, we easily accept the textures of scratched-out lights.

Many artists enjoy using speckling by splashing drops from a brush, flicking bristle brushes, rubbing a toothbrush through a sieve, or some other method. This usually corresponds best to the rest of the paint textures when the entire painting is done in a rather free and splashy manner. Murray Wentworth's *Overgrown* (figure 29) illustrates this combination well. Here the splash-drop method seems inte-

Figure 26
Untitled (Central Park) by Bogomir Bogdanovic, A.W.S., c. 1969, 22″ x 28″ (56 x 71 cm), collection of the artist. Bogdanovic combines two ways of controlling contrasting paint texture. He mixes wet washes and drybrushing fairly uniformly over the paper surface; but he also tends to increase drybrushing toward the picture's foreground, where the trees and figures are located.

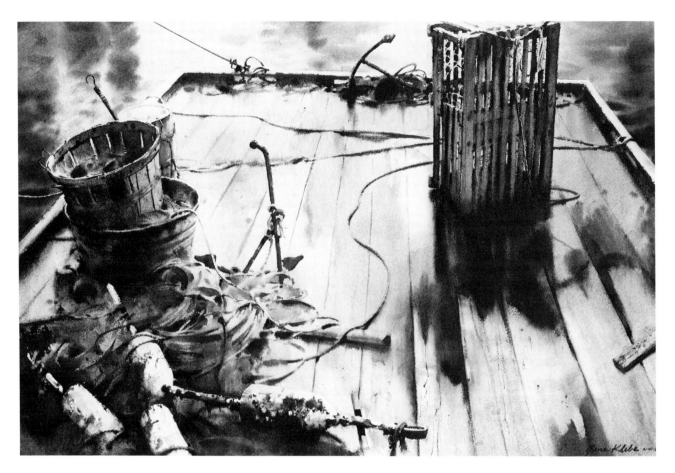

Wet Float by Gene Klebe, c. 1969, 18″ x 28″ (46 x 71 cm), rough paper, collection of Mr. James J. Rochlis, D. Wu Ject-Key Memorial Award, A.W.S., 1969. Here two ways of controlling texture are also combined: (1) overall distribution of soft and sharp and (2) selected focussing of sharp definition at a series of points of interest around the picture surface and in the picture space. The result is a tightly integrated work, full of textural interest.

gral to the picture-making process because some drops were spattered on when the washes were wet. The texture of the splashes and drops matches the range of textures seen in the strokes of the grave marker and grasses. Similarly, one can imagine Wyeth's *Bermuda* (figure 16), with its free and vigorous handling, augmented by purposeful or accidental spatters.

Knifing is another technique commonly used to produce texture or lights. John H. Murray's *Cranberry Island, Maine* (figure 30) is an excellent example of a painting given surface coherence by knifed texture. Linear scratches and gouges animate the rocks, beach, and water; but they are linked in appearance with rough brushing in the sky and background to produce overall similarity of texture. The rough striations of knifework in the rocks in figure 31 correspond not so much to the descriptive look of such ledges as to the glacial

grinding that formed them; that is, the scratches profoundly express rather than merely record the geological formation of the rocks.

Exercises

Excessive contrast in paint texture is one of the principal ways of upsetting a painting's coherence. The best way to overcome excessive contrast and hence use texture effectively is to work for similarity of texture, a balanced mixture of textures, or sequences of texture change.

It is time to ask some more questions, so get out your pictures. Remember, these questions are about how you are using *paint* textures, not the textures that describe or represent your subject.

You have already made some decisions about your preferences and uses of stroke and wash, wet and dry; you have seen how these decisions and tendencies merge into textural considerations. We'll ask some questions

Figure 28 (left)
Berries by Samuel Kamen, c. 1969, 6″ x 7¼″ (15 x 18 cm), rough paper, collection of the artist. This elegant small study shows how successfully unusual textures can be incorporated into a coherent textural surface. Scraping and scratching are teamed with rough drawing over free washes to produce an equally worked surface. Photo by Peter A. Juley.

Figure 29 (below)
Overgrown by Murray Wentworth, c. 1974, 20″ x 30″ (51 x 76 cm), very smooth paper, collection of the artist. Murray Wentworth's use of paint texture offers a superb example of many varied textures unified into a coherent surface. His organization is sequential, so that visual excitement coincides with his central points of representational and expressive interest. These are the right foreground weeds, the front of the tombstone, and the spruce branches at left. Photo by Fasch.

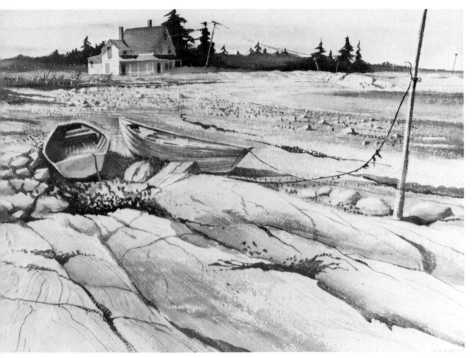

Figure 30
Cranberry Island, Maine by John H. Murray, 1962, 15″ x 23″ (38 x 58 cm), rough paper, courtesy of Mrs. Virginia Murray. Rough paper, rough brushing, and rough knifing together form a coherent surface in Murray's picture. His organization depends upon similarity of surface texture achieved through cooperation between choice of paper, choice of brush handling, and choice of unusual techniques. Here the overall roughness is more a way of expressing the innate nature of the place than simply a description of it.

Figure 31
Cranberry Island, Maine, (detail) 5″ x 6¾″ (13 x 17 cm). In this enlargement you can see clearly how paper, brush, and knife work together. The washes are laid on roughly; the dark linear accents of cracks give a feeling of the direction of the rock formation and shape; the vigorous knife strokes gouge the paper surface and speak directly of the rocks' striation.

about these, but concentrate on uses of textures obtained by means other than the ordinary materials and tools of transparent watercolor.

1. Do your pictures tend to be texturally bland? If so, your textures may be similar, thus creating textural coherence, but you may be overlooking an opportunity to add visual interest to your work by varying the textures.

2. Is there *too much* textural contrast in your pictures? This may be the case if, as you look at the works thoughtfully, you feel a kind of purposeless activity in them, a degree of visual excitement unjustified by the subjects.

You can tame this tendency, should you detect it, by harnessing texture and making it work for you. We shall refer to this in a larger context later; for now, consider how similarity of textures in your painting might unify the surface. Or, if that seems inappropriate, consider whether more or less of a particular texture throughout a picture might help. If neither of these alternatives works, what about gradation from one texture to another? Could you have shifted from one texture to another without unduly complicating the technical process or spoiling the representation?

3. In pictures where you have made textures with something other than brushes, are the extraordinary textures well integrated into the painted surface? For example, to work really well, knifing and scraping must be done with the authority of brushstrokes. Usually, the natural movement of your hand makes your knife strokes sufficiently similar to your brush marks to maintain surface coherence. But it is also useful to remember that modifying such strokes with brushed-on tones will very often rectify an outrageously visible

knifed or scraped area and so revive your surface coherence. An example might be fence pickets, knifed out and then modified with brushed-on shadow tones.

4. Are you familiar with the wide variety of textures you can create with materials other than brushes? If not, here are a few possibilities worth exploring.

Get out some discarded paintings with clean backs, or use fresh paper. Select several different surfaces and weights if you have them. Squeeze out some black or dark paint and assemble as many of the following materials as possible:

Sponges
Salt
Sand
Knife
Single-edge razor blade
Plastic scraper
Blotters (Kleenex)
Cheesecloth
Plastic wrap
Erasers (different kinds)
Old toothbrush
Bristle brushes
Wooden sticks (match, orange
 wood, twigs)
Leaves (fresh or dry)
Cardboard scraps
Volatile fluids
Inks (including India)

It would take too much space to outline all the possible experimental combinations that you should have before you; instead of holding your hand through each permutation, I'll give you a procedure to follow.

Line up your "unusual" tools and regular materials in a convenient way. Line up your different papers, too. (As usual with watercolor, prepare carefully: much will depend on drying time.) Working as quickly as possible, place two or three

wet patches of middle-value color, about 3″ x 3″ (8 x 8 cm), on several papers. Then, proceeding methodically, use each of the "unusual" tools or materials on one or more of the patches. Repeat the process until you have tried all the possibilities. Now paint new patches, allowing them to dry to the semigloss stage before manipulating them. Some of the tools and materials must be used on dry paint, so prepare a group of patches to dry. On these you can experiment with erasers, sandpaper, scratching with single-edge razor blades, and spattering. By pressing something into wet paint and then onto the dry patch, you can explore various printing or stamping techniques with the veined backs of fresh leaves; corrugated board; pieces of rubber flooring, door mats, or stair treads; crumpled plastic wrap or paper; sponges; and other materials. Remember also that you can use your hands and fingers to modify wet areas or dry ones by printing. (See also figure 53. The whole paper was crumpled before painting.)

As you produce these varied surfaces, think about how you might be able to exploit them in pictures. But you must also consider how you will integrate them into your picture surface. Textures produced by means other than the brush are inherently different from the "normal" surface textures of watercolor and require careful melding with brush textures if surface coherence is to be maintained.

Looking again at your pictures, a good question to ask yourself is: what reason did I have for using that unusual texture there? If you didn't have a reason, or can't now recall it, you may be using these powerful techniques

arbitrarily and jeopardizing the surface coherence of your painting unnecessarily. It may be helpful to look at these areas carefully and consider whether and how the effect you wanted could have been achieved using paint textures of the more "normal" sort.

Summary

While impasto and other textural variations appropriate to the opaque media are not available to the transparent watercolorist, this medium offers a wide range of textural possibilities, some "normal" and some made with "unusual" tools and materials. Indeed, the very richness and diversity of watercolor textures pose a central problem for the painter. Controlling these textures so as to use them effectively, while maintaining surface coherence, poses an ever-present challenge.

The main principles to bear in mind to help integrate paint textures into the picture surface are a balanced mixture and sequences from one texture to another. In addition, it is useful to remember that utilization of the same "family" of textures, those that look similar or are made in similar ways, will provide order that will help avoid too much contrast. And if you are especially prone to overstate texture, it is good to ask yourself *why* you are about to introduce a new visual accent. Is it necessary? Can you integrate it with the present or final surface of your painting? Will it enhance meaning, or is it merely decorative?

Questions such as these will force you to consider how you use paint texture and prevent you from rushing headlong into using textures without thinking.

Figure 32
Kitchen Ell by Carl Schmalz, 1970, 23″ x 17″ (58 x 43 cm), 140 lb. hot pressed paper, collection of the author. This chapter suggests that a simple approach to composition is to identify what really interests you in a subject, put it near the paper's center, and then design around that focus. Here, the window with its flower pots attracted me. I cut my paper to a shape that almost duplicated that of the window (3½ x 2¼″/9 x 6 cm), and placed the window just left and below the middle of the paper. The rest of the composition fell into place easily. For example, I moved the central chimney slightly (compare with figure 5) so that its dark vertical shape continues that of the right section of the window.

Designing from the Center

Do "rules" of good composition get in your way?

Critical Concern

We know that since the sixteenth century, and probably before that time, compositional rules were established to aid students of painting. Many of these rules are helpful. "Never put the horizon in the middle," for example, is a generally useful observation, as is "Don't allow a strong diagonal to run out of the corner of the picture."

Nevertheless, there are so many of these rules that just remembering them is stifling. Furthermore, they often seem almost to contradict one another. "Don't put a large object in the middle," and "Don't put a large object at the edge," leave you with few places to put a large object. In fact, rules of composition may be as bewildering as they are illuminating, and we may do well to approach the whole question of pictorial design from another point of view.

This, in fact, is just what we've been doing and what we shall continue to do throughout this book. In this chapter we will focus essentially on how designing lines, axes, and surface shapes affect compositions.

Why do *you* paint a particular picture? For many representa-

tional artists the answer is "Because I like it," or "The subject appeals to me." These are rather vague answers, although we know pretty much what they mean. We don't often hear ourselves saying something as concrete as, "Because I think these angles and shapes will make a great composition." And yet, for many of us, it is just such a subliminal perception that sets us to work. I have often been two-thirds along in a painting in which I fully intended to omit a telephone pole before realizing that the pole was essential to what I saw as a good potential picture in the first place.

This chapter is about raising your awareness so you can recognize more easily what interests you in a painting. It is desirable to make such decisions because the easiest—and frequently the best—way to begin composing a picture is to identify what attracts you most in a scene. You can then place that thing or things in or near the center of your paper and compose the rest of it to support and strengthen that center focus.

Illustrations

Let's begin by noting that a picture is not just "of" a thing or group of things; rather it is of a thing or things and their context, transformed by you into a new context—the context of a sheet of paper of a certain shape and size. The paper context must become

its own organized world as well as a translation of the represented things. First, you must decide what thing(s) you want to represent—what interests you. Center that and then see how the paper context can be ordered to produce both pictorial coherence and appropriate representation of your chosen thing(s).

Often you can identify quite easily what the "thing" is: it will usually be the thing(s) that first caught your eye. In *Kitchen Ell* (figure 32), for instance, I knew from the start that my primary interest was the window with the flower pots on the sill and the tree shadows moving diagonally up the end of the ell. But the context seemed useful, for there were some verticals that could relate my central "thing" to the paper edges. I also saw some possibilities for linking foreground to distance. I cut my paper to a shape proportional to the window, but I doubt that I thought much further before beginning the drawing. I worked from a sketch (see figure 5).

The process of arranging a picture is complicated, and I see little gain in trying to simplify it. Nevertheless, there are "natural" tendencies, physical and mental, that you can rely on; and with conscious control, they help you create an orderly design to support your central "thing."

In *Kitchen Ell*, I placed the focal window to the left of the vertical center of the paper. The

DESIGNING FROM THE CENTER 41

Figure 33
Quall's House by Nicholas Solovioff, 1976, 14″ x 22″ (36 x 56 cm), cold pressed paper, collection of the artist. The bizarre architecture of the cottage interested Solovioff, so he located it in the middle of the paper. Subsidiary buildings at each side relate the cottage to the left and right margins. A suggestion of strokes in the sky helps liken it to the broadly stroked foreground, where there is hardly a hint of descriptive grass texture.

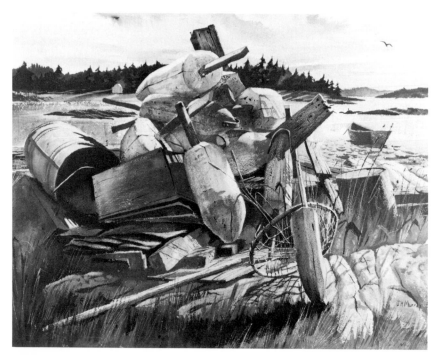

Figure 34
Buoys by John H. Murray, 1956, 18″ x 23½″ (46 x 60 cm), rough paper, courtesy of Mrs. Virginia Murray. Through the use of multiple parallel and sequential lines Murray relates the paper context to his centrally placed pile of decaying lobster fisherman's paraphernalia. Some are very subtle, such as the parallel between the edge of the rocks at lower right and the shadow of the shack at upper left. Notice also the light-to-dark sequence below the crate at center left. As in *Cranberry Island, Maine* (figure 30), the consistently rough surface also contributes to pictorial coherence.

right edge of the shadow inside the right side of the frame is almost at the exact vertical center of the sheet. The top of the window is about a quarter of an inch below the horizontal center of the picture. So my central focus is close enough to the paper center to demand the attention I want it to have and also to reinforce the vertical and horizontal center lines of the paper.

Had I placed the window at the exact vertical center of the sheet, it would have altered the intervals at either side of the window and made them less varied. The result would have been a considerable loss of interest in the proportional relationships of these elements. I located the window slightly below the horizontal center of the paper because I wanted enough bright blue sky at the top of the picture to balance the visual interest created by the irregular shapes and value contrasts of the tree shadows on the foreground snow.

Having made these decisions, partly without being fully conscious of them, I painted the picture. As I painted, I continually made decisions, but again, many of these decisions were made unconsciously. Disregarding colors, let's see what happened.

The final composition is based on a series of verticals. The window becomes not only the representational center of interest, but also the focal statement of the main compositional theme. Its horizontals are picked up in other architectural elements. There are architectural subthemes, too, notably the white triangle to the left of the ell roof, which appears as an inverted echo of the gable. This subtheme reappears even in the snow shadows and the branch pattern at upper right. The importance of this kind of echoing is significant, for I am concerned not only to include the repeat, as in ornamentation, but to make it

work expressively for me. Repeats order a picture by stating a likeness between superficially dissimilar things or by emphasizing likenesses generally overlooked.

Let's examine this concept. Notice that the shape of the shadow on the snow at the bottom of the paper is strongly echoed in the lowest branch coming in from the upper right. The angle of the shadows makes it clear that the shadow cannot be cast by this branch. Rather, it is a product of my use of the human tendency toward repetition. But even if it was unconsciously done, observe the result. Not only do I gain a valuable compositional repeat, but I make a statement about the similarity between transience and insubstantiality (the

shadow) and permanence and tangibility (the branch). This is appropriate to the picture as a whole, which is about the consistency of change—the winter sun picking out the clay pots that will grow green plants when spring comes.

Another by-product of our human urge toward order is the likeness between the contour of the distant hill and the foreground snow at the base of the ell. The lower contour of the snow moves to the left in a curve that suggests a parallel of the unseen hilltop curve and so makes what is hidden almost visible.

Two quite different ways of designing the context around a centrally placed focus can also be seen in figures 33 and 34. In

Nicholas Solovioff's *Quall's House*, alternating serpentine lines of sand and grass lead in from the foreground to the small value contrasts of the central cottage. Murray's *Buoys*, on the other hand, is treated as an "outdoor still life," with order created by the sequential lines and their echoes.

Exercises
Start this section with some doodling. Get out a sketch pad, some half-sheet backs of old watercolor papers, and a couple of large pieces of paper, if you have them (newsprint will also do). You'll need a pencil, crayon, brushes, and black paint.

Take your usual painting position. Let your mind become as

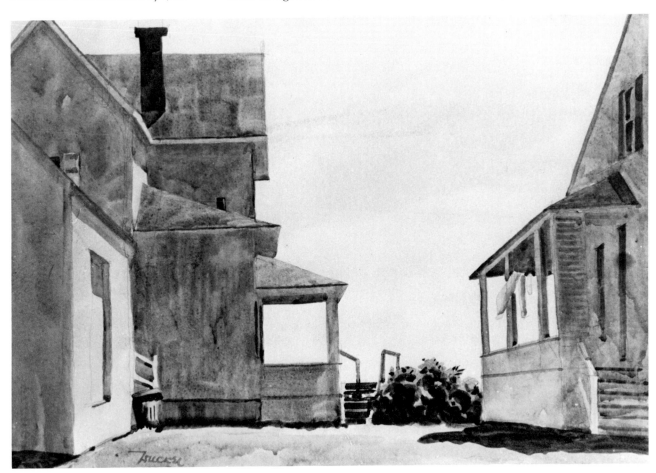

Figure 35
Afternoon by Robert W. Ducker, 1975, 15″ x 22″ (38 x 56 cm), 140 lb. hot pressed paper, collection of the artist. The force of this picture derives from clearly created and limited foreground space contrasted with the infinite space of the sky. The play between finite and infinite is stated thematically by the central vertical of the porch support, which bounds the view of sky under the porch while pointing to the unfettered space above and to the right.

Figure 36
Portrait of R. Confer by Robert Andrew Parker, 1963, 27″ x 20″ (69 x 76 cm), collection of Mr. and Mrs. Jeffrey Rochlis. Parker, like Ducker, uses a central space expressively. Three-dimensional space is of little concern to him, but the two-dimensional gap between the sitter's head and the bases of the trees forces the viewer to make a connection between them. The picture surface is highly coherent because of the brush and scratch marks all over it.

blank as possible and then begin drawing with your pencil on your pad. These should be fairly small marks and combinations of marks. Doodle until you have filled up at least one sketchbook page, two if you can. Now switch to crayon, still working on a sketchbook page, and do a page or two of doodles.

Using a medium-size brush, either round or flat, do the same thing with black paint on a half-sheet back. Try to work as fast and as mindlessly as you can. If you find yourself wanting to vary your marks, do so—trying not to slow down.

If you have larger paper, try a shot or two at it (using a bigger brush if you have one).

Rest a minute. If you have really forgotten yourself, you may be inexplicably tired. Look at your sketchbook pages. You should quickly spot a good deal of similarity among your marks, even if, despite yourself, you tried hard to vary them. The similarities will be those of shape, size, angle, and interval between lines and will include both repetitions and sequences. You will probably notice that the kinds of marks you made display a resemblance, even though you used different techniques and different sizes. You can check this by comparing what you did on the sketchbook pages with the half-sheets and the newsprint.

This adventure has a twofold purpose. First it demonstrates that insofar as "composition" depends upon similarity or likeness, it is natural, if not unavoidable. Orderly repetition or repetition with variations is inherent in human beings and is the basis of design. Second, it provides you with some simple abstract examples of *your* compositional tendencies and preferences.

Get out your group of paintings now for comparisons and analysis.

1. Perhaps your doodles tend to be bold and angular, or they include lots of parallel lines, right angles, or oval or circular lines. Compare the doodles with your paintings to see whether any of them contain a similar boldness, angularity, or other tendency you've noted. The chances are that you will see in not all of your paintings, but in some, the same propensity. And you may find that these similarities to your doodles appear most often in those parts of your pictures where you feel most secure and have to think least consciously. Check skies for instance, or backgrounds, or the periphery of your pictures, such as the very near foreground at the bottom of your paper. Sometimes your very choice of subject may reflect these preferences, as when a person who prefers curvilinear forms avoids architectural subjects, or a person who likes acute angles rarely undertakes pure landscape.

2. Have you been placing your center of interest near the center of your format? Is it still clearly the picture's focus? If not, can you figure out whether you misunderstood what your interest was, failed to emphasize the center of interest sufficiently, or tried to place the main focus deliberately off center? If you maintained the primary interest in your picture as the focal point of the painting and, even better,

reinforced and enhanced it compositionally, you can start to think more adventurously about creating a composition in which the focus is definitely *away* from the center. Remember that you can rely on your natural tendency to repeat parts of this main shape elsewhere in the design, but you also need to think consciously about the placement and visual emphasis of such repetitions.

If your paintings seem to vary a lot as to the kind of forms they display (especially if they vary significantly from your doodles), and if the center of interest tends to become lost or deemphasized, you will probably do well to do the following when painting: (1) try very hard to decide exactly what interests you most in a given subject; (2) place it near the middle of the format; and (3) look for similarities between your subject and its context that can be used for both design and expression in your pictorial context.

Summary
A simple, sound way to think about composition is to determine what interests you most in a subject and put it near the middle of your paper. You can count on human nature, as well as your own sensibility, intelligence, and experience, to create a composition in which repetitions and sequences help form a good design that may also enhance expression. You will find that a few preliminary sketches will start you thinking about how such repetitions might be formed and used.

Often the basic trick, though, is discovering precisely what it *is* that interests you. Thinking clearly and deliberately about your subject helps—but think with your pencil in your hand, for a painter can only think visually about painting. Your doodle exercises should provide you with some clues as to the kinds of lines and shapes that attract you. Something in your subject that reflects those lines and shapes may provide a key to your interest in it.

It is always possible that the central thing that interests you isn't a "thing" at all, but some eloquent space or gap, as in Robert W. Ducker's *Afternoon* (figure 35), for it is less about the architecture of the cottages than about the infinity of sea beyond them. In a similar way, Robert Andrew Parker's *Portrait of R. Confer* (figure 36) centers on the space between the head and the trees, suggesting simultaneously that Mr. Confer lives among trees, is sitting in front of them, and is thinking about them. Yet another alternative is that you are drawn by a cluster of things *around* the center, as in *Wet Float* (figure 27) by Gene Klebe. Regardless of what you identify as the focus of your interest, you can begin to think about composing your picture by setting it near the center of your paper.

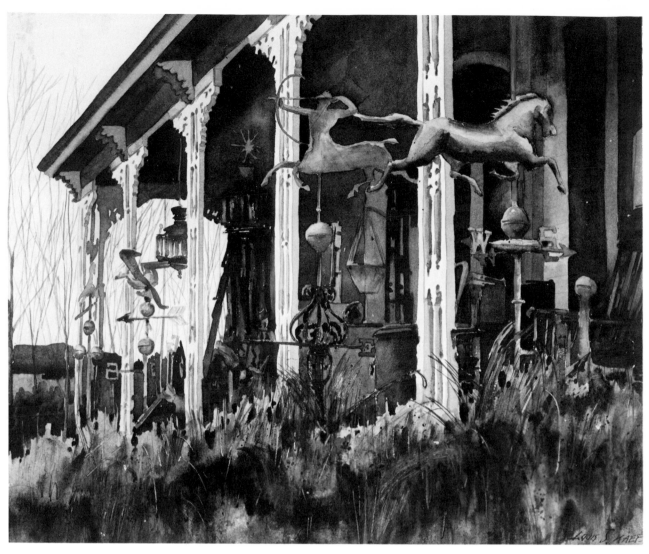

Figure 37
Antique Dealer's Porch by Louis J. Kaep, A.N.A., 9″ x 11″ (23 x 28 cm),
collection of Mr. George V. Mallory. Any sequence of diminishing size tends
to powerfully direct the observer's eye. When accompanied, as here, by per-
spective lines, the rush into pictorial space is precipitate. Kaep controls this
force with the screen of trees at left, and counters it with the horse weather-
vane that points so determinedly to the right.

Using Similarity

Are you using similarity in your painting as an active ordering principle or merely as passive reiteration?

Critical Concern

Similarity is the basic ordering principle in human thought. We all perceive many kinds of likenesses in the world around us, ranging from the practical to the poetic, the useful to the mistaken. Perceived similarities help us simplify and organize our complex world. Furry animals with four legs, for example, are usually mammals. If they share more similarities, they may fit the category of horse or cat. Mistaken likenesses can be tragic, as when a driver "sees" a shadow across the road that is, in fact, a log. Poetic and artistic perceptions of likeness are less practical and often suggest some unusual insight. They are presented in terms appropriate to poetry or painting.

For artists the most important types of similarity are repetition, sequence, and balance. These can occur in the color elements (see Chapter 9) and in the spatial elements and in both two and three dimensions. Here we will deal primarily with two-dimensional spatial elements.

The same physical and psychological tendencies that help you achieve compositional coherence through repetition, sequence, or balance of lines, shapes, sizes, and intervals can also produce boring pictures. Unless you consciously seek effective and imaginative similarities, uncontrolled repetitions may rob your paintings of expressive force.

We have all experienced moments of fatigue or inattention while painting. These are the times when the brush, almost by itself, makes a group of marks that add nothing to the picture's development and may actively ruin it. As you emerge from such a trance, you wonder how you could possibly have made all the trees so nearly the same size and shape! You can avoid this problem by becoming more *aware* of your particular tendencies and learning to discipline them. Painting is always partly a matter of turning a fault into a virtue.

Illustrations

Louis J. Kaep's *Antique Dealer's Porch* (figure 37) is a painting dominated by repeated vertical lines. Yet the picture is far from dull. First notice that the major themes of the work are focally stated by the centaur weathervane. Rising up the vertical center of the design, it includes a base that is the wrought-iron equivalent of the grasses, a ball that repeats as a contrapuntal shape across the horizontal center of the paper, and the centaur—an organic horizontal reinforced by the drawn arrow. The insistent verticals of the porch pillars are repeated in the grasses below and in the bare trees at left, as well as by bits of architecture within the porch. The pillars avoid dreariness because of the sequential gradation of their size, the intervals between them, and the variety of ways in which they are interrupted—mostly by horizontals. The ornamented "capitals" of the pillars resemble trees, a motif that is emphasized by the pillars' similarity to the vertical trees and grasses.

Among the horizontal elements, the bodies of the horse and centaur weathervanes are loosely echoed by the hill at extreme left, linking foreground and background in terms of shape.

In this picture, repetition of vertical lines and similar horizontal shapes (as well as many other refinements) not only knits the composition together, but enhances its meaning. This is what finally prevents similarity from being merely dull: it has an expressive as well as compositional purpose in the painting.

We might say that the painting literally describes an antique shop, or that it projects emotional overtones of nostalgia. But Kaep clarifies these more superficial meanings by his use of sequences, since sequences, especially gradations in any of the spatial ele-

quite distinct shapes can, of course, be very nearly the same size. In fact, size is among the most treacherous of pictorial factors for this reason. For instance, it is all too easy to produce a foreground in which rocks, bushes, and logs, although varied in shape and color, produce a deadening effect because of excessive similarity in size.

4. Seeing *intervals* can also be tricky because, on a picture surface, they are not equivalent to the spaces between objects. The two-dimensional breadth or height of an object itself constitutes an interval as well. This element was carefully weighed when I considered the placement of the window in my painting *Kitchen Ell* (figure 32).

You may not have to examine all your pictures for these elements of similarity, but look carefully at a minimum of six or eight paintings. Ask yourself first whether you are even taking advantage of these elements. It is unlikely that you are not, since, as we have seen, they tend to appear spontaneously. But should you discover that you are ignoring them, consider what

adjustments you might have made to enhance compositional unity. It is much more probable that you *are* using these similarities, but doing so partly or completely unconsciously. You may also discover that you are alert to similarities of line and shape, but not to those of size and interval.

Having checked your pictures for the presence of similarities of line, shape, size, and interval, you must now address the even more important question of how you are using these elements. To do this, ask yourself, picture by picture, what purpose (or purposes) is being served by the similarities you've noted. Do this systematically, observing your use of similarities of line first, then those of shape. Pay special attention to size and interval, for they are normally the most easily overlooked of the spatial elements in design. At this point concentrate on the similarities that seem to be serving a purely compositional function.

Consider how you are using arbitrary lines, for instance. If you like to "contain" your pictures with lines that cut off the paint-

ing's corners, are you integrating them with the rest of the paper by making them parallel or perpendicular to other lines or edges? In O'Hara's *Chez Leon* (figure 41), you'll notice that the arbitrary line at the lower left parallels the dominant oblique angle of the St. Raphael sign in the center of the picture.

In *John Smith's Beach* (figure 42), a linear sequence in the waves changes the angle of the lines from a slight tilt in the lower left to horizontal at the middle right. A suggestion of such a sequence also occurs in the sky at top left. The upper and lower sections of the paper are further linked by similarities of shape in the clouds and rocks below.

You may find that you tend to make the humps of cumulus clouds the same shape and size. This can often happen with rocks and bushes, too. Dullness may be compounded if all three are similar to each other, for even though a metaphorical significance may be intended by these likenesses, the eye is quickly bored by such repetition and is unlikely to grasp your meaning.

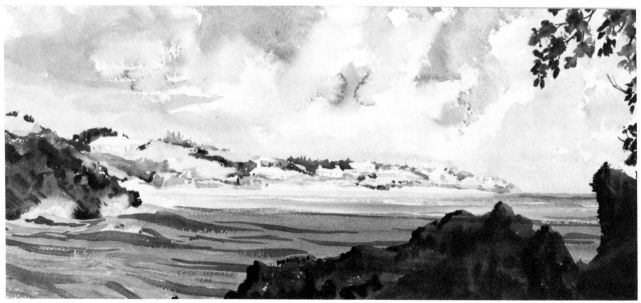

Figure 42
John Smith's Beach by Carl Schmalz, 1963, $10\frac{1}{2}''$ x $22\frac{1}{2}''$ (27 x 57 cm), 140 lb. rough paper, collection of the author. A sequence of directional changes in the waves helps to hold the distant headland together with the foreground. The same end is served by shape likenesses in the clouds and nearby rocks.

An interesting use of similarity of interval appears in O'Hara's *Plaza Borda, Taxco* (figure 43). The distance from the bottom of the picture to the bottom of the buildings is about equal to the distance from the base of the buildings to the eave of the roof; and the distance from there to the top of the next light is again close to the same. Similarly, the height of the roof and that of the darker horizontal band behind the foliage above are nearly the same. These likenesses provide a scaffolding of somnolent regularity against which O'Hara can play his strong value contrasts and brilliant colors.

You may have found that you are using similarities intelligently, but as compositional devices only. Obviously this is fine, for *composition* is simply a word for two- and three-dimensional integration of your picture. Nevertheless, you can strengthen your work by using similarity as a support for your expressive purposes as well. In this way, you introduce a coherence between what your picture *is* and what it *says*. This is what you must look at now.

Recall the ways in which compositional structure supports and emphasizes meaning in Kaep's *Antique Dealer's Porch* (figure 37), and use our analysis of it as a guide in your assessment of your own use of similarity. As you go through your paintings, you will discover that you often have done something good without knowing you were doing it. This will, of course, continue to be the case; but the more you can reinforce your meaning with your design through thought and awareness, the richer your pictures will become.

Summary

Similarities among the spatial elements—line, shape, size, and interval—offer some of your most powerful means for achieving pictorial organization and coherence. Danger lurks in excessive, thoughtless, or careless similarity, however. Most artists are alert to the value and hazard of line and shape. Few utilize size and interval similarities as imaginatively as they might. Try, therefore, to be more aware of these, both as possible explanations for visually boring pictures and as possible means of ordering the varied lines and shapes of your subject. In other words, consider how you can play the spatial elements against each other for varied emphasis in your pictures, especially as a means of coordinating your composition with your expressive intent.

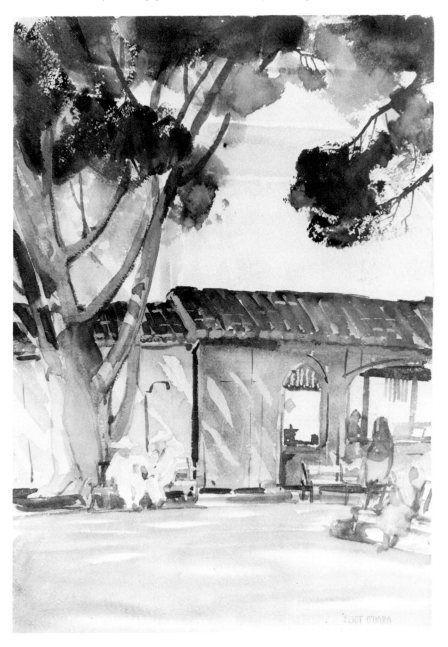

Figure 43
Plaza Borda, Taxco by Eliot O'Hara, 1937, 22″ x 15½″ (56 x 39 cm), 140 lb. rough paper, courtesty O'Hara Picture Trust. O'Hara uses intervals tellingly here, both to organize the picture surface and to reinforce expression. The interval from the bottom to the base of the building equals that from the base to the eave. As you look up the picture, there is an *A, A, B, A, B* rhythm. Both intervals are also repeated horizontally. From the left margin to the light architectural vertical just beyond the tree is *A. B* occurs in the openings at lower right.

Figure 44
Deserted Dock by Gene Klebe, A.W.S., c. 1968, 18″ x 28″ (46 x 71 cm), rough paper, collection of Mr. and Mrs. Arthur K. Watson. Contrasts of both line and value make this an arresting picture. Klebe tames the contrasts with sequential changes in the axes of the posts and boards. Strong value contrasts are spread fairly evenly over the paper, creating an asymmetrical balance. Focal areas are pointed up through judicious use of descriptive texture.

Exploiting Contrast

Is thoughtless use of contrast violating the coherence of your pictures?

Critical Concern

If similarity is the primary ordering or unifying principle in visual language, contrast is certainly the primary principle of differentiation. Contrast is essential to our vision: we cannot separate the simplest figure from its ground without some sort of contrast; lack of contrast makes camouflage and protective coloration in animals and birds work.

All drawing and painting begin with contrast; it is the root of representation. Perception of differences allows us to show a tree against a wall, a wall against a sky, or an ear against a head. Without contrast we could not see; without similarity we could not *order* what we see.

Precisely because it is so basic to seeing, contrast is often a cause of grief to artists. It is all too easy to overstate differences. We have all been plagued by the too-sharp gable, the too-big mouth, the too-sharp edge, the too-dark, too-light, too-red, and so forth. These are all sins of well-meant, but overdone, contrast. We are painting what we see, isolated and exaggerated by contrast.

Obviously we cannot get along without contrast, but we must harness and tame it. To tame it, we can deliberately modulate it, or we can use various types of similarity to counter-balance it. But to make it work for us, we must think about where and how to use it in every painting we undertake.

As with similarity, there can be contrast in spatial elements—line, shape, size, and interval—and in the elements of color hue, value, and intensity. Here we will deal with spatial elements, but will include value as well, since it provides one of the strongest types of visual contrast.

It is not difficult for most of us to recognize similarity, but contrasts can sometimes escape notice. Let's review some of the most common kinds.

There are two types of *linear contrasts:* lines can contrast in position or in quality of movement. The strongest contrast of position is opposition, such as lines or axes meeting at right angles (either horizontal/vertical or at other angles). A strong contrast in quality of movement would be a straight line versus a wavy line or a jagged line versus a curving one. Firmly drawn lines also contrast powerfully with deliberately hesitant ones.

Shape contrasts also vary: circles contrast with squares or triangles, and all three geometric shapes contrast with non-geometric ones.

Contrasts of size and interval are pretty straightforward, and value contrasts—black and white or dark and light—are equally clear.

Illustrations

Gene Klebe's *Deserted Dock* (figure 44) is a painting based largely on an ingenious interplay of lines, chiefly visible through value contrasts. Notice that there are virtually no right-angle intersections among the posts and supports of the old pier. Nevertheless, contrast of directions is very strong, for many junctions are *almost* right angles. Klebe tames these strong oppositions by relating many of the lines either sequentially or by direct repetition. For example, the two dominant posts in the right foreground begin a right-to-left tilting sequence that is picked up by the short foreground post, which is paralleled by the more distant leaning pile at left and then neutralized among the entire group of piles near the left margin. A similar set of changing angles relates some of the horizontal or nearly horizontal elements. The long piece of railing at top left is integrated into a sequence that includes the two major lines immediately below it and ends in the two long leaning posts at right. In addition, the direction of the main joist of the dock at the upper left parallels the axis of the boat below it.

Since the distant scene is al-

Figure 45
Pumpkins and Apples by Samuel
Kamen, c. 1938, 5¼" x 6⅞" (13 x 17
cm), rough paper, collection of the
artist. The jar is similar to the
pumpkins in size, but contrasts with
them in shape. The apples are simi-
lar in shape, but contrast in value.
The framed picture is similar in
value (and pattern) to the left
pumpkin, but contrasts in shape.
Kamen's use of contrast is completely
controlled in this complex and re-
fined little painting. Photo by Peter
A. Juley.

most obscured by the fog, one
might contend that this fore-
ground and middleground play
of contrasts and similarities is
really Klebe's subject. Sequences
(or gradations), especially of line,
very often carry the visual con-
notation of temporal change, as
we saw in Kaep's *Antique Dealer's
Porch* (figure 37). Here they pro-
vide an apt image of decay,
whereas the contrasts of direction
indicate the original strength of
the structure.

Two small paintings by Samuel
Kamen provide interesting exam-
ples of contrast in shape and size.
Pumpkins and Apples (figure 45)
displays a very sensitive balance
between shape contrast and size
similarity. The two pumpkins and
the jar vary in shape but are simi-
lar in size. They are arranged in
a tight inverted triangle that sta-

bilizes the design; the decoration
on the jar and the base of the
pumpkin at left echo each other
almost exactly. The apples, sim-
ilar in shape *and* size but varied
in value, form a sub-theme,
whereas the smaller whites create
a visual counterpoint through
their strong contrast and asym-
metrical placement.

In *Berries* (figure 28), Kamen
clusters small whites in the upper
left. This group of small accents
contrasts strongly with the larger
white of the jar at lower right. A
subtle, but easily perceived, bal-
ance results. Both of these
paintings are designed with re-
markable elegance and reward
careful analysis.

An astonishingly bold use of
interval contrast distinguishes
Arne Lindmark's *Side Street,
Seville* (figure 46). Approximately

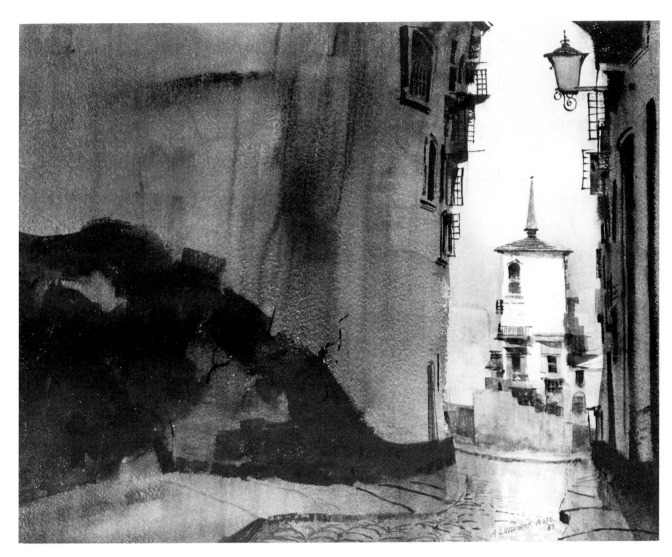

the left two-thirds of the paper is a barely articulated wall. The right one-third of the paper is split again, so that two-thirds of this section is the view at the end of the street, and the remaining one-third is the enclosing wall at the extreme right. These proportional relationships are very important to the success of the picture, for they provide a foundation of regularity on which to base dramatic contrast.

Contrast can also occur in other aspects of pictorial order, of course. In *Rocks and Sea* (figure 47), Charles Hopkinson strains contrast of paint texture to its very limit, but the similarity of his bold strokes maintains surface coherence.

Exercises

We emphasized earlier that contrast is the basic principle of differentiation in seeing, and that it functions the same way in art. Some of the implications of this are of special significance to you as a representational painter.

Pure differentiation is clearly the enemy of coherence. Nevertheless, you must use contrast, for it is the essential tool required to make a picture of any thing or things. You make a white pine tree, for example, by making it different from the other trees in your picture, not just by trying to make it look like itself. Further, a picture with few and subdued contrasts is likely to be bland, for contrasts create visual excitement.

Strong contrasts also demand the viewer's attention, attracting and holding his eye. Hence you must use your contrasts carefully, placing them only where they will

Figure 46
Side Street, Seville by Arne Lindmark, A.W.S., 1969, 22″ x 28″ (56 x 71 cm), 300 lb. rough paper, collection of the artist. Lindmark's daring contrast of intervals makes this a highly unusual picture. He uses proportional relationships among them to "tame" the contrasts and provide an orderly scaffolding for the painting. Notice also how he contrasts washes with descriptive lines which are built up sequentially to his focal areas.

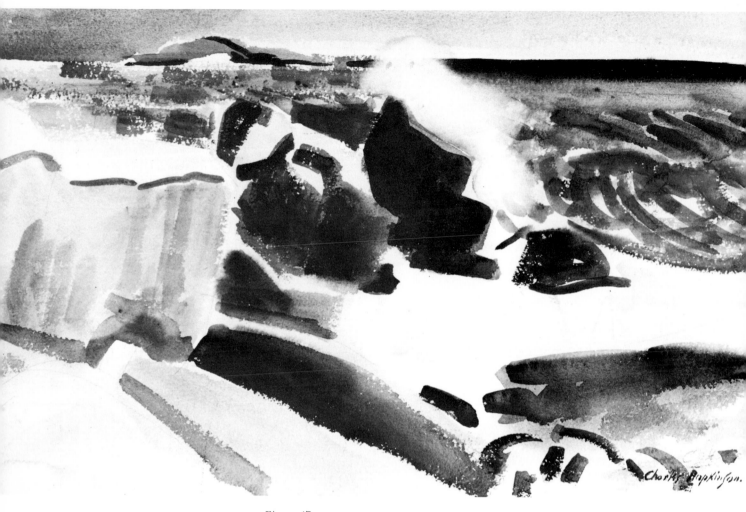

Figure 47

Rocks and Sea by Charles Hopkinson, 13½″ x 22″ (34 x 56), courtesy, Museum of Fine Arts, Boston. Startling contrasts of value (and color), shape, and surface handling contrive to project enormous visual excitement appropriate to Hopkinson's dynamic subject. The picture is held together by similarity in the brush strokes and, more subtly, by similarity of the sizes of the areas. Note also the sequences of directions in the water and rocks. This picture is very different in treatment from Eliot O'Hara's *Morning Surf* (figure 109).

Three Viewing Distances

Are you aware of the different viewing distances from which representational pictures are enjoyed?

Critical Concern

Viewing a representational painting is sufficiently complex to make it helpful to divide and analyze the ways we do it. When you enter a room or a gallery and glance around at the pictures on the walls, some usually stand out more than others. You soon recognize that the pictures that arrest your eye from a distance have especially strong overall patterns, usually of light-to-dark contrasts.

A painting that attracts you in this way invites closer inspection. You want to move up to a comfortable distance to enjoy a longer acquaintance with it. Depending on the size of the picture, you may want to station yourself four to eight feet away from it. I am referring to commonly used sizes of watercolor paper, from a quarter to a full sheet—11″ x 15″ to 22″ x 30″ (28 x 38 to 56 x 76 cm). Obviously the "normal" viewing distance for very large or very small paintings is different. At this normal, or closer, viewing position, your attention is most likely to focus on the representation—the subject

and "narrative" content of the painting.

Then, if you are like most lovers of painting, you will be irresistibly drawn farther forward, often to within a few inches of the picture. At this more intimate viewing distance, you admire the artist's technique—you relish the brushwork, the flow of colors, and the deftness of characterization.

The reason for this analysis will be obvious to you: as a painter, not merely a viewer, you clearly can profit from these three different ways of looking. You want to produce pictures that attract attention from afar, sustain it at a normal distance, and reward even the closest inspection.

Illustrations

Loring W. Coleman's *Among Bare Maple Boughs* (figure 48) is a painting that is worthy of the most careful scrutiny. Let's examine it from the standpoint of the three viewing distances.

Distant Viewing. Imagine yourself fifteen to twenty feet away from the picture. As it catches your eye, you cannot help but be gripped by the thrusting central darks against light and the massive light against dark below. At the same time, you recognize a huge, bare-limbed tree. When you draw closer, you realize that Coleman has achieved his first aim: he has intrigued you.

Whether you choose to look at

a picture or pass it by is determined by its composition. From the distant viewing position, the most important aspect of a painting is the force of its major design components. These are normally perceived chiefly through value contrast and include the picture's linear structure, the pattern of its primary shapes, often the size and interval relationships, and sometimes the color (see Karl Schmidt-Rottluf's *Landscape*, color plate 11). In a truly fine picture, these components, seen from afar, clearly state the themes of the composition when viewed more closely. In a representational picture, the design elements are so closely allied with the subject that they also announce the dominant expressive theme of the painting. This is exactly what happened when we first looked at *Among Bare Maple Boughs* (figure 48).

Composition, then, is not simply a matter of creating a pleasant, balanced design; it is your means of stating simultaneously both the visual and expressive themes of your picture.

Normal Viewing. As you draw nearer to Coleman's painting, you increasingly sense its complexity—not just in terms of descriptive detail, but especially in terms of design. Whether you initially read the design motif of the tree as a strong vertical axis, as modulated S-curves, or as a

basic X (all, and others, are possible), you find that these readings can alternate with each other. You find, too, that each reading becomes richer and is supported by more and more echoes as you get close enough to see more layers of meaning.

You are now at a normal viewing distance, about four to five feet, from the painting. Perhaps you become newly aware of the focal role of the big limb scar in the middle of the tree (and nearly the middle of the paper). You can almost read it as the intersection of the X. You notice how many times, and with what subtle variations, the slight curves of the limbs are repeated; and you observe the way the white birch at left and the larger trunk to the right echo each other while picking up the branch shapes. Perhaps you also enjoy the interplay of wedge shapes of similar size in the sky, background, trunk, and foreground.

Above all, however, you are now in a position to appreciate the artist's interpretation of his subject. The huge-crowned maple spreads its limbs all about it, but those to the right, away from the sun, seem to be dead or dying. Twigless, are these the "bare boughs" of the title, so stark in contrast to the lively interlacing of the small branches at left? You see that someone has cared about this tree: some dead limbs have been cut off fairly recently. The birds, the wall, and the shadows point you to the right, however, to the dead side of the tree. So you may sense that, although the imposing old maple has little time left, it stands as a monument to itself, a record of its own complex life. And, with this awareness, you recognize that the complex twists and alternations of your perception of the design parallel the artist's visual expression of his subject.

Intimate Viewing. By now you are probably bursting to see how the magic was done and to make the acquaintance of the hand of the magician. You draw in close to admire the paint handling, noticing how nicely the background wash is varied (and linked to parts of the coarse bark) by patches of rough brushing. You look, too, at the many examples of crisp, deft drawing in details, the economy of effect in some of the stones, the freshness despite precision.

As you move back, now, for another overall look, you know you have had a thoroughly satisfying experience. This is what all good paintings provide, and it is what you want yours to give.

Exercises

You will want to do quite a bit of moving around for this exercise, so you might limit your selection of pictures to four or five. Pick what you think are your best ones and set them up together at one end of the room or in a way that allows you to get well back from them. (Take them outdoors, if the weather is good, but place them in the shade.) You may find a note pad helpful.

1. *Distant Viewing.* Station yourself at least eighteen to twenty feet away from your pictures. If possible, try looking at them from even farther away. Do you see clear pattern or compositional structures in your pictures? If not, your paintings do not "carry" well. Not all pictures should. Both the artist's expressive aim and the final purpose of the picture affect the need—or lack of it—for "carrying power" (see Chapter 19). But if you are not deliberately seeking to make quiet, retiring pictures, you may be making namby-pamby ones inadvertently. In this case, resolve to make much more forceful value studies before you begin to paint and to get well away from your work at least three or four times during painting to check on the development of your com-

position. Remember that with the light-to-dark painting procedure, your value pattern is slow to emerge, so you have to see your picture as leading toward your initial value sketch.

As you look at your pictures, observe what "sticks out" in each. Look from one to the next. See whether there are similarities among the major patterns; if so, ask yourself whether they are justified. That is, are the similarly patterned paintings all pictures of similar subjects? If the subjects are different, it is possible that you are using a basic composition only through habit. Such habitual use of design is a good thing to nip in the bud: it generally means that you are not thinking enough about the "expressive" part of your art, and probably not even enough about the "decorative" part. Variety for variety's sake is a step in the right direction, but it is better when it springs naturally from your thinking and feeling about your expressive purpose in each picture.

Ideally, from this distance your pictures reveal strong, varied compositions. Wonderful! But do the compositions provide clues to the design in detail and to the subject and meaning of each work? Again, ideally, they do. Almost all of us, however, can profitably continue to work at making this integration more effective. Trial sketches can be an aid in helping you think through your particular interest in a subject. Painting a subject over and over will work, too. In both cases you give yourself an opportunity to explore variations of design, point of view, and color that will allow you to see in preliminary form what your conscious and subconscious mind, working together through your eyes and hand, is making of the subject. You can then decide more easily on composition, color emphasis, and the other variables in your bag of skills as an artist.

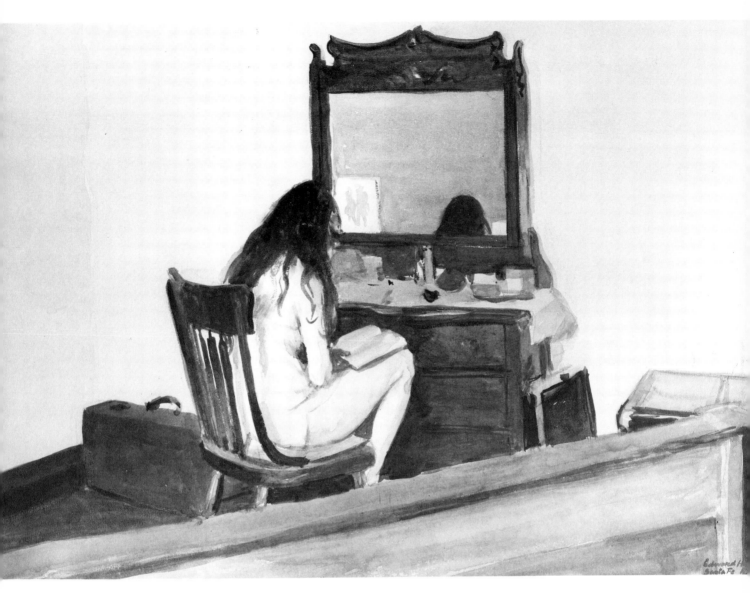

2. *Normal Viewing.* Move up now to four or five feet from your paintings—a comfortable, normal viewing distance. Check each picture individually. How does it measure up to what it promised from a distance? Does the design follow through with elaborations on the initial theme? Did the initial impression tell you what the subject theme was and make you curious to see it more closely? Are you, in fact, rewarded by finding out more about it? Finally, does the composition support and qualify the subject?

The answers to these questions should give you a good idea as to whether you are using your artistic knowledge to the best advantage. If any one of them is negative, you are missing an oppor-tunity for pictorial coherence that you probably should be using. The best way to deal with the problem is to tackle it a bit at a time. Try to work on whatever omission seems most apparent in your work, and don't worry about any others until you have that one under control.

3. *Intimate Viewing.* Get up to within a foot or so of your pic-tures. How do they hold up at close range? This is where you examine technical finesse. Apart from good, workmanlike water-color, are there some nice felicitous passages? Are there sur-prises? These may be "happy accidents," or they may be places where something worked even better than you thought it would.

Figure 49
Interior, New Mexico by Edward Hopper, 1925, 13$\frac{9}{16}$″ x 19$\frac{9}{16}$″ (34 x 50 cm), courtesy of the Art Institute of Chicago. The basically triangular composition insures clarity at a dis-tance. It also encloses the "subject"— notice that the book is just below the center of the paper. Hopper's tech-nique is almost deliberately awkward. Close inspection shows that he wanted the viewer to sense how the paper surface had been worked and changed by the artist. You might like to compare this painting with two others of girls reading, figures 112 and 113.

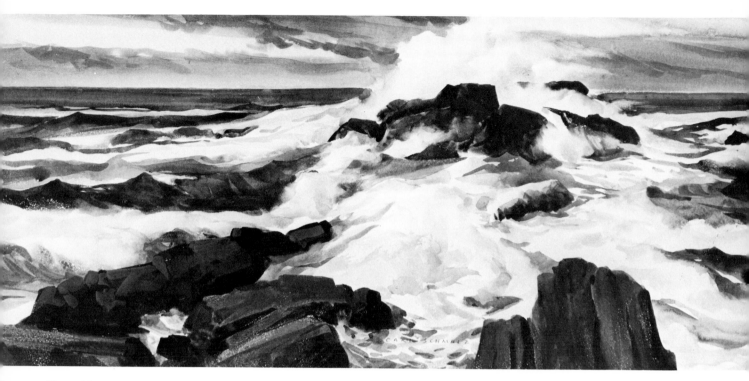

Figure 50
Westerly by Carl Schmalz, 1965, 10¼"
x 23" (26 x 58 cm), 140 lb. hot
pressed paper, collection of the au-
thor. Alternating sequences of dark
and light change direction in a nice
gradation around the reef at right,
forming a visually exciting pattern
that tells the viewer about the subject
even from a distance. Many nuances
of color in the foam and rocks give
interest to the intimate view.

Look especially carefully at those
areas where you were most sure
of yourself. You may find there
the best indication of your own
stylistic bent.

Perhaps you are a watercolorist
who values overall results and is
not much interested in facility of
technique. You will be intrigued,
then, by Edward Hopper's *Inte-
rior, New Mexico* (figure 49),
which, at close range, provokes
wonderment of a different sort.
How can such seeming clumsi-
ness resolve into so solid and
unassailable a statement? At the
intimate viewing distance, Hop-
per's painting is fascinating. One
way or another, yours ought to
be too.

If you have any energy left,
you might go through this pro-
cess with the other pictures in
your collection. In any event,
look over your notes and collect
your thoughts so you can deter-
mine where you will put your
first efforts toward taking more
systematic advantage of the
three viewing distances.

Summary
The three viewing distances are a
reality, of course; but delineating
them this way is also a device for
analyzing your pictorial prob-
lems. The simple fact is: a good
picture works well from any view-
ing distance.

You will find it useful to
scrutinize your works in this way
periodically—perhaps twice a
year. And you will learn a lot
about the process by looking
carefully at any pictures available
to you. Go to museums, traveling
exhibitions, your library, friends'
homes. Try to submit pictures to
this kind of analysis whenever
you can. You will learn a lot
about what works and what
doesn't—and why. All of it will
help you identify ways of improv-
ing your own work—what to try,
what to avoid. And, do be patient
with yourself. Painting well is an
immensely complicated business.
It takes effort, and it takes time.

Knowing Your Palette

Is your palette working for you or against you?

Critical Concern

Despite a multitude of books and articles on the subject, color perception is one of the least understood elements in human vision. Even painters do not know much about how it works (although over the centuries they have accumulated a good deal of practical information about how to use it). Still, color is one of the most powerful tools at your command, and you need to know as much as possible about it.

The color situation closest to home is your own palette. How long has it been since you really thought about what colors you're using, much less about what other tubes of paint you have in your box or drawer? Curious collections of paint can turn up on an unexamined palette. Perhaps now is the time to see what you have, what you can do with it, and whether it may be limiting your expression.

Illustrations

In this chapter we are going to analyze charts more than pictures. Our purpose is to review the basic dimensions of color, outline fundamental color relationships, and speak of some of the peculiar properties of color, so that you will have a refreshed understanding with which to judge the results of the exercises you will be doing next.*

Most of the colors we ordinarily perceive are composed of three elements. These are *value* (lightness or darkness), *hue* (blueness, redness, greenness, and so forth), and *intensity* (brightness or dullness).

Value can be measured on a scale of nine *neutrals* (colors with no hue or intensity), ranging from white to gray to black (see section A, color plate 1). This means there are seven value levels excluding white and black, with level five being the middle value. Middle value contrasts equally with white and black; level three contrasts equally with white and middle; level four contrasts equally with three and five, and so forth.

The nine-value scale gives you a useful number of divisions and a way to understand an important relationship between value and hue. If you are accustomed to designing within a framework of fewer values than nine, this scale can easily be simplified to five—white, light (three), middle, dark (seven), and black—or to three—white, middle, and black.

Hue is most usefully diagrammed for painters on a

*The substantive material in this section is based closely on the invaluable work of my former teacher, Professor Arthur Pope of Harvard University, to whom I gratefully record my debt (see Bibliography).

circular scale in which the spectrum that results from breaking down white light is bent into a circle, joining the red and blue ends at purple at the bottom (see section B, color plate 1). Yellow is at the top, with the *warm* hues (reds and oranges) at left and the *cool* hues (blues and greens) at right. (Yellow and purple may be warm or cool, depending on context.)

Red, yellow, and blue cannot be mixed from other colors; they are the *primaries*. Orange, green, and purple can be formed by mixing red and yellow, yellow and blue, and blue and red respectively: they are called *secondaries*. Each of these six colors can be mixed with the one adjoining it to form six intermediate colors (red-purple, blue-green, and so forth): they are often called *tertiaries*. These twelve hues are ordinarily enough for common description and discussion of color, although, theoretically, any number of intermediate colors exists.

This division of the hue scale is somewhat arbitrary, since there are, for instance, many more possibilities for hues in the yellow family—according to the spectrum breakdown of white light—than in the purple family. As painters, however, we are interested less in what light can do than in what pigment can do, and since this simplification is made for pigment, it serves.

When someone says, "green,"

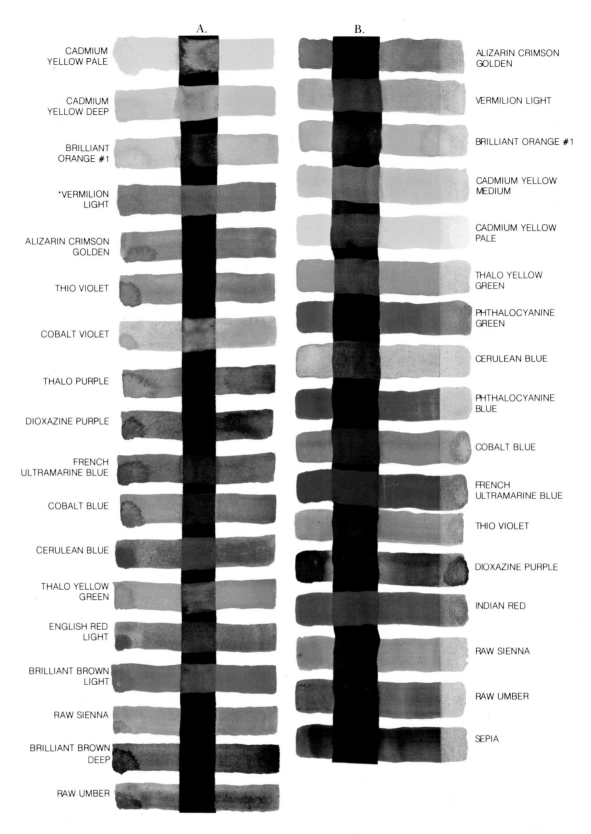

A.

CADMIUM YELLOW PALE
CADMIUM YELLOW DEEP
BRILLIANT ORANGE #1
*VERMILION LIGHT
ALIZARIN CRIMSON GOLDEN
THIO VIOLET
COBALT VIOLET
THALO PURPLE
DIOXAZINE PURPLE
FRENCH ULTRAMARINE BLUE
COBALT BLUE
CERULEAN BLUE
THALO YELLOW GREEN
ENGLISH RED LIGHT
BRILLIANT BROWN LIGHT
RAW SIENNA
BRILLIANT BROWN DEEP
RAW UMBER

B.

ALIZARIN CRIMSON GOLDEN
VERMILION LIGHT
BRILLIANT ORANGE #1
CADMIUM YELLOW MEDIUM
CADMIUM YELLOW PALE
THALO YELLOW GREEN
PHTHALOCYANINE GREEN
CERULEAN BLUE
PHTHALOCYANINE BLUE
COBALT BLUE
FRENCH ULTRAMARINE BLUE
THIO VIOLET
DIOXAZINE PURPLE
INDIAN RED
RAW SIENNA
RAW UMBER
SEPIA

Color Plate 2.
Transparency/Opacity Tests. Column A shows the relative transparency of 18 colors selected from my own palette and a few from the palettes of my students. The extreme right ends of these color samples have been exposed to 350 to 400 hours of direct sunlight. Note that only one shows any change. This, marked with an asterisk, is vermilion light, which has darkened slightly. Column B shows similar colors, with phthalocyanine blue and green added. The right ends of these colors have been sponged off. The phthalocyanine blue, a student grade, washed off as completely as the cerulean blue. Indian red, a very opaque color, stained deeply. Surprises like this illustrate the importance of running these tests on any new color you acquire, even on the same color made by different manufacturers. These tests also reveal that artist-grade colors are far more reliable and predictable than student grades.

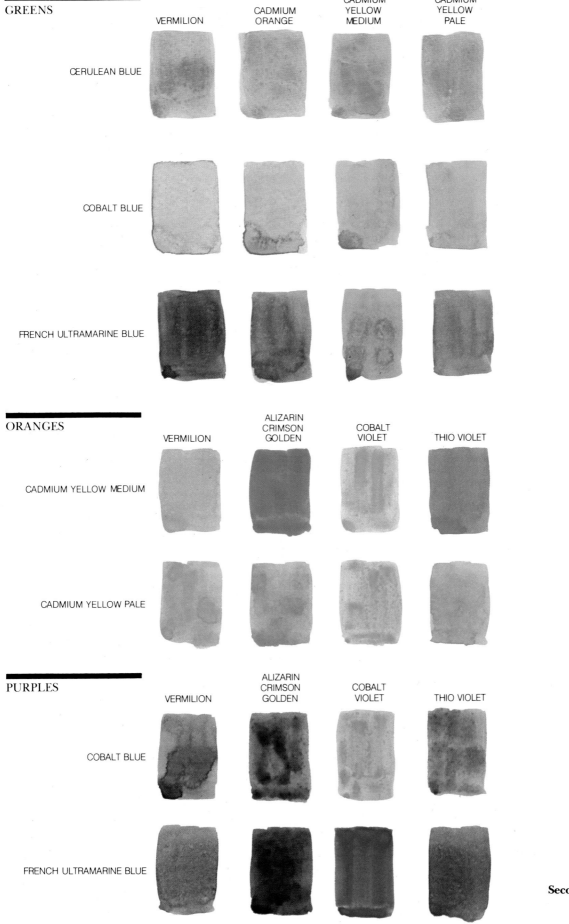

GREENS

	VERMILION	CADMIUM ORANGE	CADMIUM YELLOW MEDIUM	CADMIUM YELLOW PALE
CERULEAN BLUE				
COBALT BLUE				
FRENCH ULTRAMARINE BLUE				

ORANGES

	VERMILION	ALIZARIN CRIMSON GOLDEN	COBALT VIOLET	THIO VIOLET
CADMIUM YELLOW MEDIUM				
CADMIUM YELLOW PALE				

PURPLES

	VERMILION	ALIZARIN CRIMSON GOLDEN	COBALT VIOLET	THIO VIOLET
COBALT BLUE				
FRENCH ULTRAMARINE BLUE				

Color Plate 3
Secondary Mixing Exercises

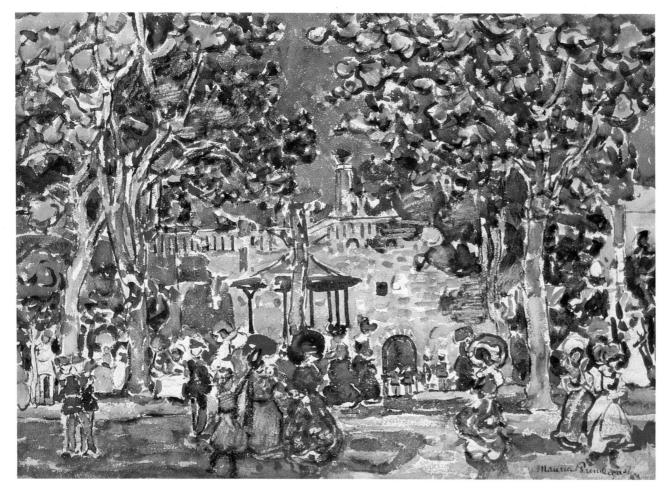

Color Plate 4 (above)
Band Concert by Maurice Prendergast, c. 1909-10, 13$\frac{7}{16}$″ x 9$\frac{1}{4}$″ (34 x 24 cm), rough paper, courtesy, Amherst College Collection. Prendergast unifies his surface principally by keeping brushstrokes relatively small and about the same in size (and often in shape). He breaks up larger areas arbitrarily to avoid excessive contrast between them and the areas articulated by obvious strokes; therefore, the sky here is treated as a discontinuous wash. He also employs color patches for surface coherence.

Color Plate 5 (opposite page)
The Ell by Loring W. Coleman, A.W.S. 1976, 20″ x 40″ (51 x 102 cm), cold pressed paper, courtesy, Shore Gallery, Boston. The key to surface coherence is not a particular kind of edge, but consistency in the handling of edges. Coleman treats all edges here with crisp clarity, Concern with accurate descriptive textures supercedes emphasis on paint texture and is the basis of a unified surface that can include the smooth blue sky as well as the grassy foreground. The reds of door and chimney relate, and the blue window shade forms a triangle with the reds.

all time!) Write the abbreviated tube color name near the patch if you can. Go through this same process with all full-intensity colors on your palette and try to label those you are unsure of by a process of elimination.

Your next step is a little more difficult. Estimate *both* the hue and the intensity of your more neutral colors (such as burnt sienna, Payne's gray, yellow ochre). In the same way as before, paint a patch on scrap paper. Consider first what hue (or, if it is very low in intensity, its hue family—for example, reds) it most closely approximates. Next, checking the patch against the full-intensity colors outside the periphery of your circle and against the center gray, if you have one, judge which of the intensity lines inside your circle most closely corresponds to the intensity of your sample. Then paint a patch of it where the appropriate hue inter-

sects the relative intensity circle. Label the tube name as before and continue with all the neutrals on your palette. This will produce a "map" of *your* palette similar to that of mine in section D, color plate 1.

You are now prepared to take a good analytic look at your palette as a working tool. You may want to set up your paintings along with this schematic map of your palette.

1. Consider first your palette's balance. Do you have a lot of colors grouped in one part of the hue scale? Sometimes this exercise reveals a painter with, say, one lonesome yellow. Often you can recognize in your palette map the same preponderance of colors that you can see in your pictures. If you are not altogether happy with the overall color tonality of your pictures, it is easy to see what to do about it. Suppose, for example, your pic-

tures are running to a 1/2-intensity blue-green look. Check your reds, red-oranges, and oranges. Have you only a few? Try eliminating some of your blues and greens and adding a red or two. Perhaps you have many patches on your inner circles. Maybe you should consider eliminating a few neutrals and adding some full-intensity colors. In general, the warm colors tend to be somewhat weaker in mixtures than the cool ones. So if your palette shows more warms than cools, this is usually all right. Fortunately, there *are* more warms than cools among pigments.

2. Another common result of this exercise is the discovery that your palette includes more colors than you really need. If your palette map is packed, you should perhaps think about some economies. Start with redundant colors such as phthalocyanine blues by two manufacturers; you don't need both on your palette at the same time. Do you seem to have a lot of browns? Check your palette to discover whether any browns are hard and dry. Those might be eliminated, since you are not using them very often

anyway. In general, it is wise to strip down your palette while retaining as much richness of mixing as possible (see Chapters 10 and 11).

3. One of the watercolorist's pleasures is buying tubes of new colors. It is an innocent indulgence and an indispensable way of exploring new coloristic ground, but it can produce a large number of rejects. If you have energy (and space) enough, you might now either add to your palette map samples from the additional tubes you have at hand—or, better, place them on a new hue and intensity scale. This will suggest to you something about your color preferences. The new colors may reflect the pattern of your actual palette, but they may also reveal a secret trying to get out! More intense colors? More warm colors? More violet colors? If you seem to be trying to tell yourself something, why not act on it? Make some substitutions; see what happens.

Summary
It is all too easy to fall into comfortable color habits and forget about the intelligent control you can exercise over your palette. Especially in a period when manufacturers of artists' pigments are developing new colors every year, it is important for every painter to do some exploring. Only a decade ago we were still in antiquity with respect to a good permanent purple; now there are several. Indeed, today you can paint with a palette close to the full-intensity hue scale if you wish.

Many painters, too, are subjected to the limitations of their local art supplier. Too often only one brand of watercolor is available. Habits are formed that have nothing to do with informed choice. Try to familiarize yourself with the products of all the reputable manufacturers; each makes some useful colors not produced by the others. I regularly use paints of three, sometimes four, major brand names.

It remains true, however, that with experience all artists tend to use fewer colors in more varied ways. So, while remaining open to new possibilities, you should seek an economy of color consistent with your expressive needs.

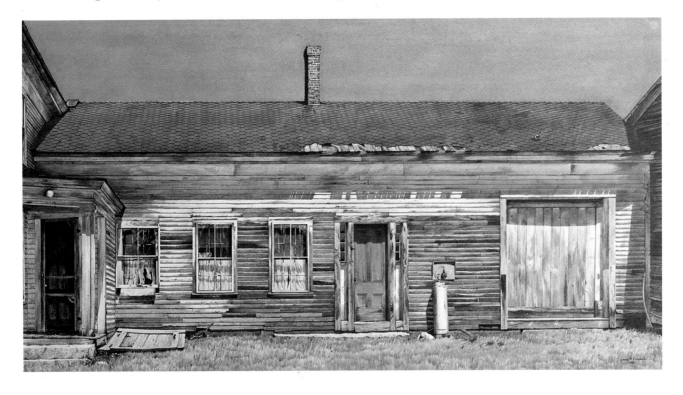

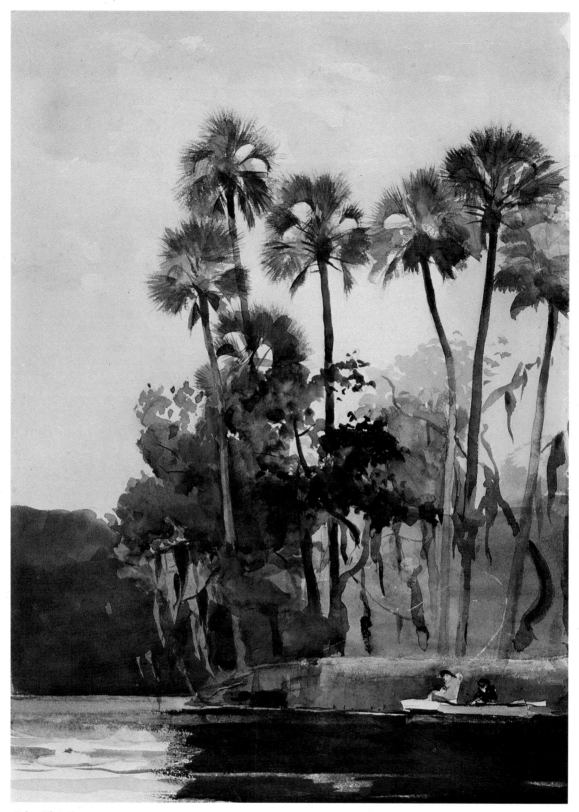

Color Plate 6

Homosassa River by Winslow Homer, 1904, 19¾″ x 14″ (50 x 36 cm), collection of the Brooklyn Museum Purchase Fund. Homer's use of reserved lights provides an economy of technique that made the actual painting of the picture simpler and makes the viewer sense that simplicity, even though he may not recognize how it was done. Particularly effective here is the way the same wash is employed for the distant jungle at the right and, by reserving, for the Spanish moss and the palm trunk at left. Some lights were lifted out by wetting a dried area and blotting it after a moment. This is true of the foreground ripples. Color organization is based on similarity of low intensities as well as similarity of hues: orange, yellow-orange, yellow, yellow-green, green, blue-green, and blue, plus accents of red-purple.

Transparent and Opaque

Are you aware of the options of transparent and opaque pigment that your palette offers?

Critical Concern

Artists working in all media have long been aware of the different effects that result from the relative transparencies of their paints. Tempera painters of the thirteenth and fourteenth centuries treated the more transparent red madders in ways quite distinct from their handling of vermilion, which is fairly opaque. Oil painters of the seventeenth century, notably Rubens, also exploited the varying transparencies of paints.

To the transparent watercolorist, however, this variability offers perhaps even greater opportunities. Especially at the intimate viewing distance, the play between the limpid clarity of a wash of transparent color and the granulation left by more opaque pigments can be a lively source of pleasure for the viewer. In addition, the behavior of the two types of pigment in mixtures is distinctive, and all these variations can be used for particular effects, some descriptive and some more exclusively for pictorial coherence and expression. It is important, therefore, that you acquaint yourself with the relative transparency/opacity of your colors so as to use them effectively.

Illustrations

For the ordinary artist it is difficult to find out exactly how watercolor paints are made and what makes various colors behave so differently. We have all watched some astonishingly aggressive color "invade" still-wet colors already on the paper. We also know that a smooth wash of low value is impossible with some colors, and that relative transparency and strength in mixtures vary greatly. Here is a general explanation of why some of these things happen.*

Pigments are tiny substances that absorb some light rays and reflect others. For example, cobalt blue absorbs nearly all rays (or wavelengths) except blue ones, which it reflects, making it look blue to our eyes. These substances vary in molecular structure, which causes them also to vary in particle size, in inherent transparency, and in refractive index (a measure of the power to absorb, transmit, and bend light).

There are two main classes of pigments—inorganic (mineral) and organic (vegetable). Today the latter are nearly all synthetic, and those from which artists'

*I am deeply grateful to Mr. Murray Greenberg, Chief Chemist at M. Grumbacher, Inc., for providing much of the following information, and clarifying much else.

paints are made are often *lakes*. These are manmade pigments produced by dying powdered alumina hydrate or some other inert base. In general, inorganic pigments tend to be opaque, whereas organic ones tend to be transparent.

Although the precise recipes for colors vary considerably, watercolor paints are basically made from a mixture of pigment and a binder of gum, glycerine, and other substances, including ox gall, a "wetting" agent. Apart from the inherent transparency of the pigment particles, their particular refractive index affects their transparency when made up as paint. The closer the refractive index of a pigment is to that of water, the more transparent that watercolor paint will be. Some heat-treated earths, for instance, are far more transparent than their raw counterparts (for example, burnt and raw umber) because their refractive index has been changed. With some pigments, relatively little colorant is needed to make a satisfactory paint. This also increases that paint's transparency. Conversely, the synthetic organic paints very often contain proportionately more colorant, which is also often stronger than most inorganic pigments. Hence, synthetic organics tend to stain the paper.

Among the inorganic pigment-based paints, some settle out, or granulate. This is the result of their "grind," that is, the size of

Color Plate 9 (top)
Fort River, Fall by Carl Schmalz, 1974, 15″ x 22″ (38 x 56 cm), 140 lb. hot pressed paper, collection of Ellen Berezin and Lewis A. Shepard. The water's edge divides this picture into two distinct parts—the upper is crisp and intense, the lower is somewhat darker and less intense. The rock and leaves in the right foreground are linked in color and value to the upper section. The overall shape of this light is echoed by the red reflection at the center of the picture.

Color Plate 10 (above)
Indian Point by Carl Schmalz, 1965, 10¼″ x 22½″ (26 x 57 cm), 140 lb. hot pressed paper, collection of the author. Sometimes similarities are hard to detect. Here, for example, the general mass of rock and trees at left is similar in shape to the much smaller rock on the beach at far right. The light top of the left foreground rock is similar in size, but not shape, to the light water area above and left of it. The shape and size of that rock is echoed in the dark island ledges at extreme left.

to their transparencies. If you know only about relative transparency, you can't easily predict whether a pigment will wash off easily and completely. Since this information is valuable, you need to do another experiment, exemplified in column B, color plate 2.

Using discarded paper to cover the stripes you've already made, mask off all but about one-half inch on the right side of each stripe. If you have two rows of stripes, do both, but also protect the left ends of the stripes on the second row. Hold the paper mask down well and, with a small sponge, wash as much as you can off the exposed ends of the stripes. You won't need much water, but it must be clean.

Depending upon the make and quality of your paints, there will be some surprises here, too. (I

had one phthalocyanine blue—a student grade—wash off completely!) In general, the more transparent colors do not wash off as easily as the more opaque ones, but again this is variable. The ultramarine blue of some manufacturers is quite opaque, but nearly all ultramarines stain fairly deeply, as do the darker cadmiums.

3. Finally, you may wish to run one other test of the colors you are using. This test is imperative if you are using anything but the finest artists' colors produced by a reputable firm. This is a light-fastness test (column A, color plate 2). Using a heavy opaque board, cover all but one-half inch of the left end of your stripes. Fasten the paper and board, paint side out, against the glass in a south window (or east or west,

Color Plate 11
Landscape, Karl Schmidt-Rottluff, 1911, 19½" x 25½" (50 x 65 cm), collection of the Dr. William R. Valentiner Estate. One of the German Expressionists, Schmidt-Rottluff uses bold strokes and intense colors for maximum visual excitement. Color is controlled principally by similarity of high intensity and, to a lesser degree, by a sequence around the hue scale. Similarities of shape also order the surface, containing the powerful color that draws the viewer's attention from a distance and delights him on longer observation.

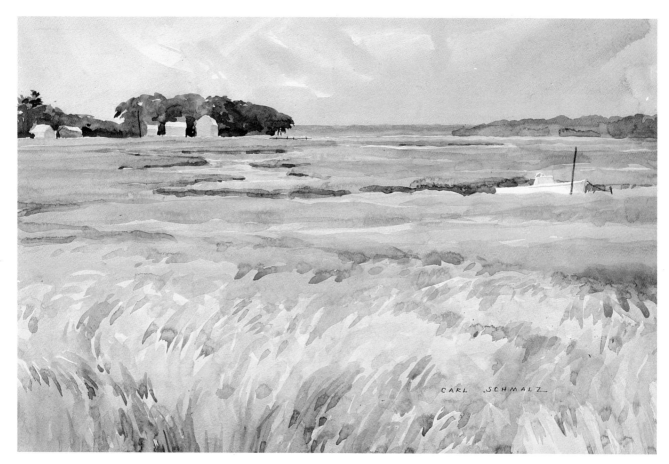

Color Plate 12
Salt Marsh, June by Carl Schmalz, 1976, 15″ x 22″ (38 x 56 cm), 140 lb. hot pressed paper, collection of Polly Bain. This painting "carries" because of color contrast. Value contrast is minimal, but the color is relatively intense. Color design is based on yellow-green/red-purple and orange/blue complementaries. The surface is unified overall by strokes which vary in size within a reasonable range and by deliberately courted granulation obtained from opaque colors.

if you have no southern exposure), and leave it until you calculate that is has received between three and six hundred hours of direct sunlight. With good paints, you should find little change. Some reddish purples are still not very fade resistant, and vermilion will occasionally darken and lose its brilliance. Overall, you should discover that your paints are remarkably permanent, but you should probably abandon, however reluctantly, any color that fades markedly under this treatment.

Apart from ridding your palette of any impermanent colors, what can these exercises tell you? Most importantly, by identifying your opaque colors, you acquire the knowledge necessary to use them well. Surely you were already aware of some opaques, but you have probably found

more. You also know which opaques are most easily removed. You can now decide which blue to use for a sky that you will need to wash color from for lighter yellow-green foliage. You know which colors *not* to use beneath a glaze.

Similarly, you have identified your transparents and know which lift most completely. Transparents are good for any glazing or overpainting, and those that stained most are excellent for underpainting. Transparents are also your best bet for keeping dark areas lively. Those that are naturally dark are particularly good.

Finally, in mixing, you know which colors to reach for to produce a clear, luminous wash (of whatever size) and which will produce the lovely granulations mentioned earlier. Almost any

two opaques will give you some granulation, but the most opaque will generally provide it best. Among the double mixtures most used for these effects are: cerulean blue and Indian red, vermilion, cadmium red, or cobalt violet; cobalt blue and Indian red; cadmium yellow light and cobalt violet; and cobalt violet and Thalo yellow green. The background interest in *Ebbing Tide, Kennebunkport* (color plate 16) derives largely from this type of mixture.

Summary
A rule of thumb for judging transparency/opacity is this: metals (for example, cadmiums, cobalts, iron oxides, manganese, vermilion) tend to be relatively opaque, as do mineral earths; organic colors, including synthetic organics, tend to be relatively transparent. This rule doesn't always work, but it may be helpful as a guide. In general, the most opaque paints are best used in areas of lighter value because they can so easily become muddy, whereas dark transparents are helpful for dark and very dark areas.

The usefulness of your palette depends on the degree to which you understand it as a tool. You should know it as profoundly as possible—where it is flexible; where it is obstinate; when, how, and why you must augment it; when you can limit it. It is as much an instrument of your will, wish, and feeling as your brushes. The colors you employ and the mixtures that express your ideas are only as rich as your palette's capacity. So don't take that array of paints too lightly!

Color Plate 13
Bell House by Murray Wentworth, 22″ x 30″ (56 x 76 cm) smooth paper, collection of the artist. Color organization here is based on similarity of very low intensities and balance of complementaries. Value contrasts form the basic upside-down "T" of the design, and are also used to accent much of the descriptive detail. The visual interest of the bell at left is equalized by the wealth of weeds and splashes of intense color at right. Overall, the paper illustrates a sequential ordering of brushstrokes, from the quite broad strokes at the edges to the small, fine, descriptive ones near the center. The movement implied by sequential ordering helps to emphasize the breezy quality of the representation.

Color Plate 14
Landscape, Bermuda by Charles Demuth, 1916, 8″ x 10½″ (20 x 27 cm), hot pressed paper, courtesy, Amherst College Collection. Demuth organizes his color in this little landscape chiefly in terms of a hue sequence from blue through the greens to yellow. The viewer senses strongly the family resemblances of these colors. Played off against them are high-value, low-intensity complements—pale purple and pink—in small amounts. The interlocking of sharpedged shapes of about the same sizes unifies the picture's surface.

Color Mixing

Are you getting the most your palette can offer?

Critical Concern

As were Chapters 9 and 10, this chapter is more about the essentials of color than about criticism. It is a necessary preliminary to Chapter 12, "Color Design," however, as well as to some of the concerns of later chapters.

Since brilliance is one of transparent watercolor's primary attractions, it is easy to forget that the reflection of white paper through a pigment layer, which is what produces watercolor's luminosity, is also responsible for some of the subtlest effects in all painting. Using pure color, or colors only slightly mixed, encourages brilliance; but you also need to know how to create softly luminous tonalities. This means understanding the color mixtures your palette can provide.

The simplest color mixtures are "double"—that is, one color added to another. If your palette contains eighteen colors, those possibilities total 153. If you add the variations in value and proportion of each double mixture, your number of possible colors becomes astronomical.

Actually, you choose to use only a few of these possibilities, and only a few of the customary triple and quadruple mixtures as well. You should try to be as aware as possible of these choices, for recognizing that color mixing involves selection is one of the most effective ways of grasping the essence of painting. Painting is ordering—ordering all of your visual means according to your personal sense of priorities. It is your intellect, eyes, and hands employing your materials to impose a visible structure on your emotions. Selecting among the millions of color possibilities your palette affords is one of your most powerful means of ordering your perceptions.

Illustrations

For the representational painter, the principal usefulness of color mixing is to reduce intensities, or to gray colors. This is because the world we see normally shows relatively few full intensities, and those usually in small quantities. Apart from the blue sky (and its reflection in water), birds, butterflies, flowers, fruits, and berries are typical sources of natural high-intensity colors, which is why fall foliage is such a delight.

The other function of color mixing is to alter the hue of a paint. Your palette, no matter how copious, is hue-limited. The particular yellow-green of a field in sunlight usually must be mixed. The simple rules of these two types of mixing are:

1. To gray a color, add its complement.

2. To alter a hue with minimal loss of intensity, add the intense hue nearest it on the hue scale in the direction you wish to change it. For example, to push phthalocyanine green toward yellow, add cadmium yellow lemon, pale, or light, rather than cadmium yellow medium.

Most of you are so familiar with these rules that you scarcely think of them anymore. In fact, you probably have developed a number of shortcuts for graying colors. Most commonly, shortcuts involve mixing a color you want to gray with one already low in intensity, such as raw umber or burnt sienna. An equally good but less frequently used shortcut is deliberately to mix hues distant from your intended hue. That is, where phthalocyanine green and cadmium yellow lemon will yield an intense yellow-green, a neutral yellow-green can be mixed from cerulean blue and cadmium orange. This neutral yellow-green will be quite distinct from one mixed from phthalocyanine green and cadmium yellow lemon, and grayed with, say, alizarin crimson, although they can be very close in hue and intensity.

The usefulness of color theory in predicting the results of any given mixture must, of course, be augmented by experience. Unless you are using a scientifically prepared spectrum palette—which is uncommon among watercolorists—you know that few of your

Color Plate 18
Wind Blown Iris by William Preston, 20″ x 14″ (51 x 36 cm), rough paper, courtesy, Shore Gallery, Boston. This painting beautifully illustrates an overall balance of sharp, ragged, and soft edges, as well as skillfully reserved lights. Note especially the foliage at lower right. To augment the drawing, Preston accents the intensity contrast between the weathered shingles and the leaves and blossoms, creating a strong sense of intervening space. Though the blossoms are massed to the left of center, the intensity and complexity of the leaves balances them effectively. For an interesting contrast of technical handling compare this with Color Plate 7.

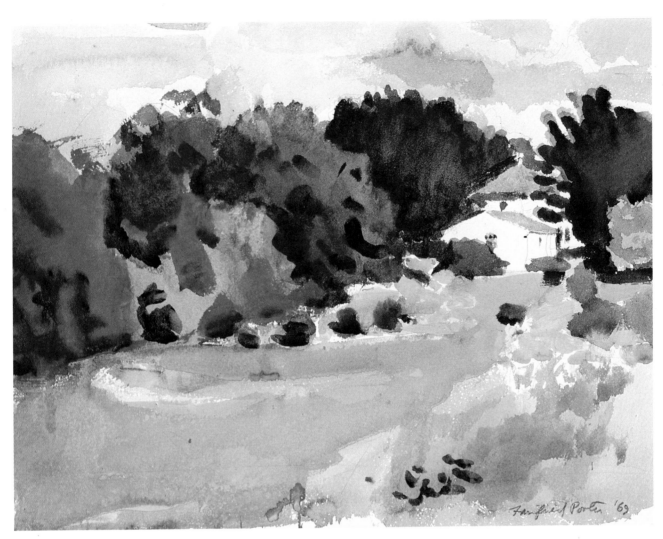

pigments fall exactly on "true" hues. This makes accurate prediction difficult, but is actually a great advantage because it permits all kinds of wonderful maverick mixtures; these you simply have to learn.

Exercises

These exercises are designed to give you some *systematic* understanding of the mixing capabilities of your palette. You will need two or three sheets of paper, preferably clean backs of old or discarded paintings. It will be helpful, but not necessary, to include various kinds of surfaces, such as cold or hot pressed paper, in addition to rough. If you use more than one kind of paper, make patches on each as you go along. Get out your usual equipment, including your regular palette. You may also find

that your hue scale provides a handy reference to the relative hues of the paints on your palette. *Remember to label all your mixtures.*

1. Begin by making simple double mixtures, approximately half and half, of the intense hues on your palette that are most nearly complementary. Where you do not have an exact complement, use the hue closest to a complement. For example, if you have no yellow-green, use whatever is closest—your yellowest green or greenest yellow. If you have no red-purple, use the purplest red you have.

This effort will produce six mixtures. They may vary greatly in relative neutrality. Your blue-orange mixture may be quite gray and your yellow-purple one much less so. You should come

Color Plate 19
Lawn by Fairfield Porter, 1969, 11½" x 15½" (29 x 39 cm), 140 lb. rough paper, collection of the author. This sketch is both strong and delightful: strong because of telling value contrasts, delightful because of richly modulated color. Mild overcast masses the darks and softens colors so that nuances of hue and intensity are more perceptible. The shapes of low-value touches in the foliage describe different kinds of trees. Color—overall about 1/2 to 3/4 intensity—is organized around a red/green balance, accented by touches of blue and orange.

Color Plate 20
12:15, Cape Porpoise by Carl Schmalz, 1976, 14½″ x 21½″ (37 x 55 cm), 140 lb. hot pressed paper, collection of the author. Color organization in this picture is based on blues, greens, and yellow/greens at relatively high intensities and values and in large quantities, accented by reds and purples at very low intensities and in small quantities. Small darks played against the larger, more broadly handled areas, enliven the surface and focus attention. They result naturally from strong top lighting. Notice that this also produces emphatic reflected light in shadows.

up with at least three pretty good grays, though, including red/green, red-orange/blue-green, and orange/blue. Fewer than three suggests that you may find it helpful to rethink your palette, substituting another paint for something presently there, to give you increased complementary graying strength.

Consider this with care, however. You may be graying largely with natural neutrals, such as Indian red with phthalocyanine green; or you may be graying very satisfactorily with black. Both are perfectly acceptable ways of graying colors, although many painters use little or no black because they feel other mixtures have finer undertones.

To complete the complementary mixing exploration, you can make samples of intense colors mixed with their neutral complementaries. These might include ultramarine blue and burnt sienna, cadmium yellow lemon and

mars violet, alizarin crimson and terre verte. You might also mix neutral complements such as lamp black (bluish) and burnt sienna or yellow ochre and mars violet.

2. Now try altering hue with the least possible intensity loss. For this you can make a continuous graded wash changing from, say, lemon yellow to phthalocyanine green. This will show you the range of hue changes and indicate how much, if any, intensity reduction results from the mixture. Do this with all your intense hues, going around the hue scale, mixing each color with the one closest to it. For example, you might next mix phthalocyanine green with phthalocyanine blue, phthalocyanine blue with ultramarine blue, ultramarine blue with alizarin crimson, and so forth.

3. Next, to determine the range of your palette in both graying

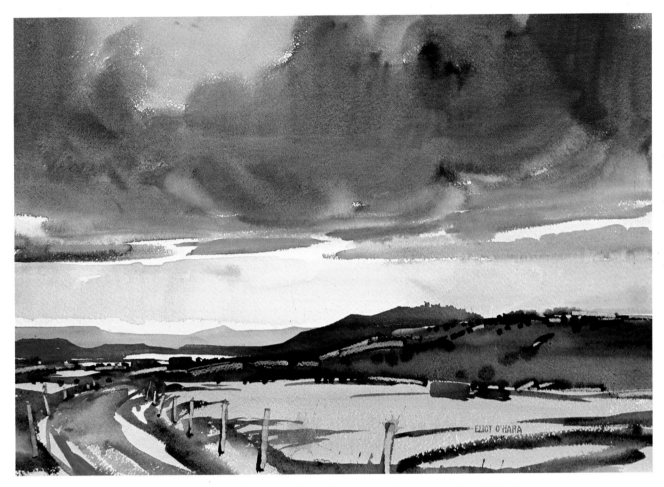

power and hue alteration, it is useful to try mixing secondaries from primaries, that is, using anything that might plausibly be called *yellow* and mixing it with anything that might plausibly be called *blue* to make your green range. Set up a grid, such as that in color plate 3, and label each vertical and each horizontal row. Make similar grids for the orange and purple ranges.

4. A last double mixture test of great value is to mix each of the colors you identified as relatively opaque with each other. For this a grid will again work.

5. Triple, quadruple, and other complex mixtures are often necessary in watercolor, and they frequently arise spontaneously during the painting process. If you want to test some of them, I recommend the grid procedure in which you use a particular double mixture for one coordinate and mix it with a selection

of other colors. For most painters, complex mixture experiments are most instructive if they are organized in some way; for example, you might try alizarin crimson and ultramarine blue on one coordinate, and mix that mixture with any set of other colors. When using complex mixtures be especially wary of your opaque pigments: they can easily go muddy.

6. There is one other type of mixture you might like to explore here, although it approaches the subject of the next chapter. This is the triad. We all know about painting a picture with red, yellow, and blue; but we often forget that, on a twelve-hue scale, there are three more such triads. These, too, can be used as the basis for paintings. To see which are available on your palette, and how you like them, try making three small sketches using your hues nearest to red-orange,

Enclosed Garden by Carl Schmalz, 1976, 15½″ x 21½″ (39 x 55 cm), 140 lb. hot pressed paper, collection of Mr. and Mr. Constantine L. Tsomides. In this painting the preponderant darks function in a passive way, defining areas lighter than themselves. This is very clear in the picket fence, and only slightly less so in the leaves and the clarification of the blossoms. Nevertheless, I tried to vary the shapes and sizes of these darks to help distinguish the different kinds of foliage. One further note: the shadows on the picket fence were painted before anything else, in continuous strokes across the paper. They were then dry when the time came to paint over them to define the pickets with darker colors.

yellow-green, and blue-purple; orange, green and purple; and yellow-orange, blue-green, and red-purple.

Summary

Knowing the mixing capacities of your palette is necessary to your using it intelligently. A series of tests such as you have made will also help you identify any further lacks your palette may have. If you have discovered any serious gaps, you can remedy them at your nearest art supply store, for the colors available today cover the spectrum pretty thoroughly. In case you have concluded that your palette requires a really drastic overhaul, here are some suggestions. Remember that they are not prescriptions!

Most watercolorists agree that a good basic palette is the "double-primary" palette—that is, have a warm and cool version of each primary. For example, I have vermilion light and alizarin crimson golden; cadmium yellow deep and cadmium yellow lemon; ultramarine blue and cerulean blue. Such a palette allows considerable flexibility in mixing secondary hues. Many artists also like good intense secondaries, too, such as cadmium orange, phthalocyanine green, and Thalo purple. The only tertiary color not available today is blue-purple; the others have been purchasable for decades, except for Thalo yellow green and Thio or Acra violet (red-purple), which have recently come on the market. Tertiaries are normally unneces-

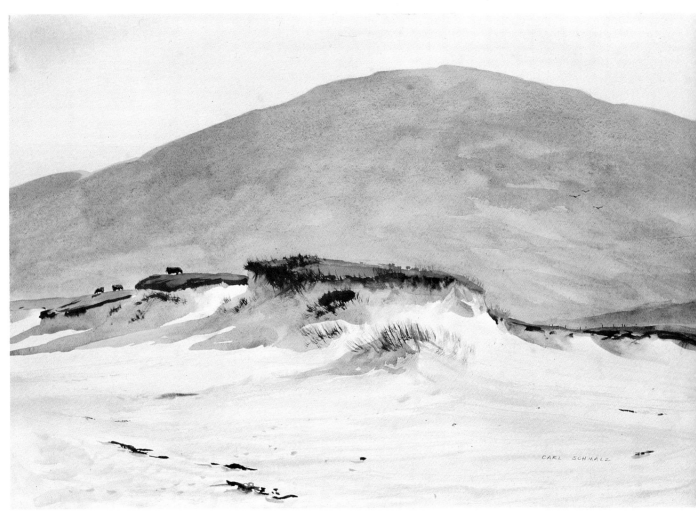

sary except for their ability to add interesting new transparent and opaque colors to your palette.

Therefore, in addition to the double primaries and, perhaps, the intense secondaries, you may wish to consider the transparent-opaque characteristics of your palette. The same colors by different manufacturers can vary quite widely in relative opacity, so you may have to shop around a little. Hansa yellow will give you a good transparent yellow to play against your cadmiums. Cadmium reds are opaque against the alizarin colors, and phthalocyanine blue, in addition to being cool, is highly transparent.

You will need some natural neutrals, too. Among the most useful are Indian red, burnt si-enna, raw sienna, yellow ochre, raw umber, sepia, and lamp black. You won't need all of them, and again, their relative opacity may help you select which will work best for you.

Some other useful colors are Cobalt Violet (a weak mixer with nice opacity), Thalo yellow green (very intense and opaque), cobalt blue (as nearly "pure" blue as we have), manganese blue (not as strong as cerulean and a little greener), burnt umber (a good warm brown and a low-intensity yellow-orange), and ivory black (a warm black and a good mixer).

Sixteen to eighteen colors should provide you with ample range and flexibility for most painting. You can always add a color for special subjects.

Color Plate 23
Beinn Tangaval, Barra by Carl Schmalz, 1972, 15½″ x 22″ (39 x 56 cm), 140 lb. hot pressed paper, courtesy of Mathew N. Schmalz. I chose the classic middleground focus for this study of the empty landscape of the Outer Hebrides. Three cattle and three birds, all in the middle space, animate the bleakness; and the lowering sun warms it. The plainly painted sand and mountain frame and contrast with this zone of life. Color organization is based on orange and blue, plus yellow/green, which lies halfway between them.

tensities used to organize color and suggest the sparkling brilliance of sunlight was an Impressionist invention. It is exemplified in the watercolors of Childe Hassam, Maurice Prendergast (color plate 4), and Dodge Macknight, among other Americans.

Much more familiar today are pictures ordered by similarity of middle or low intensity. These are a result of what is frequently called a "limited palette." I prefer to name all such deliberate planning of color a "controlled" palette, recognizing that every palette is to some extent controlled by the artist who selected it. For example, if you intentionally use Indian red, burnt sienna, raw sienna, terre verte, Payne's gray, and mars violet, you will make a painting easily marked by similarity of low-to-medium intensity. You have all six major hues and a full value range, but you have created color coherence by similarity of intensity. In the same way, you might select burnt umber, raw umber, and lamp black to yield a picture ordered by similarity of very low intensity. Murray Wentworth's *Bell House* (color plate 13) comes close to this. Very low intensity yellows, oranges, and blues are set off by tiny, brighter splashes of the same hues.

For the representational painter, achieving order in color by establishing similarity of value does not ordinarily work very well. When at least some such order is feasible, rather strong contrasts in hue and/or intensity have to be used for both descriptive differentiation and visual stimulation. My *Salt Marsh, June* (color plate 12) exemplifies near similarity of value. Only a few darker and lighter accents interrupt a surface that is at value levels two to three overall. Contrast of hue and intensity substitutes for value contrast.

Sequential relationships in color generally involve colors that

occur next to each other around the hue scale (analogous colors) as already mentioned. Schmidt-Rottluff's *Landscape* (color plate 11) is again an example, since it consists of red, orange, yellow, green, and blue. Charles Demuth's *Landscape, Bermuda* (color plate 14) also illustrates a sequential scheme: varying intensities from blue, blue-green, green, yellow-green, to near yellow are set off by low-intensity red.

More common in representational painting are sequences of intensity, frequently accompanied by corresponding value sequences. (This is often because of the regular decrease in intensity that results from raising or lowering value; see Chapter 9.) When objects are modeled from light into shade, for example, sequences of decreasing intensity and value occur. In *Winter's Work* (color plate 15), the background is shaded by clouds. You can see the gradual intensity reduction into the background at right. Similarly, atmospheric perspective decreases intensity and raises the darker values as more distant colors gradually approach the color and value of the atmosphere itself. It was this kind of sequential ordering that you capitalized on when you painted the "easy" picture in Chapter 1 (see color plate 16).

Otherwise, value, as you know, is most often employed as a contrast element in painting. Indeed, in the usual representational painting, value (and various of the spatial elements) provides contrast, whereas likenesses among the spatial elements, hues, and/or intensities provide similarity. With color, as when dealing with spatial elements, artists generally set the integrating principle of similarity in one or more elements against the discriminating principle of contrast in others.

Apart from value, the basic contrast in the color elements occurs between warm and cool; that

is, red-orange and the colors near it on the hue scale contrast with blue-green and its neighbors. Psychologists and physiologists have done little work that suggests why this contrast should be so significant. The most relevant research was done by Edwin Land more than a decade ago, in preparation for the Polaroid color camera. His work indicates that the human eye has a tremendous capacity for distinguishing subtle differences in relative wavelengths quite apart from identifying the particular wavelengths that we name orange, green, and so forth. Possibly it is this ability that makes us so sensitive to the warmness or coolness of color.

Whatever the cause, warm versus cool is basic to hue perception, and the color organization of many paintings is rooted in this distinction, which we seem to appreciate as *balance*. As warm/cool contrasts become higher in intensity, so that individual hues are clearly discernible, we refer to most of these contrasts as complementary. (Yellow and purple, although complementary, are neither warm nor cool until, by further contrasts, we make them so.) Complementary hues exhibit similarity through opposition or balance. Hence in this case, contrast performs an ordering function. Complementary hues, therefore, often provide a basis for pictorial color organization.

The burnt umber/raw umber/lamp black scheme that was mentioned earlier as an example of similarity of low intensities is, of course, also an example of warm/cool (that is, hue) balance. *Maine Still Life* (color plate 7) is a warm/cool painting in which relatively high intensity oranges and yellow-oranges balance larger amounts of relatively low intensity blues and blue-purples.

In *Salt Marsh, June* (color plate 12), I saw a subject that I had painted before and which continues to interest me. In this particular version I organized

color by intertwining complementaries, basically, yellow-green and red-purple. As we have already noted, the values are close and rather high. This means that the yellow-green can be fairly intense, but the red-purple will necessarily be neutral, and the red-purples in the foreground grass *are* quite neutral. Blue and orange are the complementary pair used as a counterpoint. The blue is not dominant—a rather neutral bit in the sky, and a bit in the water and the shadow on the boat. Orange, on the other hand, is intensely present in the middleground marsh grass where it provides a hot accent in the picture and where the blue in the water becomes vibrant against it. The hue complements and relatively high intensities keep the middleground as interesting as the more visibly stroked sky and foreground, so that all parts of the surface are about equally interesting.

A simpler picture based on color balance is my *July 6, 1976* (color plate 8). This is a green-red picture. There are a few telling accents of yellow-orange and blue, but the painting is basically a play of red and green. The intensities here are sufficiently high that the complementary organization is visible and appreciable. High intensities and snappy value contrasts balance and "contain" the inherently interesting flag. Containment could, of course, be achieved by *lowering* the intensity of the flag, but that would produce a less cheerful picture.

Color organization is often based on a three- or four-color scheme, such as a regular triad from the color circle or a triad plus one complementary. In this case, similarity arises from our recognition of the regular intervals between the dominant hues. Susan Heidemann's *Nursery* (color plate 17) illustrates this sort of organization. Heidemann uses the triad yellow-orange/blue-green/red-purple, plus yellow-green.

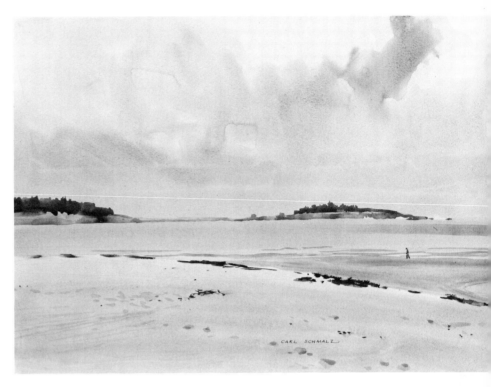

Figure 51
Overcast Island by Carl Schmalz, 1976, 14½" x 21½" (37 x 55 cm), 140 lb. hot pressed paper, collection of the author. By compressing the dark values here, I extended the range of variation in the lighter values. This gave me a good deal more freedom, especially useful in the sky, which needed articulation because of the relatively large proportion it occupied on the paper surface.

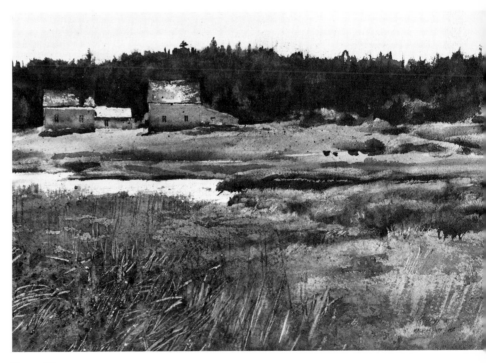

Figure 52
Machiasport Marsh by William Preston, c. 1973, 14" x 21" (36 x 55 cm), rough paper, courtesy Shore Gallery, Boston. Preston pushes all the lights toward the white of the paper, which increases his range for the middle and darker values. This enables him to describe value and color variation in the marsh and background trees in greater detail. Photo by George M. Cushing.

Most of the yellow-oranges are high in value and very low in intensity, but they pervade the picture. The red-purples are also of high value and low intensity, so the colors we are most aware of are the yellow-greens and blue-greens that define the nursery plants.

While contrast of hue creates a balance that can act as a basis for color ordering, value and intensity contrasts act predictably as differentiating agents. Contrasts of intensity are frequently used to focus visual attention and/or augment spatial description; in the absence of contradictory evidence, an intense hue always appears nearer than a less intense one. In William Preston's *Wind-Blown Iris* (color plate 18), the blossoms attract our eye partly through their relatively high intensities. Notice that they are balanced effectively by the intense yellow-green of the turned leaf at right.

The powerful visual excitement of value contrast is, as we have seen, principally employed for the descriptive differentiation fundamental to representation. (We will consider this further in Chapter 15.) But artists can use some sort of equalization of value contrast over the picture surface to produce order, as well as use such contrasts to focus attention.

Color, as all other aspects of pictorial language, is relative. The color elements are relative to each other, of course, and to the spatial factors in design. The *size* of color areas is especially significant, since a large area of intense color attracts your eye much more than a small one (see color plate 22, where the developed blossoms are far more visible than the buds). Even more importantly, color is relative to your *expressive* needs. This means that to achieve effective color design—ordering of color—you must ask yourself what you are aiming to express as you begin a picture. This involves three main

considerations. What does your response to the subject demand, how does it make you feel? What can your palette deliver? What principles can you impose on both to make the best possible translation?

Ordinarily, you want to decide on some basic principle of color organization and then modify it to suit the particular circumstances. You think about both the similarities and the contrasts that are most suitable to your ends. You recognize that some organizational principles and some kinds of contrast or visual excitement are inherent in your subject. In fact, they may even be one reason for your interest in the subject and should be taken advantage of in your painting. Doing this, you will be freed from the boring artificiality of rules that require you to put an arbitrary dab of any color you use in two other places on your paper, as well as from the inadvertent production of pictures that are all similar in color.

Exercises

It is time to get out your painting collection again. Spread the pictures out and get comfortable. Your primary purpose in this exercise is to discover how you are using color well and where you could improve.

1. Start by analyzing your use of value, since this is usually easiest to see. Do your paintings resemble each other in overall value or in value pattern? That is, are they all generally light or dark; or do a lot of them have a dark in, say, the lower right corner? Probably not, but if so, you may be using value in a habitual way rather than adapting the power of value to your expressive requirements in each subject.

As you know, watercolor dries lighter than it goes on. One result of this is a common tendency toward pictures rather uniformly pale in value. If you notice any

evidence of this tendency, resolve to number your values for a while, to try and obtain a better proportional relationship between the values of nature and the much narrower range of values your palette can produce.

Because of the value limitations of your palette, it is sometimes desirable to push the values at one or the other end of the value scale together arbitrarily. In my *Overcast Island* (figure 51), for example, the darks are all low and close in value, giving me extra leeway for variation of value from level six up. Compression of the light values strengthens William Preston's *Machiasport Marsh* (figure 52). The lighter values are all pushed toward white, allowing the artist a wider range of darker values to detail the varying rich colors of the marsh, buildings, and trees. The same device is used by George Shedd in his *Maine Gables* (figure 53). The object of these procedures is to retain the force of light/dark contrast while extending as much as possible the value range at one end of the scale. Check to see whether you are using this device in your all-over "light" or "dark" pictures. Congratulate yourself if you are!

Since value is primarily useful to you for contrast, examine the way in which you are exploiting it. Do your contrasts of value occur at points in your pictures where they tend to support or emphasize meaning, or are they merely creating unnecessary visual excitement? Value contrast is so powerful a tool that you want to use it as effectively as you can.

2. Hue is very important in representational painting. It tends to discriminate areas, so you must control it to avoid producing a coloristically chaotic surface. The two most usual ways of doing this are by selecting a limited number of hues, ordinarily related by similarity or complementarity, such as yellow, yellow-green, and

blue-green; or yellow-orange, yellow, yellow-green, and blue-purple; and by using a fuller range of hues but imposing some intensity limitations on them. Examples of the latter (nearly always the option chosen by representational painters) include Karl Schmidt-Rottluff's *Landscape* (color plate 11), organized by similarity of high intensities; Fairfield Porter's *Lawn* (color plate 19), organized by similarity of 1/2 to 3/4 intensities; as well as pictures painted with the better known "limited" palettes such as Payne's gray and burnt sienna. Another option is the use of a fairly full range of hues with varying restricted intensities. My *12:15, Cape Porpoise* (color plate 20) shows an organization based on blues and greens at fairly high intensities and in relatively large quantities, played against reds and purples at low intensities and in small quantities.

Look at your pictures to see what you are doing with hues. Do you have some color preferences? Probably you do. As with value, though, you want to be sure that your selection of particular colors and combinations of colors is not just reflexive, but represents thoughtful purpose on your part. Try to figure out whether you are exploiting the different "feel" of hues and hue families; using high intensities as much as you might; playing off warm and cool as effectively as possible—all with reference to the expressive purpose you envisioned for each picture.

If you like medium to low intensities, consider whether you are using as full a range of hues as you might. Also, could your pictures be visually richer and expressively more forceful with occasional high-intensity touches?

Summary
The purposes served by color are so varied that we often avoid try-

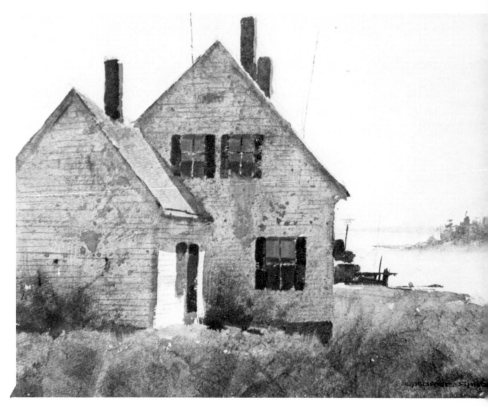

Figure 53
Maine Gables by George Shedd, c. 1972, 9½″ x 12¾″ (24 x 32 cm), 72 lb. rough paper, collection of the author. Here Shedd, like Preston, compresses the lights. All are unmodulated white paper. The full value range is thus reserved for description of variations within the middle and darker colors. Extra textural unity was achieved by crumpling the entire sheet of paper before Shedd began painting. You can see the effect in the sky and the foreground grass.

ing to understand its use by taking refuge in the assertion, "Color is personal." Well, of course it is; but so is every aspect of picture-making.

Using color as intelligently as you use the spatial elements in painting requires only that you appreciate its three dimensions and their relationships. Although you may find that planning color before you paint is inhibiting if done in detail, you will certainly discover that a general color plan is easier to think about when you understand color well. And whether you plan your color at all, knowing how color works helps enormously when you assess your efforts after completing a picture.

To aid you in color analysis of your own work, here are some additional sample questions you

might ask yourself.

Am I using overall color—and intensity—for expressive effect, creating a similarity of, say, hue not only for a coherent design, but also for unity of design and content?

Have I been as adventurous and imaginative as I might be about selecting colors, not just to be different, but to enhance my meaning?

Do my pictures really hang together coloristically, or are there places where a too-strong value contrast or a too-strong intensity contrast seems to jump off the paper?

Is there an overall balance or sequence (usually toward the focal point of the painting) in the visual interest of color in my pictures?

Figure 54
Maine Morning by Carl Schmalz,
1973, 15″ x 22″ (38 x 56 cm), 140 lb.
hot pressed paper, collection of the
author. Cast shadows, especially the
longer ones that usually result from
side lighting, aid you in explaining
the three-dimensional shape of the
forms on which they fall. Here the
lawn bank at right is so described as
well as the peculiar hump of the
road. On the central house, the
angle of shadows on wall and roof
help to clarify their planes; and, to
the left, the cylindrical tree trunk is
defined by shadows cast upon it.

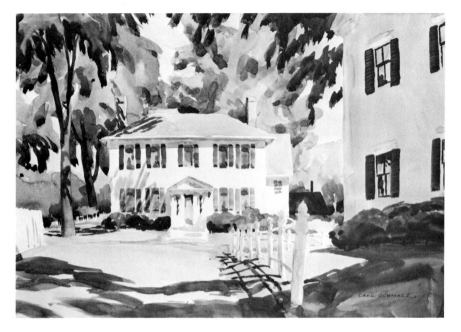

Figure 54 A
White River at Sharon by Edward Hopper, 1937, 19⅜″ x 27⅜″ (49 x 70 cm), rough paper, collection of the Sara Roby
Foundation, New York. The revelation of three dimensionality afforded by side-lighting is clear throughout this picture;
but it is especially evident on the tree at center right. Notice how Hopper emphasizes the shadow contour. Cast shadows
help to define spatial planes in this area. One falls on the rock in front of the tree, another sneaks down behind that rock
and the others to the left. A bit of illuminated ground then establishes the distance between the center rock and the tree
behind it. Notice, also, the way in which shape similarities link the feathery clouds and the foliage shapes below them.
Photo by Oliver Baker.

Lighting

Critical Concern

Light is one of many representational elements in painting. Like the spatial and color elements, it can emphasize either similarity or contrast. Visual perception depends on light, and the amount, kind, and color of the light falling on objects alter their appearance. In antiquity, and since the Renaissance, Western representational painters have appreciated the enormous power of consistent light to unify a picture, so the direction of light is also important to artists. Clearly, a systematic understanding of the ways you represent light will be valuable to you.

Illustrations

There are two fundamental possibilities in painting ordinary daylight: direct light and indirect light. When the unclouded sun sheds its white light on objects, they are in direct light. For artists, there are four primary kinds of direct light—*side light, top light, back light,* and *front light.* Here are some of their characteristics, advantages, and disadvantages for you as an artist.

Side Light. This is sometimes referred to as cross lighting and occurs when the sun, or any other light source, strikes objects more or less from the side. When you are painting nearby objects, you can often change the light you see by moving yourself or the subject around to produce more or less direct side lighting, or even a different kind of lighting.

Artists in the Western tradition have tended to prefer side lighting to all others because it most emphatically reveals the three-dimensional form of objects and the spaces between them. In side lighting the strong value contrasts of direct light create dark shadows that provide visual clues to an object's form. Hence, in addition to the profiles you see at the edges of an object, you also see a shadow contour *on* the object that confirms or modifies the profile edges. The shadow contour gives you 50 percent more information about the surface shape than the two profiles alone as it reveals the solidity or mass of the object.

Side lighting also creates relatively long cast shadows, which are useful in orienting yourself in a world of space and solids. Cast shadows conform to the shape of the surfaces on which they fall. This helps to indicate the distance between objects as well as the shape of the ground or other objects on which they rest.

With side lighting, as with most direct light, value contrasts tend to be high and to overpower more subtle color relationships. Both Impressionist and Expressionist painters found that to maintain high hue intensities, it was necessary to "model" with intense hues, so that darks were painted with reds, blues, and purples—the naturally dark hues.

White River at Sharon (figure 54 A), by Edward Hopper, is an excellent example of the way side lighting emphasizes three-dimensional solidity. Notice especially the trees, tree trunks, and rocks. My *Maine Morning* (figure 54) shows how cast shadows reveal the form of the areas on which they fall. Shadows in the foreground show the contours of lawn and road; and on the house in the center, shadows of leaves accentuate the vertical plane of the façade and the pitch of the roof. The strong value contrasts of both pictures are a typical result of side lighting.

Top Light. This is direct light from above. It occurs outdoors at or near noon and commonly produces a rather flat effect that can be very useful to artists. If you think of it as a kind of side light from above you will realize that the three-dimensional form of objects is not concealed by it, but revealed in a relatively unfamiliar way. Nevertheless, because cast shadows are short and small, a great deal of light from surrounding illuminated surfaces is usually reflected onto the shadow sides of objects, lightening them and generally reducing the modeling. Especially in regions close to the equator, this results in a

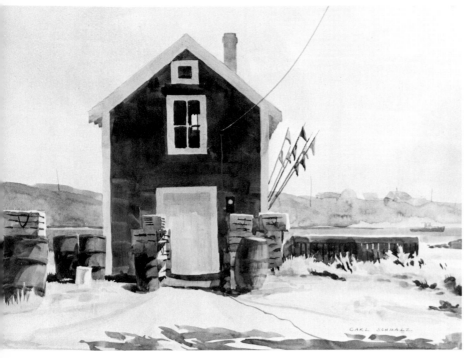

Figure 58
Tuna Flags by Carl Schmalz, 1975, 15″ x 22½″ (38 x 57 cm), 140 lb. hot pressed paper, collection of the author. This picture illustrates very simply the use of dark shapes to announce a representational theme from a distance. The darks of the shack, the lobster car at right, and the barrels and boxes can be read clearly from afar. They are justified by the same kind of shadow values against light that often occur with back lighting.

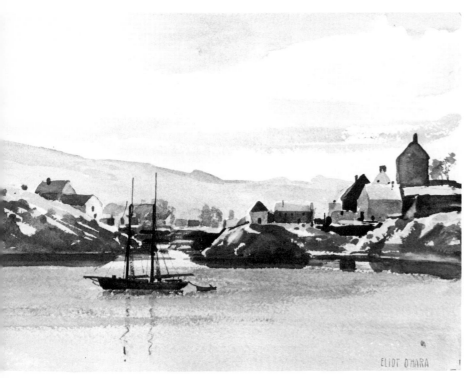

Figure 59
Brigus, Newfoundland by Eliot O'Hara, 1931, 14⅞″ x 19⅜″ (38 x 49 cm), 200 lb. rough paper, courtesy, O'Hara Picture Trust. O'Hara uses back lighting to dramatize his center of attention. The boats and village are revealed in terms of strong value contrasts, and hue variation is also greatest here. Surface interest is equalized by broad rough brushing in sky and water·

back-lit subject in which descriptive textures in the relatively dark foreground contrast with the deep darks of the shack's interior, which in turn contrast with the relative lights of the sun spots and background.

Although technically top lit, my *Tuna Flags* (figure 58) shows many characteristics of the back-lit subject. By stationing myself on the shadow side of the fisherman's shed, I was able to dramatize the simple shape of the building against a light background and emphasize the shapes of lobster traps, barrels, and other illuminated paraphernalia in the foreground. The light in Eliot O'Hara's *Brigus, Newfoundland* (figure 59) is much the same, creating a zone of sparkling light and dark silhouettes across the center of the picture.

Front Light. Illumination from behind the artist falls on the front of objects and is often termed down-sun lighting. It is used by artists less often than the types of lighting already discussed, but should not be overlooked, for it offers some interesting advantages.

Front-lit subjects, like back-lit ones, do not usually reveal much modeling. The relative flatness of such light is often relieved by small, very dark shadow accents. It also tends to emphasize color; most elements in such a scene are distinguishable by hue and intensity differences, since value contrasts are minimized. Hence, this light presents special opportunities for expression through high-intensity hues and tapestrylike patterns. Maurice Prendergast (color plate 4) often adapted such light to his personal mode of watercolor, and Fairfield Porter's *Lawn* (color plate 19) exemplifies near-frontal light softened by mild overcast. The somewhat flat shapes are characteristic of down-sun illumination.

The other basic type of daytime light is indirect light. In

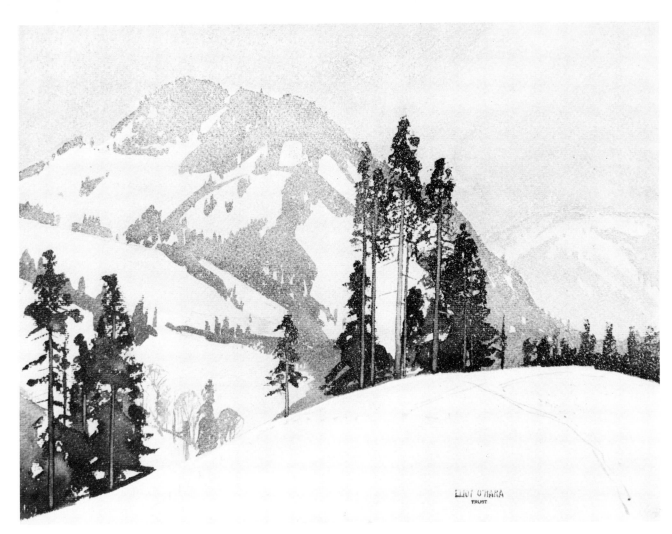

most temperate climates it occurs often, so it will be helpful for you to understand what is involved in painting it.

Just as we would be unable to see form in shadows without reflected light, so we would not see things on sunless days without indirect light. Indirect or diffused light occurs when clouds cover the sun and cut down the amount of light coming through. Clouds, fog, rain, snow, dawn, and dusk produce indirect light.

One important effect of clouds obscuring the sun on overcast days is a lessening of value contrasts compared with contrasts apparent in direct light. This means that hue and intensity variations tend to become more visible, revealing color richness. The reduced value contrast created by diffused light also means that your palette's value range

corresponds more closely to nature's range, giving you a better chance of rendering an illusion of nature's full color variations.

Because fog and snow (as well as heavy rain) actually fill the air with a material substance, they tend to produce accentuated value contrasts between foreground and background as in *Morning Fog* (figure 1) or *More Snow* (figure 60). They also reduce hue and intensity variation, pulling all colors toward their own relative neutral.

Fairfield Porter's *Lawn* (color plate 19) is an example of the subtle strength of color on an overcast day. Notice the nuances in the greens and the delicate play of pinks. *More Snow* by Eliot O'Hara (figure 60) shows both distant darks and lights coming closer to the value (and hue) of the atmosphere, especially in the

Figure 60
More Snow by Eliot O'Hara, c. 1929, 15″ x 20″ (38 x 51 cm), 140 lb. rough paper, courtesy, O'Hara Picture Trust. Fog, snow, and heavy rain accentuate the effects of atmospheric perspective, causing both lights and darks in the distance to approach the hue and value of the atmosphere. This is clearly visible at right. O'Hara spattered opaque white over the entire surface of this picture to obtain the effect of falling snow. It is no longer quite "pure" transparent watercolor, but it is convincing.

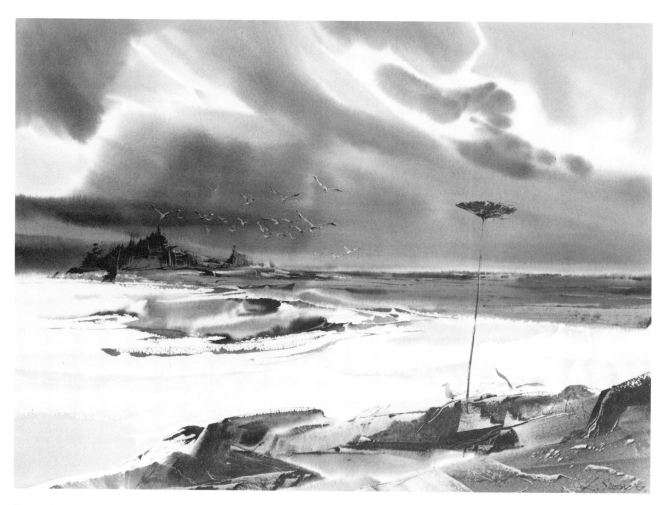

Figure 61
The Osprey Nest by Laurence Sisson, 1973, 24″ x 36″ (61 x 76 cm), rough paper, courtesy, Shore Gallery, Boston. Light is greatly reduced under heavily clouded skies, which simultaneously reduce intensities; hence, here we tend to perceive value contrasts as primary. Sisson exploits value contrasts to create counter-movements in the light wedge of water and the sweeping clouds. Photo by George M. Cushing.

mountain at right. Laurence Sisson's *The Osprey Nest* (figure 61) emphasizes dramatic value contrasts among the low-intensity hues characteristic of light under heavily clouded skies.

Exercises

Get out your picture collection again, make yourself comfortable, and start thinking. There are two main categories of questions to deal with here: (1) How effectively are you using both the unifying and the expressive possibilities of direct light? (2) Are you taking sufficient advantage of the opportunities for coherence and expression offered by indirect light?

It may be easier if you divide the first question into the lighting categories just discussed, but first take an overview of your work to decide whether you appear to prefer direct or indirect light.

A preference for either is, of course, perfectly all right; neither is inherently better than the other, and sometimes particular personal expressive needs are much more responsive to one. However, if you have not yet made a conscious decision as to the general kind of light you use predominantly, you will probably find that about two-thirds of your pictures are painted in direct light and one-third in indirect light. This proportion does not reflect the weather in your part of the world, but indicates that watercolor landscapists seldom paint in rain and snow! A substanially different ratio of subjects painted in direct or indirect light may indicate a semiconscious or unconscious preference. Try to figure out *why* you paint subjects in the light you seem to prefer. Is it accident, or do you actually feel better on sunny

days? Do you like the muted color of overcast days? Does the drama of stormy weather attract you? What personal reasons for your choice can you discover?

Are there artistic reasons for this preference? Do you enjoy working with a strong feeling of the volume of things? Do you prefer high intensities? Low intensities?

The answers to these questions are neither right nor wrong; they simply yield information about you as a painter and show you where you might increase your range or build on your strengths.

Here are a few questions you might ask yourself about your use of direct light.

1. *Side Light.* Are you making good use of the unifying effect of direct light by carefully indicating the consistency of the light source? (This question applies equally to other direct lighting situations, but often has special force in side lighting.)

Are you capitalizing on the information about volume and surface offered by the shadow contours on objects?

Are you using cast shadows to help you model the forms on which they fall and to help define the space between objects in depth?

2. *Top Light.* Is top light an option you use often? Occasionally? Never? Could you profitably explore it further?

Are you making the most of the unusual shapes created by top light?

Are you using the flattened forms sometimes associated with top lighting to enrich your picture pattern and surface?

Are you seeing and exploiting the visual excitement offered by the small darks that top lighting frequently produces? (See *Reflections*, figure 62.)

3. *Back Light.* Have you used back lighting? If not, have you thought about how its accentu-

Figure 62
Reflections by Eugene Conlon, 15″ x 21¾″ (38 x 55 cm) rough paper, purchased by the Junior League of Springfield, Missouri and donated to the Regional Girls' Shelter, Springfield. Top light (like side light) falling on any irregular surface will produce many small shadows that can often be used to add excitement to a painted surface. *Reflections* is largely articulated by the varied repetition of the clapboard shadows and paint texture, and represented texture is used with equal skill.

ated value contrasts and emphatic shapes might answer your expressive needs?

4. *Front Light.* Have you explored this least-used lighting option? If you are interested in the unifying effect of surface patterns and the similarity of intense hues, this may be something to try.

You also need to ask questions about the pictures in which you used indirect lighting. Look at them now and consider the following queries.

1. Are you taking full advantage of your palette's capacity to reflect accurately the narrow value range created by an overcast sky? This can produce greater subtlety in value relations than is usually possible in direct light.

2. Are you enjoying the unifying possibilities of medium- to low-intensity similarities and the rich color relations typical of overcast days?

3. Have you made the most of the neutral colors and spatially

gradated values created by hard rain, snow, and fog?

Summary

Light variations offer you opportunities for both unifying your pictures and differentiating elements within them. A consistently presented direct light from any angle is one of the strongest unifying agents in picture-making. At the same time, direct lighting offers you numerous ways of differentiating pictorial elements. These include value, hue, and intensity contrast, as well as emphatic lines and shapes.

Indirect light in its various forms gives you the chance to increase pictorial coherence through similarity of hue and/or intensity. It can reduce the clarity of lines, shapes, and intervals, permitting a harmony not achieved so easily in direct light. On the other hand, in rain, snow, and fog (and in the often pale skies of other types of indirect light), you have opportunities for representational value contrasts that can define shapes and space.

Figure 63

Mexican Bus by Carl Schmalz, 1946, 13″ x 19″ (33 x 48 cm), 90 lb. rough paper, collection of the author. This was painted from the memory of waiting for a bus to start late at night. Though I had no notes and was working six months after the experience, the vision remained in my mind sufficiently clearly for me to reconstruct it. One small incandescent bulb provided the only light source, accounting for the very dark shadows; there is almost no reflected light. Light diminishes very rapidly away from the source, so that the right side of the picture is relieved only by the glint on the metal pole.

Colored Light

Do you understand the theory and uses of colored light sources in painting?

Critical Concern

Although the occasions for using colored light sources in watercolor painting are rather few, at least in practice, they are frequent enough to justify your being aware of both the special problems and special opportunities they present.

Conditions under which you can expect colored (or perhaps only tinted) light include sunrise, sunset, moonlight, firelight, and light from nearly all artificial sources. Hence any night scene, interior or exterior, will almost surely involve colored light sources.

The primary artistic advantage of subjects illuminated by colored light is its strong tendency to unify the scene by similarity of color. This can also, of course, be thought of as the disadvantage of color limitation. But a more important reason for relatively few watercolorists using colored light sources may be that such subjects frequently produce pictures that are dark in overall value. In transparent watercolor, large areas of low-value colors can be tricky to handle effectively.

Illustrations

The first thing to remember about a tinted or colored light source is that it is *incomplete* light. White light contains all wavelengths of the visible spectrum from the long reds to the short violets. A colored light source is deficient in some wavelengths. Firelight, for instance contains virtually no short wavelengths, whereas moonlight contains almost no long ones. This means that you cannot see blue by firelight or any red by moonlight. Everyone has probably had the experience of seeing lipstick and other reds go black under mercury vapor street lamps. We cannot see reds by this light because there are no red wavelengths in it to be reflected back by the pigment that appears red in ordinary daylight. When complete (white) light falls on something that looks red to us, it appears red because the surface has on or in it a substance that absorbs most other wavelengths and reflects only the red ones.

It follows that in a firelight picture, all colors will be warm or black. Since the human visual apparatus is remarkably adaptive, however, we actually perceive a surprisingly wide range of hues in colored light. This capacity is called *color constancy.* Because of it we see the shadow side of a white building as white, even though it may be bluish gray. Much of

your task as a representational artist is to edit color constancy to serve your pictorial ends. In ordinary light you want to learn to see the actual color, the bluish gray, so as to paint it. But in colored light, color constancy can be extremely useful, since it permits you to avoid painting a completely monochromatic picture. To go back to the example of the firelight scene, color constancy allows you to include some low-intensity blues and greens, rather than paint only black for cool colors. The same phenomenon also usually gives you the opportunity to employ some low-intensity warms in a moonlight picture.

Because colored or tinted light is incomplete, it is usually quite weak compared with sunlight. Hence, it generates little or no reflected light, so shadow areas tend to be very dense. Silhouette effects are frequent, and shapes are prominent because contrasts of value are strong. These offer you splendid opportunities for powerful, dramatic paintings.

Eliot O'Hara's *Sunset between Santa Fe and Taos* (color plate 21) is a fine example of the unifying effect of tinted light. Apart from the blues, the colors range from yellow-orange all the way around the warm side of the hue circle through the reds and red-purple. Even the snow picks up a red-purple reflection from the clouds, and the most distant mountains

are veiled in orange haze. Value contrasts strengthen the picture and emphasize the forms of the mountains.

I painted *Mexican Bus* (figure 63) many years ago, before my personality as a painter was developed, but it remains a picture of considerable interest because of the telling value pattern and the way the strong light/dark contrasts are unified by the pervasive yellows from the incandescent bulb. More importantly, the low intensities and generally warm colors help reinforce a mood of tranquil, late-night waiting.

Chez Leon (figure 41), O'Hara's mildly abstract Paris night scene, has some of the same expressive qualities. It, too, is a low-intensity picture in which value contrasts are fairly strong and are responsible for most of the accented shapes. Light comes from several sources—the various shop fronts —and is reflected in the wet street surfaces. The architectural clarity of the painting helps make it quite serene. It depicts a far-from-nasty night.

Jonee Nehus's *Polly's Piano* (figure 64) treats a night interior with great sensibility. Value contrasts of light and shade are understated. Nehus reserves her darks for shape accents across the picture surface and exploits the limitation of warm incandescent light to create a range of muted, middle-intensity colors of great subtlety. These visually emphasize the auditory harmony suggested by the piano, and the varied darks strike the eye in much the way separate piano notes would strike the ear. The whole evokes a palpable mood of the delight of music in a quiet room at night.

Exercises

The chances are excellent that among your selected pictures you have none that employs colored or tinted light. In fact, the chances are pretty good that you've never painted such a picture. But just in case you have one or two, here are a few questions you might ask yourself about them.

1. Ignoring for a moment the kind of colored light that may be involved, have you made full use of it as a unifying factor? Have you overemphasized the unity of color—is your picture too exclusively pink, orange, green, or whatever? If so, you may have disregarded the factor of color constancy.

I recall once painting an upcoming summer storm at dusk that turned out all pink, gray, and black. The drawing and painting were fine, but the picture lacked coherence for an interesting reason. It was purely representational except for the color, which reminded me of a Hollywood bathroom or a young girl's carefully planned party costume. Because the color scheme read as abstract, it conflicted with the rest of the picture. Color constancy is not just an excuse for broadening your palette in colored light situations; it is an inherent perceptual faculty in all of us. To overlook it may result in an unnatural-looking, hence incoherent, picture.

2. Have you capitalized on the value contrasts that figure so prominently in most scenes illuminated by colored light? In an interior scene with a single light source such as my *Mexican Bus* (figure 63), the strongest value contrasts, as well as the most telling silhouettes, tend to be located near the middle of the picture. A moonlit scene, on the other hand, may not arrange itself so easily. Outdoor, sunset, or night subjects must be as carefully thought out as any scene in sunlight. For instance, have you used the best angle to take advantage of long, descriptive cast shadows?

The type of colored light illuminating what you have painted makes a significant difference in the pictorial problems and possibilities you faced, mainly because the tint of the light varies so much, but also because the amount of light varies. One candle, such as Georges de la Tour often painted, provides a single weak, warm source in which forms are potently relieved against extreme darks. Sunset, however, often produces fairly diffuse, but still quite strong, warmly tinted light. Moonlight is bluish or greenish and, after you adjust visually, it appears single and strong. Actually, it is extremely weak light, which accounts for its inability to create reflected light.

A typical late-twentieth-century interior includes multiple light sources, often of different tints. If you have tried painting a conventional living room, for example, you have faced quite complicated problems. But let's take sunset as an example. Did you paint up-sun (subject backlit), which is customary, for the sunset color is in that direction? You lose two things painting that way: the pronounced modeling that results from low light, and the transformations of greens and blues that would result if your subject were illuminated by such deeply orange light.

3. If you chose cross light, did you achieve warm neutral greens in trees and grass? Again, have you utilized the long descriptive shadows? Have you made your whites sufficiently pink or orange?

4. If you looked into the light (up-sun), did you get sufficient color into the silhouettes? Did you color the sky enough?

5. Finally, whatever type of colored light effect you painted, are your darks dull and lifeless or glowing and vibrant? As you know, the very nature of transparent watercolor is hostile to large areas of extremely low value. Since the luminous quality of the medium depends on light reflecting from the paper's white

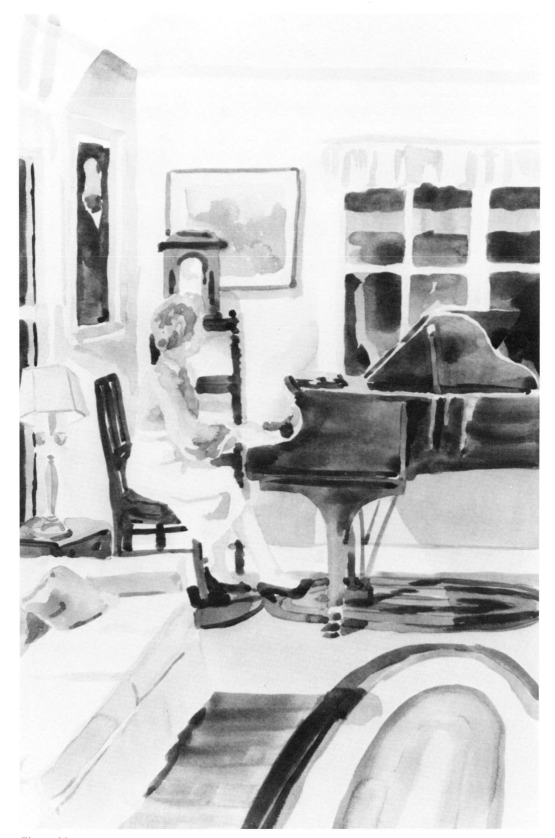

Figure 64
Polly's Piano by Jonee Nehus, 1976, 22″ x 15″ (56 x 38 cm), 140 lb. hot pressed paper, collection of Mr. and Mrs. Robert L. Chew. Nehus understates the darks here: thus the viewer only slowly recognizes the significance of the dark windows. More important at first is the play between muted color and the accents of dark, as they build a convincing image of the absorbed pianist and her instrument.

surface up through the paint layer, you want to avoid a paint layer so dense that reflection from the paper through it is prevented. This heavy or dense paint layering is what we usually call a dead or muddy passage. Such a passage stands out because it disrupts surface coherence.

To minimize the chance of deadness in extreme darks, you must use the most transparent darks on your palette. These may include sepia, alizarin crimson, red-purple (such as Thio violet), purple (such as Winsor or Thalo purple), some ultramarine blues, and phthalocyanine blue and green. Working carefully with these or comparative colors, you can attain low-value areas that still remain quite vivid. Mixtures and glazes often yield even lower values, although you will probably not produce an absolute black. Here the trick is to push your whole value range up just enough to make your darkest darks *read* as black.

If you have never attempted a picture illuminated by colored light, or have not done one recently, it might interest you to attempt one now. Since we have been dealing mostly with landscape in this book, try a moonlit landscape.

First, you need a picture to work from. Select a painting from among your supply—not necessarily one of the group you've been using in these exercises. It should, of course, be a scene painted in direct light, and, since you will be concentrating on color and value, it need not be overly complex. Check your palette to be sure you have fresh, workable amounts of your most transparent darks, squeeze out new color if desirable, and get a clean sheet of paper. Draw your scene on the paper as usual.

Now you have to think about colors. Moonlight is very cool, a sort of neutral blue or green tone. Hence, if your picture in-

cludes anything that is white in direct light, a very pale wash of neutralized blue-green should go over it. Do not make it darker than value level two (see Chapter 9). You want to constrict your value range as little as possible.

The neutral blue-green of this tinted light will affect every other object in the picture. Objects that are cool in color will therefore tend to be more intense than warm-colored ones. The latter should also be painted considerably darker than they appear in daylight, for little cool light can be reflected from warm surfaces.

The sky, also, will be proportionately darker than it is in the daytime, so you may want to delay painting it until the values of objects in direct light have been put in. It will be a neutral blue, lightening slightly toward the horizon. When the picture is finished, you can pick out a few stars with the tip of a knife.

The value of all things in the picture will be somewhat darker than in your daylight version of the scene, but remember that both the shadow sides of objects and the cast shadows will be especially dark. Be sure to reserve enough of your lower value range to accommodate these. The strength of the contrasts they present is absolutely necessary to the illusion of moonlight.

Look carefully at the warm colors in your original picture. You will have to cut their intensity greatly and also reduce their value. But, allowing for color constancy, you can include some warm darks. Think about where they might look best and be most believable.

You should be ready to continue painting at this point. Proceed as usual, moving generally from the lighter to the darker tones. Begin thinking about the colors you will use for your deep darks shortly after you start painting values below the middle level, and be conservative about warms. It is the effect of cool

light, after all, that provides part of the unity of your picture.

Summary

Subjects in colored light provide an infrequently accepted challenge to the transparent watercolorist. Although the color of the light itself imposes color coherence on the subject—which contributes to pictorial coherence—the problem of painting lively darks may discourage more artists than it needs to.

In addition, virtually all colored light subjects *must* be painted from notes in the studio. If you habitually paint on the spot, this change of working procedure may also be deterring you from attempting such subjects.

As we have seen, though, the problem of the darks can usually be overcome by thoughtful selection of paints and extra care in execution. Learning to paint from notes takes a little practice, but is not sufficient reason to deny yourself the fun of dawn, dusk, and nocturnal subjects. All you need is a notebook, drawing tools, and a good method for noting hue, value, and intensity. Such a method may easily be derived from the color system discussed in Chapter 9. For example, intense orange at value level four might be noted: O-4. Blue at value level six, somewhat neutralized, could be noted: B-6—3/4 (intensity). This is simple, clear, and as accurate as you will need. A color-annotated sketch, including enlarged drawings of particular details, comments, and other memory aids, gives you plenty of information for a painting. With a little experience you will learn to include whatever other kinds of information you find particularly useful.

If you remain reluctant to try pictures set in colored light, remember that they stand out on a wall, not only because they are generally dark and dramatic, but because there are so few of them!

Figure 65
Highland Light, North Truro by Edward Hopper, before 1930, 15¾″ x 24¾″
(40 x 63 cm), rough paper, courtesy, Fogg Art Museum. By looking nearly
up-sun, Hopper gets most of the advantages of back lighting without forfeit-
ing those of side lighting. The pattern of changing gable shapes unites the
block of buildings against a lighter ground. Notice that angles in the clouds
repeat some of those in the roofs below, and the turn in the road falls imme-
diately under a similar curve of the roof of the lamp housing.

Figure 66

Rural Fire Station by Carl Schmalz, 1976 $15\frac{1}{2}''$ x $21\frac{1}{2}''$ (39 x 55 cm), 140 lb. hot pressed paper, collection of the author. The vaguely triangular or wavelike shapes of the shadows on the white pine foliage differentiate the foliage from the rounder, broader, less regular shapes of the maple shadows at left. I included the red stop sign to prevent the road from pushing too drastically into the picture space: but I kept it relatively low in intensity (and of a hue close to that of the chimney) to maintain its integration into the picture surface (refer back to Chapter 12).

Drawing, Pattern, and Darks

Are you seeing and using dark shapes effectively?

Critical Concern

Virtually all painting is drawing, but this is particularly true of direct painting where you apply colors with relatively little preliminary preparation. And, as noted in Chapter 2, among the forms of direct painting, transparent watercolor is preeminently drawing. Recall again the likeness between pen or pencil drawing and watercolor. In both, you work on a white (or light) surface and apply tones gradually in a general light-to-dark sequence. Since you do not normally add any lights, the darks have an especially important function: they must describe the shapes of both dark things and lighter ones, while also providing visual excitement or giving sparkle to the image.

The chief differences between what is usually called drawing and transparent watercolor are that you work in color in watercolor, you work with washes as well as strokes (which tend to be somewhat wider than drawing strokes), and you normally cannot erase your darks, as you can with pencil or charcoal.

Because darks serve so many purposes, and because they are largely ineradicable, the impor-tance of understanding how they function cannot be stressed too much.

Illustrations

Although there is some overlap, for clarity's sake let's divide the use of darks into four categories that we can consider more or less separately. These might be: (1) characteristic silhouette, (2) shadow patterns, (3) reserved lights, and (4) design or composition.

Characteristic Silhouette. The point of view from which you approach a subject and the lighting conditions surrounding it alter the placement of your darks. Because of the role these options can play in attaining descriptive clarity, you need to be aware of them as you begin painting.

Edward Hopper's *Highland Light, North Truro* (figure 65) is interesting because, as far as we can tell, he had an unobstructed view of the subject from any direction. It is instructive to think why he chose the angle he did. You'll notice that it is almost, but not quite, directly up-sun. He achieves here maximum back lighting, with its pungent revelation of characteristic silhouettes in the gable shapes and chimneys, and sacrifices very little of the volume revealed by cross lighting. In addition, the late morning light creates relatively small cast shadows, so that the generally dark pattern of the whole complex of buildings is sharply relieved by a generally light background.

Taking advantage of strong silhouettes includes using the shadow contour, the revealing edge on objects discussed in Chapter 13. It is especially important in Hopper's painting because it reveals the cylindrical volume of the lighthouse tower. It is also one of the main ways in which forms are specified in Murray's *Buoys* (figure 34) and Preston's *Wind-Blown Iris* (color plate 18).

Selection of telling darks is as necessary in diffused as in direct light. *Bell House* by Murray Wentworth (color plate 13) is a case in point. Relatively light in overall value, it nevertheless packs a wallop because of the shape and placement of darks. The large window, slightly to the left of center, anchors the palely lit structure and helps define its pyramidal form. The opening in the bell's base is another significant dark shape. The straps and bolts that hold the bell are accented darks, as is the glimpsed underpinning of the house itself. Details of dark weeds proliferate to the right of center, their small, spiked shapes attracting the viewer's eye by contrast.

Shadow Patterns. An inescapable necessity in working with transparent watercolor is acquiring the skill to see and paint the patterns of shadow areas—both the shadow side (and shadow edge, or contour) *on* objects and shadows

Figure 67

Detail by Carl Schmalz, 1975, 10″ x 14″ (25 x 36 cm), 140 lb. rough paper collection of the author. Darks of varied shapes and sizes differentiate the lush vegetation of the Maine coast. Color modulation also helps; but I hoped to produce an effect of roses, grass, and sumac sufficient to alert those familiar with them to their identity. For other vegetation, simple differentiation is enough to produce pictorial interest and maintain pictorial coherence.

cast *by* objects on other surfaces. This is particularly important in representing foliage and other nongeometric volumes, but it applies universally.

Complex (or nongeometric) volumes reveal their structure through shadow patterns, just as simpler forms do; discerning them is only a matter of attending to them with an analytical eye. Note the difference in shadow shapes (and relationships) between white pine trees and deciduous trees or bushes in my *Rural Fire Station* (figure 66) and *Winter's Work* (color plate 15). Also note the difference between the shadow shapes among the background trees, the dahlia leaves, and the baby's breath in *Enclosed Garden* (color plate 22). The same distinction of shadow shapes in the detail of the foreground in figure 67 differentiates grass, bayberry, sumac, and other vegetation.

Merely distinguishing these darks is, of course, not the point. Rather, the idea is to observe the characteristic shadow shapes of commonly encountered trees and shrubs. These shadow patterns can then be employed, in addition to typical silhouette and branch structures, to identify such greenery. Accurate observation almost always promotes economy of means and helps you deal succinctly with most complex forms such as rock formations, wood piles, industrial detritus, and other apparently confused or complicated subjects. Remember, too, that Burchfield (figure 56) deliberately made these shapes *similar:* he was enough aware of them to use them to unify rather than differentiate, a use to which you might also want to put them.

Reserved Lights. Chapter 3 has already dealt with some aspects of this procedure so exclusive to transparent watercolor. Although the problem of edges was the subject discussed there, it was mentioned that underlying the problems painters face with edges was the fact that watercolor darks are applied as *positive* marks even though they often serve to define something light. Hence, when they are used to affirm and clarify lighter shapes, they have a negative or passive function. Therefore, in addition to thinking about drawing shapes in shadow areas, you must consider this self-effacing but vital role of darks.

Dee Lehmann's *405 Hill Street*

(figure 68) is full of retiring darks that "draw" the reserved lights, notably in the porch columns and railing. The windows of the cupola at the top left of the house offer another example. The shadows on the side of the house isolate and bring forward the illuminated corner of the wing projecting toward us, and the darks under the porch at left describe the low branch of the shrub in front of it. The viewer senses a justness and economy of technique that contribute to pictorial coherence.

I sought a similar correspondence of method and representation in *The Anchorage, October* (figure 69). The subject particularly interested me because it encouraged playing with reserved lights. The erratically lighted trunks and dead leaves of the oak trees were painted in a series of variegated washes so that some of the illuminated lower trunks and the more distant foliage masses were painted at one time. I did the same thing with intermediate values and then defined particular trunks and branches last with low value mixtures of reds, purples, and oranges.

There are many examples of the directness, economy, and coherence attained by skillfully reserved lights among the illustrations for other chapters in this book. It might be helpful to look for them.

Focal Contrast and "Sparkle." The desirability of locating strong value contrasts at or near the representational focus of your painting has been mentioned in several contexts. Remember, though, that the effectiveness of this device is enhanced if the contrast also announces the pictorial theme. This can be quite simply done, as in Mary Kay D'Isa's *A Brush with Winter* (figure 70). Here the central mass of dead weeds and bushes contrasts strongly with the surrounding snow—the fundamental theme of

the picture. Not only is this shape repeated with variations in the distant woods, but you also see it in the swelling mounds of the snow-covered ground. In addition, at the representational level, the contrast of dormant life against hostile snow sets the expressive theme of the whole painting.

Sidney Goodman's *Eileen Reading* (figure 112, Chapter 20) is a very complex picture, but it, too, has the basic design theme near the center in the contrast of the light, rectangular paper against the dark, rounded head. This painting will be discussed further in Chapter 20.

"Sparkle" is the visual result of contrasts of relatively small darks against lights. It may be largely non-representational, as in the left foreground of D'Isa's *A Brush with Winter*; or it may be more closely associated with representation, as in my *Enclosed Garden* (color plate 22), Dodge Macknight's *First Snow–Winter Landscape* (figure 71), and Nicholas Solovioff's *Martinique Boats* (figure 72). The chief thing to remember about this delightful, eye-catching possibility is that it can easily be arbitrary (visual "noise" without justification) or overdone (too much of a good thing).

Exercises

Drawing is first of all the accurate seeing and recording of shapes. This does not necessarily mean recording with scientific exactitude, but rather with an eye to revealing inherent patterns. Drawing is also recording the illusion of volume (modeling) and the relationship of things in illusory space. Here we are mainly concerned with seeing and recording shapes accurately, especially shapes defined directly by dark-value areas and indirectly by darks that define light-value areas.

Arrange your selected pictures now and prepare to examine

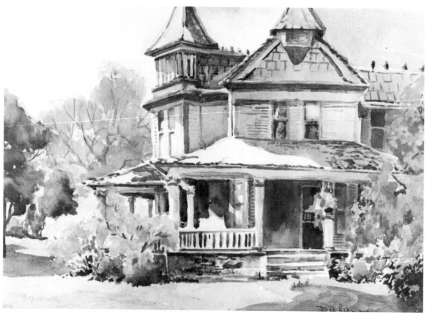

Figure 68

405 Hill Street by Dee Lehmann, c. 1974, 15″ x 22″ (38 x 56 cm) (sight), 140 lb. cold pressed paper, collection of Mr. and Mrs. Nathaniel C. Baker. Lehmann employs reserved lights deftly and with an understanding of their profound contribution to economy as well as to the viewer's sense of the ease of picture making. Notice here the many places, in the foliage as well as the architecture, where a shape is defined by the darker color around it. The picture is also interesting as composition. The pale triangle shape at center is repeated in varied ways throughout the house (it even appears, modified, in the shadow on the foreground grass), and the building is enclosed by yellow-green and green foliage at near right and at more distance at left. A sensitive symmetry is set up that unites the picture surface with the illusory space.

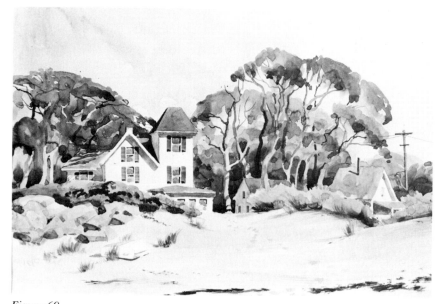

Figure 69

The Anchorage, October by Carl Schmalz, 1976, 15½″ x 21½″ (39 x 55 cm), 140 lb. hot pressed paper, collection of the author. The lighting here is virtually frontal. It gave me a chance to contrast the architectural patterns of the buildings with the organic patterns of the trees. But what interested me most was the opportunity to develop the trees simply, by planning reserved lights. The trunks were painted at the same time as the foliage lights—modulating color. Darks were introduced, also with modulated color, to serve as intermediate colors in both foliage and trunks. Only three drying times and some late dark touches were required.

your use of dark shapes in them. This will involve a straightforward appraisal of each of the four divisions set up in the Illustration section of this chapter.

1. *Characteristic Silhouette.* Do your silhouettes, at least the most important ones, usually emphasize a characteristic, readily identifiable aspect of the object drawn? In modeling objects, do you often use the shadow edge or contour to give extra information about a subject's shape?

Resolve to study these possibilities more consciously in the future if you feel that you could better utilize them. Eliot O'Hara's *Llamas, Cuzco* (figure 73) is an elegant, simple example of adroit use of dark silhouettes.

2. *Shadow Patterns.* Are you making wise use of shadow patterns in complex volumes such as trees, shrubs, and rocks? Are you analyzing shadow contours to aid you in defining the structure of the subject? If you are not, the shadows on most of your trees, bushes, rocks, and so on probably look much the same. They may appear mushy and undifferentiated, except, perhaps, for color.

Crispness and sureness in the representational aspects of your picture, even in those aspects that may not be central to your expressive concern, are a mark of consistent handling, which is a part of pictorial coherence. If you have been neglecting the visual order in shadow patterns on the surfaces of complicated volumes, try sketching them with pencil or felt pen whenever you have the chance. This practice will help you to see them better when painting.

3. *Reserved Lights.* Are you attending enough to the role of darks in reserving light shapes? This question has two parts. Are you using darks for economy in painting by reserving lights with them; and are you tailoring the

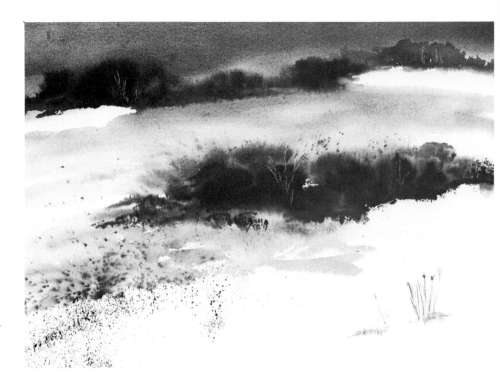

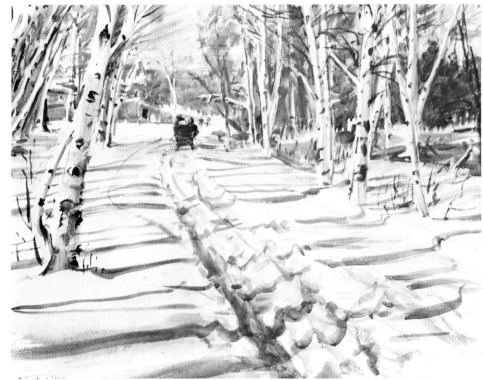

Figure 70 (above left)
A Brush with Winter by Mary Kay D'Isa, 1974, 22″ x 30″ (56 x 76 cm), 300 lb. rough paper, collection of the artist. D'Isa's theme, both expressive and compositional, is contrast: winter against potential life. She translates this into pictorial terms by her representation, but the power of the picture lies in the expressive means. Wet against dry, spatter against scraping, low dark against white. Similarities of likeness and sequence pull these contrasts into a coherent whole. We have mentioned the shape likenesses: notice that the spatters are both dry and wet, linking the areas at lower left. Further, the color intensities are extremely low, so that strong similarity of intensity and little hue contrast make the picture cohere while underlining its expressive thrust.

Figure 71 (left)
First Snow—Winter Landscape by Dodge Macknight, before 1936, 17¼″ x 22¼″ (44 x 57 cm), rough paper, courtesy, Museum of Fine Arts, Boston. Macknight was among the very few pure Impressionist watercolorists in America. His works are vibrant with intense hues, mainly in small quantities. His aim was sparkle, and in a winter scene, you can see it even in black and white. The touches of the brush are uniformly small and quick. Light/dark contrasts abound. Edges are loose and unconfined. The artist conveys a precise sense of the day. Notice, too, how he uses cast shadows to define the snow surface, the sleigh's ruts, and the depressions around the bases of trees.

Figure 72 (above)
Martinique Boats by Nicholas Solovioff, 1976, 15″ x 21″ (38 x 53 cm) (sight), hot pressed paper, collection of the artist. Solovioff is more interested in wedding sparkle to form than in emphasizing sparkle alone. A thoroughgoing stroke painter, he contrives, through value contrasts and color, to express a sense of illumination and movement. In fact, one might say that the paradoxical "subject" of this picture was summed up in the play of moored sailing vessels, all headed into the current at left against the cruise ship moving right. Small value contrasts in the clouds, boats, and water create visual interest, which is balanced by the "worked" sky above. Note that the nearby strokes in the water are about the same in size and direction as many that describe the boats in the middleground. Photo by Robert A. Grove.

Figure 73 (above)
Llamas, Cuzco by Eliot O'Hara, 1933, 15½" x 22¾" (39 x 58 cm), 140 lb. rough paper, courtesy, O'Hara Picture Trust. O'Hara adroitly uses an age-old device here—throwing the foreground into shadow. The dark silhouettes help to define clearly the illuminated space behind them. At the same time they announce the locale, a theme confirmed by the arches at left. Brilliant blue-purples, reds, and red-oranges accent the foreground and, at lighter values and lower intensities, describe the rough stuccoed surfaces of the buildings so that hue similarities help to create pictorial coherence.

Figure 74 (right)
Sea-Belle, Falmouth by Carl Schmalz, 1972, 15" x 22" (38 x 56 cm), 140 lb. hot pressed paper, collection of the author. Darks that reserve and define lights can often function actively as well. For economy of handling, it is wise to be alert to this possibility, as I tried to be in the upper left background of this picture. Notice also how the pile of boards in the foreground is suggested mainly by analysing characteristic shadow shapes.

darks so that they not only help in reserving lights, but also act as independent, positive darks whenever possible? Ask yourself where, in your selected group of paintings, you deliberately allowed an initial lighter wash to overlap an area that would eventually be darker; and where did you set in a color because you *wanted* to reserve it later?

For the second part of the question, how well do your darks that are used to reserve lights also function in their own right as darks? For example, in the upper left section of *Sea-Belle, Falmouth* (figure 74), I set in a number of light colors for trees, houses, and masts. The darks that defined them, however, also describe the shadow planes of the buildings and the characteristic shapes of elm and maple tree shadow patterns.

The more ways you can make any given stroke or color count,

the more economical your painting will be, and the more integrated the world of your picture will appear to the viewer.

4. *Focal Contrast and "Sparkle."* How well are you uniting the eye appeal of major value contrasts with the expressive focus of your painting? Is "sparkle," or small, sharp value contrasts, a part of your painting repertoire? If so, are you using it purposefully, for expressive ends, or is it using *you* and perhaps robbing your pictures of focus and expressive clarity? "Sparkle," as with other devices external to basic transparent watercolor technique, must be used with tact and know-how if it is not to disrupt either surface or representational coherence.

Summary
Good painting requires good drawing because clarity, precision, and expressive pungency of

shapes and shape relationships underlie forceful representation. As a representational painter, you are working under a multitude of handicaps: you must employ every possible means of clarifying your picture's expression and integrating your personal picture "world." Include intelligent (and sensitive) choice of characteristic silhouettes among your tools. Learn to use typical shadow patterns, telling reserved lights, and eye-attracting "sparkle" to amplify your painting repertoire.

Remember that for the representational painter, pictorial coherence includes coherence in representation. This means that appreciable similarity of representation must permeate your painting. A Picasso cubistic head, for example, would not fit happily into Sargent's world. This exaggerated example should warn you what to look for.

Figure 75
Hill by Gene Matthews, 1963, 22″ x 28″ (56 x 71 cm), rough paper, collection of the artist. In this painting Matthews has pushed rocks and trees to the edge of abstraction. They are no longer recognizable, but are only suggested by the linear patterns and textures that unite the surface. Without light effects pictorial coherence frequently demands such modification of represented objects.

Figure 76
Landscape with Trees and Rain by John Marin, 1914, 14″ x 16″ (36 x 41 cm), rough paper, collection of the Colby College Art Museum. Paying virtually no attention to light effect, Marin states as directly as possible, through his technical means, the experience of being in rain. He is less interested in the appearance of a rainy day, than in the feel of one. The intermingled wet washes are articulated by strokes that suggest trees and falling rain. Pictorial coherence is increased by the use of rather low-intensity colors with few sharp value contrasts.

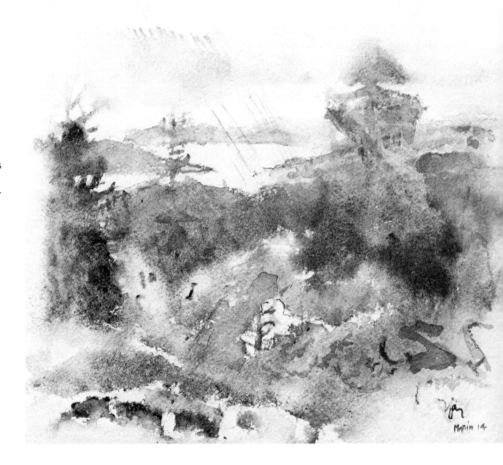

Coherence Without Light

Are you aware of your options regarding representational painting without the unifying power of light?

Critical Concern

About 1900, many progressive artists deliberately gave up the long-standing and powerfully unifying agent of light, while remaining essentially representational in their painting. This possibility was quickly picked up by watercolorists. John Marin (figure 76) was among the first of them, but Maurice Prendergast often eschewed the effects of light in works executed before World War I, and Karl Schmidt-Rottluff's *Landscape* (color plate 11) is an early example. Later, Arthur Dove and Charles E. Burchfield continued to explore the possibilities of this kind of non-naturalistic representation. A large group of watercolorists today work primarily in non-illuministic styles. You may be among them, or you may want to experiment in the mode. If so, this chapter will discuss some things you should consider.

The chief reason for eliminating or in some way modifying light effect is that you wish to emphasize something else. The expressive concern you are pursuing may range from a sense of the dynamic forces of nature, as is often the case with Marin, to the almost cubistic excitement of city activity, as in Dong Kingman's *New York City at Daybreak* (figure 77).

Despite what you seek to gain by giving up light effect, you are losing a formidable tool for creating pictorial coherence. You must therefore raise your other means to a new significance (many artists enjoy this challenge for itself) to achieve integrity and unity in your pictures. These other means include surface, spatial, and color elements. They also include many representational elements; but with little or no light effect, these must often be used differently. Gene Matthews's *Hill* (figure 75) is an example.

Illustrations

John Marin's *Landscape with Trees and Rain* (figure 76) offers a good starting point for this discussion because it is a picture done on the kind of day when considerations of light are minimal. If you normally take light into consideration, this should help you remember that you have already faced some of the problems addressed by this chapter many times.

How, in fact, does Marin's picture differ from a "normal" treatment of rainy weather? First, value (and color) relationships between foreground and background do not allude exclusively to atmospheric perspective. Distance is suggested chiefly by the size of the islands and their horizontal bottoms (which tell the viewer that they are very near the high horizon). Second, representational accuracy is played down in favor of general shapes. Finally, you notice a number of arbitrary marks in the picture that seem to have little to do with actual appearance.

Rather than concentrating on the look of nature, Marin has suggested something of the feel of spring rain. The wet flow of softly neutral blues, greens, and grays over all the surface speaks directly of our experience of rain. The same experience is then stated symbolically by the almost calligraphic rain lines at upper left and center. These form an important visual focus, as they contrast with the rest of the picture surface. But other, similar signifying (rather than descriptive) lines prevent this contrast from disrupting the total visual statement. For example, the casual, almost clumsy quality of the lines found in the spruce trees and in the foliage marks in the right foreground helps us appreciate the lines as similar to the "accidental" (natural) flow of the wet-in-wet brush marks. The picture holds together; it is a small, delicate recording of coolness, moistness, and the felt power of earth's fecundity under the fertile rain.

This deliberate linking of courted accidents and symbolic

Figure 77
New York City at Daybreak by Dong
Kingman, 1969, 22″ x 30″ (56 x 76
cm), rough paper, private collection.
Kingman uses light abstractly, em-
phasizing the excitement of the value
contrasts it creates rather than its
modeling capacity. Spatial effect is
minimized in favor of an all-over pat-
tern of approximately equal visual
interest that is underscored by the
spotting of intense colors. Surface co-
herence depends also upon similarity
of rectangular shapes that recur in a
broad sequence of sizes. The picture
expresses in direct visual terms a
sense of urban early-morning bustle.

lines or shapes is a hazardous
game to play in terms of pictorial
coherence, and even Marin did
not always bring it off success-
fully. But it is fun!

A quite different approach is
taken by Dong Kingman. *New
York City at Daybreak* (figure 77)
includes strong shadow areas,
some that model forms and oth-
ers that break it up. Value con-
trasts are very strong, and so is
color intensity. Space, however, is
again of relatively little concern:
the surface pattern sets up a field
of stimulating visual excitement
that communicates directly to the
viewer a sense of the city waking
to traffic noise and activity. King-
man uses not light but the sharp
value contrasts it creates to fash-
ion a shifting, sparkling surface
full of agitation. Like Marin, he
does not describe appearances so
much as directly provide an ap-
propriate visual experience that
he specifies with symbolic tags—

boats, bridges, skyscrapers, the
Statue of Liberty.

For the many artists who work
in a non-illuministic manner, the
lack of unification by light seems
to pose no problems. This is be-
cause they use other means to
underscore their expression and
to create pictorial coherence.
Look at Richard Yarde's *Parade
II* (figure 78). The picture is
"about" a group of people, pre-
sumably only a segment of a
longer line, who move erratically
along a pathway. We do not
know whether it is a street or
where the line is. The people are
forever frozen in their slow, but
somehow purposeful, progress, as
though a news film had been
stopped. Yet there is a sense of
inevitability about their onward
shuffle.

How does the artist do it? First,
he creates a compellingly inte-
grated world. Regarding the
surface elements, notice that this

is a wash painting; the smallest paint areas, although they have some stroke qualities, are treated as washes. And the washes never get very large: the pavement is handled as several separate washes. Overlapped edges are created deliberately so that the viewer can never quite forget the surface or the paint. The sense of gently controlled, loose paint pervades the paper. Its coherence is very strong.

Yarde uses the spatial elements ingeniously. He plays the "picture" shape against the horizontal rectangle of the paper so that the marchers turn gradually downhill, while the slope hovers between an increasing curve and a diagonal. This ambiguity marks the picture as a whole—it is its visual, representational, and expressive theme.

Most of the color patches are similar in size, and many share a resemblance in shape as well, recalling the logical order of mo-

saic. Verticals and horizontals alter their position in easily appreciated sequences. But contrasts of interval, especially between the figures, clarify and describe the informality of the procession.

It is in the freedom of color organization that we most clearly see the direct result of liberation from unity of light, as is the case in Prendergast's *Band Concert* (color plate 4). The color areas vary between fairly neutral and very intense, jewellike, transparent passages. They are not wholly "naturalistic" either. By abandoning the effect of natural light, Yarde, too, is free to treat the colors of objects with a good deal of latitude. In figure 78, you can see that this freedom dramatically affects value. Check only one example, the woman just to the left of center: although some darker tones in her skirt help reduce her contrast with the deep darks around it, the upper part

of her body—almost completely unmodeled—presents a sharp, central, visually exciting focus that helps balance the lights at right.

Before leaving this painting, notice how sensitively Yarde selects characteristic shapes in both darks and lights to tell the viewer succinctly about the varieties of human form represented in this parade. Also observe how he balances narrow dark-against-light shapes at the right border with light-against-dark ones at the left. The amount of contrast is similar enough to achieve visual balance, but the different terms of the contrast prevent monotony.

Autumn Bluff (figure 79) by Daniel Peterson, also a non-illuministic picture, illustrates a very different expressive aim. Once again we note ambiguous space and a fragmented light effect, but here the artist seems to "reconstitute" space and light to emphasize the energy they in-

Figure 78
Parade II by Richard Yarde, c. 1976, 16″ x 28″ (41 x 71 cm), rough paper, courtesy of the artist. Like Kingman, Yarde employs light arbitrarily and abstractly; like Prendergast (color plate 4), he breaks up the surface in patches of wash that have somewhat the force of strokes. Space and atmosphere are not as important as color and shape relationships on the picture surface. Ambiguities of value and color set a theme that places the scene in a mysteriously present past.

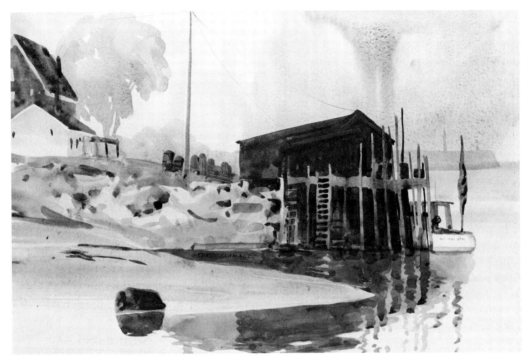

Figure 80

Government Wharf by Carl Schmalz, 1972, 15½″ x 22″ (39 x 56 cm), 140 lb. hot pressed paper, collection of the author. This and figure 81 show how the same subject can generate very different paintings. This red bait shack on its pier is the "Motive No. 1" of my summer classes: I have painted it about twenty times by now, and each picture is different. Here the day is foggy, the tide is low, and colors are very low in intensity. I flooded on opaque mixtures to increase the surface interest caused by the sediment and the granulation of pigment.

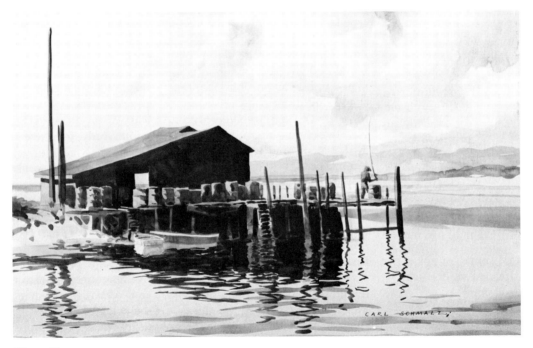

Figure 81

Fisherman's Morning by Carl Schmalz, 1975, 15½″ x 22½″ (39 x 57 cm), 140 lb. hot pressed paper, collection of the author. As in figure 80, this is also a demonstration painting, but done on a very different day. Bright sun and nearly full tide are external factors that differentiate this picture from the former one. But there are many internal differences, too. The design here is horizontal with vertical accents rather than about evenly balanced horizontal and vertical axes. I used many more transparent colors to achieve the high intensities I wanted. Surface interest is in brushstrokes instead of granulation. Although the basic subject is the same, this picture is "about" a man out early for fishing while the earlier one is "about" mood.

Subject Selection

Are you trapped by custom or are you selecting subjects freely and deliberately?

Critical Concern

From the most insignificant idea to the greatest, and from the first glimmer of the idea to the final framing of a picture, there is no choice in painting that is not an intensely personal one. Among your first important choices is selection of a subject.

As pointed out before, the picture you paint is a separate and self-defining world. It is your creation, and you are responsible for its order, its wholeness, and its meaning. Clearly, the more aspects of your picture over which you exercise conscious choice the better job you will do. No aspect is more fundamental than the initial choice of subject. The freer you can be about this basic decision, the better.

There is a remarkable number of subject constraints on contemporary watercolorists; you may not be fully aware of many of these. As with all other aspects of painting, some constraints are external and, to a greater or lesser degree, beyond individual control. Some are internal, and most of these *are* subject to your personal decision.

Illustrations

Probably the first and one of the most insidious subject constraints facing you is the weight of tradition in representational transparent watercolor. All of you have been to many watercolor shows and have felt there the dreary redundancy of subject matter. Frequently as many as 90 percent of the subjects shown are predictable. There are small shifts, to be sure. New England barns are currently seen less than they were in the 1950s; but fishing boats and shacks remain highly favored, and abandoned farm machinery has recently been very popular.

This extreme conservatism in subject derives from at least two sources. The first is watercolor's history as a medium over the last two hundred years, and the second is public expectation based on that history.

Watercolor first began as a commonly used sketch medium (just as Dürer employed it around 1500) during the early nineteenth century. It was a quick way of making color notes and was largely employed for landscapes. Turner, Constable, and other European artists worked in the ambience of Romanticism, which tended to infuse nature with human sentiments. In the work of the later English watercolorists, traces of this Romanticism lingered on. It

was, in fact, never completely overcome, even during the last third of the century, when Impressionism exerted its influence on watercolor painting.

Although Winslow Homer was never truly an Impressionist, his work does reflect the intense concern with light effect that lay at its heart. John Singer Sargent's later watercolors are very close to Impressionism, both in subject choice and handling. And many other Americans, including Hassam and Macknight, worked in the Impressionist mode.

The twin heritage of Romanticism and Impressionism remains with us, influencing profoundly the subjects of transparent watercolor. The force of tradition is seen in subjects that are overwhelmingly landscape, often with expressive overtones derived from Romantic preferences, such as nostalgia (broken-down evidences of earlier habitation) or anthropomorphism (the persevering tree deformed by wind). It is seen also in the dominant concern of watercolorists for emphasis on the total effect of illumination.

The American watercolor-loving public has become deeply attached to these subject choices and treatments. National exhibitions have, on the whole, tended to reinforce them, and private galleries, out of economic necessity, have largely catered to this

Figure 82
Studio Door by Paul C. Burns,
A.W.S., 1971, 22″ x 30″ (56 x 76 cm),
300 lb. rough paper, collection of the
artist. Every home has interesting
corners, and all possess doors. Such
subjects are not inexhaustible, but
they certainly bear investigation.
Burns here put together a dramatic
composition that speaks explicitly of
the painter's world—books and refer-
ences, other paintings, an antique
chair, and the open door to the
world beyond the work place. The
importance of what is outside is seen
in the light reflections it brings into
the studio.

taste. There is not very much the
individual painter can do to alter
so ingrained and complex a situa-
tion.

Of course, there is nothing
inherently wrong with such sub-
jects. I usually paint them, and
probably so do most of you. Per-
haps if we had an irresistible
desire to engage different sorts
of artistic problems, we would
not be painting in watercolor at
all! Even so, this tradition tends
to limit our choices, often more
than we like.

The question is: why do you
paint what you paint? And one
answer may be that it is what
dealers and purchasers demand.
Well, we've seen why it may be
so, but we don't have to knuckle
under, do we?

There are constraints on you
other than tradition. Unless you
are content to depend on photo-
graphs, you cannot paint Brazil
unless you go there. Availability

of subjects is, therefore, a serious
constraint for most watercolorists.
We also tend to return again and
again to subjects with which we
are familiar, a practice that is
fine, if deliberate (see figures 80
and 81); and we are often influ-
enced by the subject selection of
our painter friends or by what we
see by other artists in exhibitions,
magazines, and homes.

If travel and acquaintance with
the work of other artists inspire
us to try new subjects, this sort of
example is a good thing. If it
provides a smoke screen behind
which we hide a refusal to come
actively to grips with our own
subject preferences, however, it
may be deleterious.

How many of you know an art-
ist who is a whiz at and "loves"
painting flowers, but who actually
paints flowers chiefly because of
lack of confidence with perspec-
tive? Real or imagined inability to
draw well is an all-too-frequent

subject selector for many artists. Do you never put figures in your landscapes because you like the "feel" of barrenness that a lack of them creates? Or don't you draw figures very well? Do you avoid intense color subjects because you seek the modesty and calm of low intensities? Or do you fear the power and potential for disharmony inherent in full intensities?

Obviously each of you enjoys painting particular subjects; but is this a result of conscious choice? Throughout this book, the aim is to control as many decisions in painting as possible, and subject selection is among the most important.

Exercises

If you have not already been tempted to glance at your picture collection, get it out now and spread it around so you can see all your paintings easily.

1. Begin by dividing your work into broad subject categories. For example, have you only landscapes, or are there still lifes, portraits, figures, and interiors among your subjects? You can then subdivide each category in which more than one picture fits. Because you probably have quite a few landscapes, let's use that category as an example. You might divide your landscapes into categories such as rural and urban, those with and without buildings, and those with or without water. And you could further divide them according to focus—that is, a distant or close-up view of subject (see Chapter 18).

This kind of analysis organizes your sense of what subjects in general are interesting to you and gives you an opportunity to reflect on the degree to which your conscious choice has been operating in subject selection. It may also encourage you to consider trying some different subjects or different approaches to familiar themes.

2. How about attempting an interior? Look at figure 82, Paul C.

Figure 83
Seams, OK by Lucile Geiser, A.W.S., 1965, 30″ x 22″ (76 x 56 cm), 165 lb. rough paper, courtesy, A.P.S.F.A. Alliance. This straightforward wet-in-wet painting, enjoyable in itself, suggests innumerable possible subject variations. The many kinds of household tools and appliances, old and new, carry varied associations that artists can explore. Look around you at the potentials of washing machines and driers, mixers, vacuum cleaners. New stoves may not be as quaint as old ones, but they can provide as good a painting subject.

Figure 84
The Tender by Osral B. Allred, 1967, 15½″ x 21¼″ (39 x 54 cm), rough paper, collection of the Springfield Art Museum, Springfield, Missouri. This unusual close-up makes a striking image. Itself a variation on the old machinery theme, it provokes thoughts of still other subjects, such as the granite footings and beams of barns. But newer things also come to mind—the business end of a cement truck, bridge under-pinnings, and a trailer truck rig.

Burns's *Studio Door.* This is a subject available to any of you—and one open to virtually endless variations. Or look at Lucile Geiser's *Seams, OK* (figure 83), a charming picture that may be taken as a type of "domestic" still life. Consider such possibilities around *your* house. Think what might be done with sinks, supper clutter, unmade beds, the paint shelf, corners of garages, vegetable gardens, gardening tools, cellars, and attics.

3. A popular subject for at least a decade has been sign-covered façades or building walls, often embellished with fire escapes, street junk, or old machinery. How about looking even closer at such subjects? Could anything be done with peeling plaster itself?

How about pavements, with or without gutter detritus? Where are the paintings of dumps, car graveyards, freeways, and billboards—all ubiquitous evidence of civilization's impact on the earth, and all loaded with pictorial potential.

4. If you are put off by seaminess, think about closeups, what I call "outdoor still lifes." Charles Colombo's *R.F.D.* (figure 22) is an example. Or look at Osral B. Allred's *The Tender* (figure 84), a powerful image suggesting a recognizable Franz Kline. William Preston's *Wind-Blown Iris* (color plate 18) and my *Maine Still Life* (color plate 7) are further examples of this type. Adaline Hnat's *The Flock* (figure 85) is another unusual and successful variation.

The purpose of these questions is to help you decide whether or not you are in an involuntary subject rut and, if so, to suggest ways of shocking yourself out of it. If your subjects tend to be rather similar, however, that is not necessarily disastrous. In the final analysis, you can only paint well those subjects that interest you, that prompt a personal responsive resonance in your mind and spirit. You may have, even subconsciously, selected a class of subjects that appeals to you and have learned to treat them in ways that satisfy you. But if you have the slightest yen to try something new and different, indulge that appetite; it can only lead to your further growth.

Summary

The subject of a representational painting is the sum of recognizable elements that specify the meaning of the materials that make up the picture—the brush marks, colors, shapes, lines, and values. The subject is also usually the source of the artist's first germ of an idea about the making of the picture, so it is the beginning and the end. Its importance is central.

For watercolorists, subject selection has been circumscribed by tradition, and although the tradition has probably exerted considerable influence on which artists become watercolorists, it is still possible, and probably desirable, to extend the range of watercolor subjects. Certainly the individual artist can benefit by increasing his or her breadth of subject, if only to enlarge drawing capacity and technical skills. Even more important, pushing out toward new subjects widens and deepens one's imaginative power and nourishes sensitive perception.

The main reason for seeking subject variation, however, is to increase control and mastery of

Figure 85
The Flock by Adaline Hnat, 1976, 14″ x 20″ (36 x 51 cm), 140 lb. rough paper, collection of the artist. Hnat's evocation of bird flight is almost Oriental in subject and treatment. The economy of handling and the almost "unfinished" look of the birds help to express the birds' motion. Most of the characteristic subjects of Chinese and Japanese painters have also been explored by Western artists, but insects are little used by us and bear investigation. From attractive moths and butterflies to less immediately appealing creatures such as hornets and spiders, insects offer a wide range of barely explored subjects.

your art, to give yourself the greatest possible amount of freedom to paint and say what *you* want. Your scrutiny of your own work shows you pretty clearly whether or not you are presently free to range as widely as you'd like over the gamut of subjects available to all alert painters.

Should you conclude that you would like to acquire greater range, look again at your picture collection. Try to figure out what is inhibiting you. If it is a reluctance to draw buildings, go get a book on perspective from the library and practice, or take a course—but learn. You can overcome any limitation of mere technique. The same thing applies if you are uncomfortable drawing "pure" landscape. Practice trees and foliage, look for the structure of the land, notice how

it is modeled. Sketch at every opportunity. Figures and faces will yield to a similar, vigorous attack.

Take the bull by the horns. There is only one way to learn new ways; that is to try them again and again. Put out some new colors and give a really bright painting a try. Take a weekend trip—not necessarily very far away, but somewhere you've not painted before. If you are a non-driver, or otherwise housebound, look around you yet once again. There must be views and corners out of which you could squeeze a different picture. In short, adopt an actively seeking attitude, look everywhere for subjects, draw as much as possible, and put down every picture idea that crosses your vision. Never turn off the painter's eyes you own.

Figure 86 (above)
Robinhood Cove by William Zorach, c. 1950, 14″ x 21″ (36 x 53 cm) (sight), courtesy, Mr. and Mrs. Tessim Zorach. In this panoramic view, Zorach tends to look *down* and *in*, but the water surface takes one easily past the fish weirs to the distant horizon. The junction of earth and sky is the real focus of the painting, just as its subject is a sense of the largeness of creation.

Figure 87 (right)
The Latch by Larry Webster, 21″ x 30″ (53 x 76 cm), collection of the artist. Webster exploits the foreground focus to emphasize both painterly and descriptive texture. Notice that he combines them, using a sequence from periphery to center that parallels the increase of descriptive texture toward the center.

Focal Distance and Space

Are you capitalizing on your options for different focal distances and spatial constructions?

Critical Concern

Selecting a subject is, of course, only a beginning. Your response to that subject demands a great many decisions as you translate your sense of it into the visual order that makes your expression appreciable to viewers. Here our primary concern is your overall organization of pictorial (or illusory) space.

There are three primary ways of focusing a picture: in the foreground, in the middleground, and in the distance. Not only most watercolorists, but also most representational landscapists have traditionally focused their subjects in the middleground because this allows the artist to balance or contrast the foreground against the subject, which may also be set off by the distance behind or beyond it. This is an excellent way of expressing a great many human concerns, but it does not exhaust the variations.

The second most used focal point is the foreground. This can be an emphasized, even an exclusive, focus. It allows the near and the little to become large. Lucile Geiser's *Seams, OK* (figure 83) is a

case in point. The old sewing machine, with its archaic complexities and its continued utility, becomes a metaphor for the wealth of human knowledge and social evolution. It is a good subject, well handled as a close-up.

The least-used, and least-understood, focal distance is the distant one. Its difficulty lies in the fact that it makes the foreground an introduction, as it were, to nothing. Yet the distant focus offers some really splendid subject treatments. Look at William Zorach's *Robinhood Cove* (figure 86), for instance. The peremptory treatment of the foreground and the casual indications of the fish weirs in the middleground indicate that Zorach was interested in the whole panorama. This is tantamount to saying to the viewer, "None of this is important except the sense you have of the whole." The whole, of course, is the edge of the world—the distant land masses juxtaposed against the sky. The distant focus presents expressive worlds infrequently explored by recent watercolorists.

There are other sorts of spatial organization and structure that you also need to be aware of. For example, do you like to look *up, at, out at,* and *around* your subject? Or do you like to look *down at* and *into* it? If your focus is in the middleground or distance, do you prefer to give the foreground approximately equal interest, or to vault the viewer's

eye over it?

No matter what your preferences, the spatial organization of your picture must be consistent in itself and congruent with surface design and expression if your painting is to attain the complete coherence that makes it an unassailable "world" of its (and *your*) own.

Illustrations

Some of the advantages of a foreground focus can be seen in Larry Webster's *The Latch* (figure 87). Most obviously, this focus allows you to concentrate on represented, or descriptive, textures. Look back at Charles Colombo's *R.F.D.* (figure 22), for example, and at Glenn MacNutt's *Cobbler's Cove* (figure 57); in these paintings, too, descriptive texture forms the basis of the pictorial concern. Not only texture but precision in drawing—especially of small or intricate parts of a subject—is also possible with the foreground focus. Nuances of color can support these details and surfaces (see color plates 3 and 22). In addition, many, though by no means all, foreground-focus paintings tend to be fairly easy to design. Because they frequently include little depth, their surface organization is often uncomplicated by considerations of orderly arrangement in the illusory third dimension.

Middleground focus usually includes deep space, presenting you with the classic foreground

Figure 88 (right)
Lighthouse and Buildings, Portland Head by Edward Hopper, courtesy, Museum of Fine Arts, Boston. Bequest of John T. Spaulding. The effect of space isolation in this picture derives in part not only from Hopper's placing the buildings in the middleground (which pushes them back from the viewer) against a barren distance, but also from his separating them from the paper's edges.

Figure 89 (below)
Broadway, Newburgh, N.Y. by Childe Hassam, 1916, 15½″ x 21½″ (39 x 54 cm), rough paper, courtesy, Colby College Art Museum. One of the true American Impressionists, Hassam was among the few who worked much in watercolor. He developed a technique of extreme freshness and lucidity, seen here in a top-lit scene. The middleground focus—tree, windows and flags—is embraced and characterized by strong verticals and horizontals.

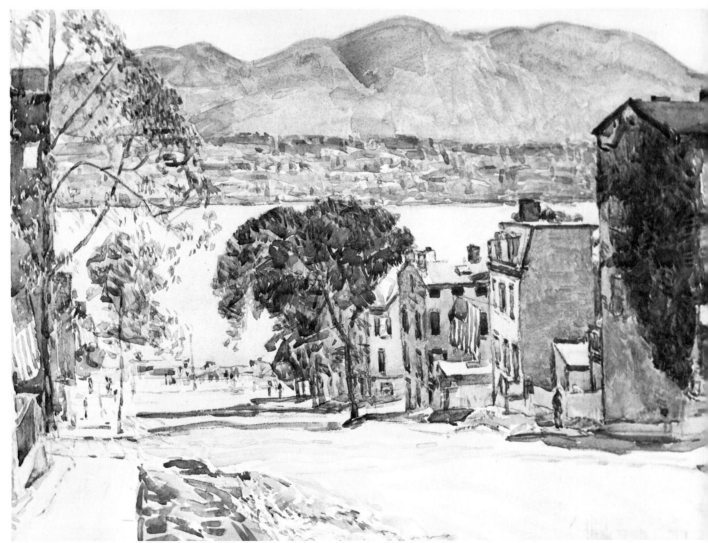

problem as well as more options and risks in surface organization. Edward Hopper's *Lighthouse and Buildings, Portland Head* (figure 88) is a simple solution. He treats the foreground grass as paint texture, which introduces the viewer to the more complicated strokes and textures of the middle distance (where, of course, he places the center of interest). The sea and sky are a pictorial *diminuendo* both as illusory distance and as paint.

In *Beinn Tangaval, Barra* (color plate 23), I have done a similar thing. A few zigzags take the viewer through the foreground to the dunes, modeled and colored by the afternoon light. The mountain is a coda in the distance, modeled by delicate hue and value changes. As for surface design, it is the simplest: the dunes and cows are the subject. They are near the center, and they place in perspective the otherwise unscaled foreground beach and more distant mountain.

A different example of middleground focus is Childe Hassam's *Broadway, Newburgh, N.Y.* (figure 89). Even in black and white, it takes but a moment to realize that the focus here is on the dark tree, windows, and flag at the center. The rest of the painting merely enfolds and qualifies this center, and—most important—guides us there. Observe how difficult it is for the viewer to get out. Strong verticals at left and dark ones at right, strong horizontals above that stop the perspective of the street, and the powerful brush activity at center all contain a middleground that gives us its whole environment in terms of Hassam's brush and color.

Note that the "foreground problem" has been taken care of by a dark at left that describes perspective. The same thing happened in color plate 23, and Henry Keller employed essentially the same solution in *Torment, Puerto Rico* (figure 90),

Figure 90

Torment, Puerto Rico by Henry G. Keller, 1926, rough paper, collection of Mr. William M. Milliken. Keller, a near contemporary of Marin, worked in a modified Expressionist mode. His color is relatively intense, his designs bold, simple, but subtle. Notice how the dark foliage that enters this composition at lower left exhibits a sequence of more and more agitation at its upper contour as it moves into the picture. By this device Keller prevents the viewer's eye from straying out the corner.

Figure 91

Corner Shadows by Murray Wentworth 20″ x 30″ (51 x 76 cm), smooth paper, collection of the artist. Well used, the vignette is simply a kind of sequence: it is a gradation from less to more representation from the edges of the picture to the focal center. Wentworth uses it deftly here, so that foreground detail is actually found mainly deep into the picture space. The foreground—treated in the same sequence as the rest of the painting—is largely paint texture. Photo by Fasch Studio.

Figure 92 (above)
Garden Market by Ruth P. Hess, 15″ x 22″ (38 x 56 cm), 140 lb. rough paper, courtesy, Mr. and Mrs. Ralph Benz. Hess unifies her picture by treating the entire surface with approximately the same degree of representational detail. As a result, her foreground is as broadly handled as the rest of the painting—areas of bright color specified by occasional calligraphic lines. Picture space is also indicated chiefly by color and value.

Figure 93 (right)
Wall Pattern, Venice by Phoebe Flory, 22″ x 12″ (56 x 30 cm), 140 lb. hot pressed paper, collection of Mr. and Mrs. Donald Rorabacher. This fine example of the head-on view of a wall or other flat surface illustrates how such a spatial organization permits a design that is based largely on subtle placement of objects of importance—in this case, the windows. The subject and treatment also emphasize both paint surface textures and descriptive textures. Flory rubbed and drew on waxed paper laid over the surface to produce the resist textures on the wall and in the grillwork.

where the focus is more distant, but still middleground. Slightly right of center is the storm, which strikes the part of the hills most set off by value contrasts. We are led into the picture by the amorphous vegetation at lower right, with its strong value contrasts and personal brushwork. The episode is concluded with a rousing finale in the distant mountains and clouds at upper left.

The foreground problem is best met (until you have other ideas) by keeping the treatment of brushstroke or wash compatible with the rest of your surface. You can be detailed or vague, but your first obligation is to the *painted* integrity of your picture. This may allow a kind of vignetting, which is very successful in Murray Wentworth's *Corner Shadows* (figure 91); or it may call for descriptive detail to about the same degree that other parts of the picture are described, as in *Garden Market* (figure 92).

There are two basic ways of handling a distant focus painting—low horizon or high horizon. Since your center of interest is far away, you are usually obliged to produce a panoramic view. This means that you want either an interesting sky or a foreground and middleground that amplify and qualify your main focus without stealing the show from it.

Color plate 21, Eliot O'Hara's *Sunset between Santa Fe and Taos*, illustrates the first solution. Here the sky is the qualifying element that dictates the entire color scheme of the painting. It is representationally dramatic and the paint handling is equally interesting. My *Meditation, Warwick Long Bay* (color plate 24) sets the horizon closer to the middle of the picture, but still includes a good deal of sky. A bit of cloud at left and some purposefully left brushstrokes at right help keep the area interesting; the foreground is articulated by footprints and seaweed; the middleground is marked by the seated figure.

Salt Marsh, June (color plate 12) exemplifies the alternative option. In this case it is the lower, or earth, section of the picture that had to be interesting without challenging the focus on the distant buildings and tree lines. I used color intensity, color contrast, and highly visible brushstrokes, but tried to avoid much specific descriptive detail.

One variety of spatial organization that has been much favored by watercolorists in recent years is the flat, head-on view of the wall of a building or other wall-like subjects. An excellent example of this is Phoebe Flory's *Wall Pattern, Venice* (figure 93). Mary Blackey's *Morning and Snow* (figure 94) illustrates a way of ordering trees in this manner. Characteristic of this arrangement is a very shallow picture space. The "wall" can range from immediately behind the picture

plane to several "yards" into pictorial depth, as in Everett Raymond Kinstler's *Morning–19th St.* (figure 95). This is a powerful and effective means of ordering space precisely because it establishes a right-angle relationship between the viewer's line of vision into illusory space and the surfaces of both the picture and the wall in the picture. This same right-angle theme can then be amplified on the two-dimensional surface of the wall where the shapes of doors and windows echo the shape of the picture itself. Two- and three-dimensional spaces are linked through the right-angle repetitions.

Pictures organized this way almost always have a foreground focus, but this is not invariable. For example, *Empty Barn* by Charles H. Wallis (figure 96) plays an interesting foreground plane against a central middleground, and both act as a contrasting foil for the real center of interest, the infinite sky. The theme of the picture—emptiness—is persuasively stated by the window that contains nothing.

The view from above can create a similar spatial organization because, although it produces a ground plane tilted into the picture from foreground to background, one can often include little or no sky, so the ground plane becomes the subject. If the view is seen head on, horizontal and vertical axes frequently order the surface, as in Sidney Goodman's *Towards the Perrys'* (figure 97) and my *Enclosed Garden* (color plate 22). Seen at an angle, such views produce a network of diagonals on the surface. This is the basis of spatial organization in William Preston's *August Wild Flowers* (figure 98) and Eliot O'Hara's *Gargoyles over the Seine* (figure 99). Notice that whereas Preston's picture has a foreground focus, O'Hara's focuses on the middleground.

Architecture seen from below

Figure 94
Morning and Snow by Mary Blackey, c. 1969, 22″ x 30″ (56 x 76 cm), rough paper. Blackey adapts the head-on spatial design to a forest. The space is ambiguous, providing the viewer with a pleasing sense of fluctuating depth that *feels* the way gently swaying trees look.

frequently yields dramatic diagonals on the picture surface, as in Edward Hopper's *Universalist Church, Gloucester* (figure 100); that view can be used to monumentalize almost any subject.

Larry Webster's *Dock Square Florist* (figure 101) illustrates another sort of spatial organization, the simple center placement of a main feature with more distant things falling away at the sides. This greatly reinforces center-focused design by adding spatial emphasis to it. A similar strengthening occurs with the opposite treatment of space, in which spatial depth is greatest near the center of the painting. *Charlie's Lane* by Al Brouillette (figure 102) is a good example of this.

Exercises

To start, line up all your selected paintings so you can examine

Figure 95 (top)
Morning—19th St. by Everett Raymond Kinstler, 15″ x 28″ (38 x 71 cm), rough watercolor board, collection of the artist. Here the wall is placed well back in the picture space, but the basic spatial organization is the same as that in the previous two figures. This painting is distinguished by unusually rich paint textures and very subtle variations of rectangular shapes.

Figure 96 (above)
Empty Barn by Charles H. Wallis, c. 1973, 26″ x 32″ (66 x 81 cm), rough paper, courtesy, Springfield Art Museum, Springfield, Missouri. Wallis varies the head-on wall type of spatial organization by allowing it to be penetrated by a hole within a hole. The picture is basically a wash painting, enlivened by paint textures and descriptive textures.

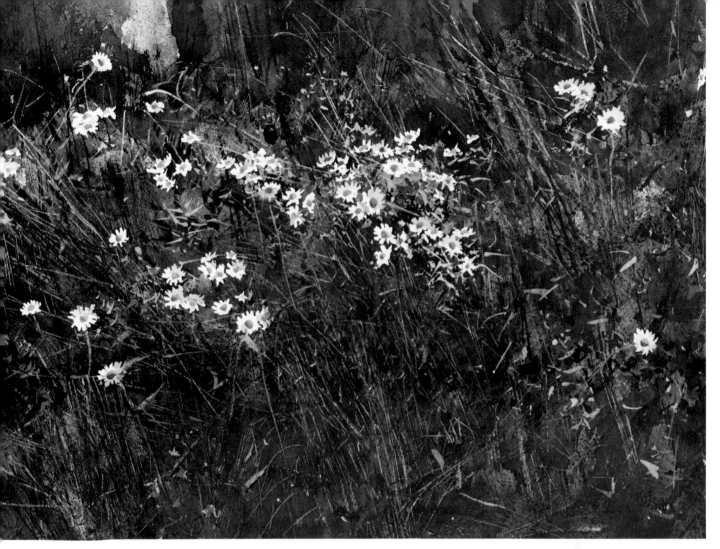

Figure 97 (left)
Towards the Perrys' by Sidney Goodman, 1974, 10″ x 13½″ (25 x 34 cm), rough paper, courtesy, Terry Dintenfass, Inc. This picture shows how a head-on view from above can yield spatial ordering based on horizontals and vertical accents. This is basically a stroke painting. The center focus on the house is augmented by very delicate balances between the clump of trees at right, the utility poles, and the foliage masses. Photo by Robert E. Mates and Paul Katz.

Figure 98 (above)
August Wild Flowers by William Preston, 1967, 21″ x 28″ (53 x 71 cm), rough paper, courtesy, Shore Gallery, Boston. A close-up from above, this picture is viewed from a slight angle. The board wall or fence at the upper margin forms a diagonal that is countered by the general direction of the grasses. Implied diagonals in the axes of the flower masses produce complementary major and minor crosses on the surface. Photo by George M. Cushing.

Figure 104
West Point by Carl Schmalz, 10½″ x 22″ (27 x 56 cm), hot pressed paper, collection of the author. Here the long, narrow, horizontal format enhances the dominant horizontals of the composition, making sequential changes of shape and position of subjects more visible by contrast. The lobster traps at left move into space at alternating angles, and the gable triangles, thematically stated by the shack at left, progress from center to right.

Figure 105
Landscape by Samuel Kamen, 6″ x 8″ (15 x 20 cm), rough paper, collection of the artist. Kamen's little black-and-white painting carries a lot of punch for its size, partly because of his knowing use of value contrast and partly because of the surface integration provided by textures of paper, paint, and manipulated surfaces. In spite of its smallness, it is a picture that would demand considerable space on a wall.

of architectural height. Here the size and shape of the paper have been determined as much by the subject as by any anticipated purpose to be served by the picture. This is true also of my *West Point* (figure 104), where the long and repeated horizontals are echoed by the shape of the paper itself.

We have seen how powerful small pictures can be in works such as Samuel Kamen's *Landscape* (figure 105). Helen Schepens-Kraus also paints pictures in various sizes, recognizing the broad range of uses to which they may be put. Her small landscape studies are economically handled, with great delicacy of color to reward intimate viewing, and she treats flowers, fruits, and vegetables with equal subtlety (figure 106). Very large watercolors can also, of course, create enormous impact; witness Larry Webster's *Interior* (figure 107).

As a transparent watercolorist, however, you know that a large painting is not just a medium-sized one blown up. Several factors contribute to the difficulty of large watercolors. A basic one is finding paper in dimensions greater than Imperial (22″ x 30″/56 x 76 cm). Few art suppliers stock Double Elephant (26½″ x 40″/67 x 102 cm) or Antiquarian (31″ x 53″/79 x 135 cm), the two traditional sizes larger than Imperial. Hence, many artists such as Webster have used illustration board as a surface. This is easily obtained in a 30″ x 40″ (76 x 102 cm) size and can be purchased in 40″ x 60″ (102 x 152 cm) size. With a good quality rag surface, it offers a sound support. Finally, one can always do as Charles Burchfield did and piece together watercolor paper glued on a fiberboard base to make any specific shape and size.

The primary problem with a large picture, however, is the technical one of getting enough paint onto extensive surfaces in one drying time. This requires a larger palette than normal, big-

Figure 106
Squash and Onion, Helen Schepens-Kraus, 1977, 5½″ x 4¾″ (12 x 12 cm), 90 lb. rough paper, collection of Charles L. Cohen. Small size does not automatically mean triviality or even intimacy of expression, any more than large size automatically confers importance and seriousness of purpose. Schepens-Kraus has a refined sense of the relationship between the size and the function of a painting, and she beautifully anticipates the uses to which her works may be put by adjusting the scope of her subject and the subtlety of treatment to the dimensions of each work. Here, for example, she focuses on the delicacy of color and form in a painting to be viewed up close.

ger squeezes of paint, and brushes larger than you could afford, if they were made. When painting, you often wish your arms were longer, too! Stroke painters will, in general, have fewer difficulties of this sort than those whose method is based on washes. In either case, the secret is to plan your picture thoroughly, proceed deliberately, and paint area by area as much as possible. If you have trouble, remember that a successful large watercolor is a real tour-de-force, and keep trying.

The purpose of a large painting in our current market situation is normally as an exhibition piece. Nevertheless, such works can fit into homes, and because of their size, they can also

serve in public spaces such as lobbies, board rooms, and auditoriums. Their size also suggests that their subjects be of somewhat greater substance than is suitable for paintings of modest scale. In fact, the size of a painting usually says something immediate and compelling about the significance of its expression or message, so that the smaller a picture, the more casual its subject can afford to be. Hence a large painting with a trivial subject comes across as bombast.

Exercises
Now, let's look at your pictures. Get them all out and consider them from the point of view of size and shape.

The chances are good that most of them are pretty much the same in size and shape; most are horizontal, with a few verticals. If this is not the case, and there is a good deal of variety, ask yourself why. Have you altered the shape and size of some by judicious surgery? Have you been parsimonious with your paper, or are you given to employing scraps as best you can? There is nothing wrong with any of these practices, of course. But the variety they produce is almost accidental: it is not the result of planned, thought-out congruence between the subject of the painting and an intended purpose other than exhibition. Important though exhibition is, it can be thought of as an incidental function of a painting. Pictures made for other purposes can, after all, be excellent candidates for exhibition. Indeed, in most cases they should be. Exhibition alone is a rather slender reason for painting, despite the realities of our time. Some serious thought about the way a picture of a given subject might be used by a purchaser can lead to greater coherence between the finished work and its ultimate purpose.

Ideally, of course, this sort of coherence is attained by painting

Figure 107
Interior by Larry Webster, 1969, 40″ x 30″ (102 x 76 cm), smooth surface illustration board, collection of Mr. and Mrs. Ronald Musil. Here again is a painting handsomely adapted to its format in both shape and size. The large surface with its dark, forbidding border encourages the viewer to look into the illuminated space of the room beyond. The interior is linked to the outside through the open window. The sequence is a continually renewed achievement of liberation, a subject big enough for the picture's dimensions.

on commission. You might consider this possibility. Portraits have continued to be painted on commission—the only major art form today done so on a regular basis. But there is a largely untapped market for "portraits" of homes or the views from homes, and there is no reason why you cannot paint certain *kinds* of subjects, if not specific scenes, on a commission basis. We have, perhaps, been less imaginative than we might be regarding such possibilities.

If your paintings are nearly all the same size and shape, ask yourself whether this results from unexamined assumptions, the pragmatic reasons discussed earlier in the chapter, or a deliberate artistic decision on your part.

It is quite possible that you have simply not thought about a relationship between size, shape, and pictorial purpose as it affects your artistic decisions. If so, examine your pictures again and consider what format changes might be desirable. Do you have a painting that looks as though it could be larger? Would it be more effective if it were smaller? Is there one that might have been vertical rather than horizontal? Could one be even stronger as a circular or oval composition?

How do you visualize your pictures in homes? Can you see them comfortable only in living or dining rooms, and perhaps occasionally in a bedroom, library, or den? Would any of them make good kitchen pictures or go over a telephone table? Could they hang on a stair wall, in a front hall, or in a dressing room? What about public spaces? Do any of your pictures have the panache to affect a bank or a theater lobby? How might they look in a doctor's or dentist's waiting room, a restaurant, or a hospital room?

As you ruminate on these questions, remember that the subject itself must be considered. Your subject preferences, as well as your explorations of size and shape, may easily predispose your pictures for one use over others. That's fine. We cannot be all things to all people and purposes. On the other hand, there is a human tendency to put blinders on and overlook alternate possibilities once we have reached a comfortable plateau in our work. Perhaps a little aggressive outreach would open new pictorial adventures to you.

If, on reflection, you think that your pictures are similar in size and shape for pragmatic reasons, you might re-examine the necessity of this self-imposed stricture. Could you, for instance, retain your selected format for some portion of your work, so that your standard mats, frames, crates, and so on continue to save you trouble and expense, while you also make a deal with yourself that would permit special framing for an affordable number of more exploratory, even eccentric, sizes and shapes per year?

You might look at your paintings once more to discover whether you show any sign of falling into compositional habits. This is a real danger that springs from working on the same size and shape of paper. It is depressingly easy to develop three or four basic designs that you unconsciously repeat with variations. The shock that comes only from dealing with a different paper shape can help set you back on the road to growing as an artist. You may owe yourself this kind of opportunity.

If you have made a deliberate artistic decision to limit your pictures to one, two, or three shapes and sizes, and you really feel comfortable with them, go to it! You will have found sufficient ways of dealing with your subjects to achieve the degree of variety you want; you may even have become a specialist of a kind; and you will certainly realize that experiment only for the sake of experiment is an exercise in futility.

Summary

Congruence among subject, size, shape, and the ultimate function of a painting is a source of pictorial coherence that is often overlooked today. Because we paint chiefly for exhibition, the final function of our pictures is usually unknown to us. We paint in a void, with only a vague notion of the use to which our pictures may be put.

Nevertheless, with some imagination you can think more clearly about the possible purposes of your work and create paintings suitable for a considerable variety of uses. Even this little clarification will allow you to adjust size and shape to meet particular needs.

You can also consider actively seeking commissions, even though this is presently unusual. This would mean that you could see the room your picture would hang in, talk with the potential owner about his or her feelings about it, discuss subject and color, and set about solving a very particular and personal artistic problem. For some, such a situation appears to offer more than tolerable constraints, but other artists could well enjoy its special pleasures and challenges.

Figure 108
Granite Coast by Carl Schmalz, 1975, 15½" x 22" (39 x 56 cm), 140 lb. hot pressed paper, collection of the author. My way of working emphasizes light and volume above energy and movement. It is a way that cannot easily speak about change because it focuses mainly on duration. While painting can comprehend many feelings that would be paradoxical if expressed in prose, it has its own logic and limitations.

Figure 109
Morning Surf by Eliot O'Hara, 1936, 15" x 22½" (38 x 57 cm), 140 lb. rough paper, courtesy O'Hara Picture Trust. This painting, in the style of O'Hara's early maturity, was probably a class demonstration painted in forty minutes or less. Its air of dashing bravura is based on the artist's intimate knowledge of his tools—brushes, paints, paper—and a delicate sense of timing. The dramatic back lighting on the spume allows O'Hara to silhouette it against the lighter sea and gives him fine dark shapes as well. Perfect estimation of drying time makes possible the knifed-in swirls of foam.

Painting Your Way

Are you looking for and developing what is "right" in your pictures or are you bogging down in what seems "wrong"?

Critical Concern

By this time you may have decided that your pictures are pretty good, or you may never want to look at your group of selected pictures again! Nevertheless, as you've examined them from one point of view after another, you have doubtless been identifying and thinking over your preferences in technique, design, color, and subject, as well as in many smaller aspects of picture-making. You have also begun to differentiate your preferences from those practices that are merely habits. The distinction is a significant one, for *preferences* are the foundation of your style, while those things that you do through unexamined *habit* are its enemy. While skilled habits may yield a coherent picture, it will have little content or expressive purpose, which can result only from a thoughtful selection and exercise of preferences.

Your preferences are the recognizable tips of the deeper elements of your personality that form the essential you. This is the you who paints and who leaves an imprint—for better or

for worse—in the visible structure of your painting. This is why self-criticism is so difficult; it is you having a discussion with you. This book has inserted itself into the middle of that conversation, a third voice providing some of the objectivity and detachment that will help you see yourself as clearly as possible in your pictures. You need to know your painting personality so you can see what to abandon and what to build on.

Illustrations

Have you ever said to yourself or a friend, "Gee, if I could only paint like so-and-so!"? Probably. We all have. It's silly, of course, for as we paint better and better, we can only paint more like ourselves. But it is a phrase that can betray a kind of wrong-headedness. A person who would like to make skies like Adoph Dehn, for example, is saying tacitly, "There's something I don't like about my skies." He is concentrating on what he feels fails in his work and looking at the styles of other artists for examples of healing suggestions. Such a procedure is certainly not all bad. But why not build from strength? Identify the best in your pictures and try to improve those aspects of your painting.

As mentioned previously, this may mean looking carefully at the ways you've handled "insignificant" parts of your work— distances, corners, perhaps fore-

grounds—those parts of pictures where you were most confident. Here you may unexpectedly find fluid brushwork, economy of representation, delicacy of color, or similar evidence of your talents and preferences that you may have overlooked in your pursuit of more obvious aims. These can give you an index of capacities that you may not have even considered: certainly they can suggest some reliable facets of your painting personality.

Identifying the best in your work may also involve accepting the "worst." To the degree that you honestly put yourself on paper in your pictures, you expose your weaknesses—*all* of them. These can range from shaky drawing and clumsy execution to a host of insensibilities and biases. Okay. We can't all be Michelangelo or Rembrandt, but the Jan Steens and Alfred Sisleys of this world have their place and purpose, too. In any case, the one thing that you can count on as impossible is seriously altering yourself. This is a fundamental reason for building on the things you do best, trusting that they will eclipse your weaknesses.

Some problems, especially those of technique, representation, and design, can, of course, be remedied. As we noted in Chapter 17, courses, books, and practice will help you overcome many of these deficiencies. Suppose, however, that you balk at the amount of time required to

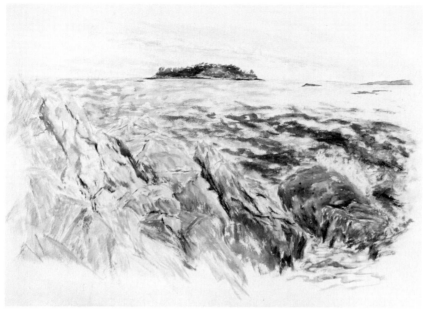

Figure 110
Haunted Island by Susie (Wass Thompson), c. 1957, 22″ x 30″ (56 x 76 cm), 90 lb. rough paper, collection of the author. Susie Thompson, a lobsterman's wife, is a self-taught artist. She learned a lot from John Marin, however, for whom she kept house during the later years of his life. Her style is remarkably her own, despite the force of Marin's presence. Broad and vigorous strokes in muted colors convey the essence of wind and water movement. Graduated sequences of many sorts even evoke the wind.

achieve your ends; or for some other reason, the thing you need to learn is impossible to attain; or you simply would rather base your future painting personality on what you can already see of it. In these instances you face facts. You say something like, "If my color is weak, I'll use a controlled palette and work on strengthening values"; or, "Since perspective is my *bête noir*, I'll stop worrying about spatial effects and concentrate on color and pattern." Actually, no artist fully exploits all of the options discussed in this book. Each of us must select those elements in picture-making that most suit our own temperament, preferences, and expressive aim. In the end, the final kind of pictorial coherence is congruity between artist and painting. This unity of subject transformed into the visual and physical order of paint produces that wholeness of the picture world that is called *style*.

About style, however, a word of caution is in order. We live in a time when few values are generally shared by our society, and but one is commonly held—individualism. In art this takes the form of "originality," which sometimes appears to be prized above all else in painting. Style is very frequently equated with originality (although they are not necessarily either identical or inseparable), with the result that artists can be made to feel they are nothing until they have achieved *their* style.

Style, though, is really only the evidence of visual thinking, so if you pursue style merely for style's sake, you risk shallowness and imitation. The only style that counts is the one that develops out of your own painting personality. You must also recognize that although a style is liberating—in the sense that it permits you to create your own coherent picture world—it is also limiting, for it can be responsive only to a particular set of possibilities. The world of dynamic natural forces created by Susie in *Haunted Island* (figure 110) is not accessible through my style, any more than the world of form and light in my *Granite Coast* (figure 108) is accessible through hers. And neither of us possesses a style that permits the sheer dash and flamboyance of O'Hara's *Morning Surf* (figure 109).

Rather than consciously pursuing a style, therefore, you might better work at developing what we can call your "personal vision." This may be splitting hairs, but it is intended to help you concentrate your focus in a way that will *produce* your style rather than encourage you merely to seek one. Style is too often thought of as an end, a stationary "thing," and the last thing we want is to acquire our style and then just churn out paintings. Any style worth the name grows and changes precisely because it is a reflection of the artist's personal vision, his thought about the world he experiences. For this reason it is best to look for what you respond to most deeply in your subjects, your paintings, and—cautiously—the pictures of others, gradually identifying the unique bent of your talent and nourishing and building on this base. Your style will then start emerging; it will become a living, growing means of expressing your own growth as a person and as an artist.

Exercises

For a change, let's look at some pictures other than your own! Our purpose is to see what elements artists have chosen to use and how they have put them together to form their different coherent picture worlds.

August 17 by Bill Tinker (figure 111) is not an "easy" picture, although he has made it economical by placing darker, modeling washes over lights in many areas, by reserving lights, and by maintaining loosely crisp edges. It is basically a wash painting in which surface coherence arises in part

from the viewer's appreciation of the uniformity of paper texture.

The composition is a modified center-focused design: the couple with the child are placed at the vertical center just below the horizontal center of the paper. Its visual richness derives from the complex interplay between similarities and contrasts of line, shape, and size, as well as contrasts of value. The large value pattern of lighter areas from lower right to upper center contrasted against middle tones creates an attractive thematic statement from a distance, while smaller darks create flickering contrasts at normal viewing distance.

Tinker has relied heavily on the force of his design for pictorial coherence because he chose an essentially non-illuministic kind of representation. Notice, nevertheless, how effectively he

has selected the darks and how they define the autos and architectural details.

The subject is absorbing, for it is a visual encapsulation of time. Probably working from old photographs, Tinker assembles a virtual collage in which spatial contradictions and strange juxtapositions of objects and styles suggest the jumble of visual recollection. Time does not just stand still within the picture's enframement, it telescopes. A large painting, its size is fully justified by its subject.

How does he make this bizarre assemblage work? By means of the artistic devices mentioned above, he presents viewers with a coherent idea and gives them clues to it. For example, the presence of the cars tells viewers to think back to the late 1920s or early 1930s, and the clothing styles support this. The late-

Figure 111
August 17 by Bill Tinker, c. 1970, 29¾″ x 36½″ (76 x 93 cm), collection of the Springfield Art Museum, Springfield, Missouri. In this large wash painting, Tinker kaleidoscopes objects as figures of memory. His style, in certain technical ways, resembles that of DeWitt Hardy (figures 10 and 113), but style is not just a way of handling paint or designing compositions. Finally, it is the way we see; it is our personal vision, ordered and structured in our own way. Tinker and Hardy each give the viewer a valuable, though very different, visual statement about their human experience.

Figure 112
Eileen Reading by Sidney Goodman, 1974, 15″ x 22½″ (38 x 57 cm), collection of Mr. and Mrs. Michael Schwartz. Goodman's vision emphasizes sturdy vertical and horizontal lines, full modeling of volumes in light, and eloquent contrasts of curvilinear and rectangular shapes. Value contrasts are also significantly used.

Figure 113
Studio Interior, Fall by DeWitt Hardy, 1975, 32″ x 22″ (81 x 56 cm), cold pressed paper, courtesy Frank Rehn Gallery, New York. Hardy's vision emphasizes diagonals, letting horizontal and vertical lines provide accents. His modeling is marvellously limpid, but played down. Value contrasts tend also to be accents at the edges of the subject, such as the Cosmos flower against the book at right and the flicker of sunlight on the floor at left.

nineteenth-century architecture suggests a generation even further removed. This is confirmed by the empty chairs and the wraithlike presence of the people at right who are thin and small compared with the building behind them. Contrast is the primary means by which the artist clarifies his meaning, while similarity helps maintain the work's coherence.

Notice that, despite contradictions in the fractured picture space, there is a clear movement back into illusory depth. The sequential diminution of size in the fence, the chairs, and, to a lesser extent, the figures creates this feeling of movement, which also functions as a paradigm of passing time. One wonders whether the artist is the child at the painting's center.

Karl Schmidt-Rottluff's *Landscape* (color plate 11) is obviously a very different sort of picture. Although there is a sense in which all paintings of quality—even those with brutal subjects—can be said to be celebratory, Schmidt-Rottluff's undeniably is. It freely and spontaneously offers joy.

Although its effect derives primarily from the luminous color, the sense of wholeness also depends on similarities and contrasts of line, shape, and size. The blue roof shape at the center of the picture is repeated in a varying gradation to the left, and the reserved gable shapes are echoed at right. The embracing beach shape above the center roof appears inverted in the edge of yellow grass at the bottom of the painting. These curves are sharpened in the various globular trees and shrubs and more loosely reaffirmed in the top of the dark forest between the houses and the foreground. Curves similar to the beach are also visible in the ocean. All the curves and angular shapes contrast strongly with each other, heightening and qualifying the visual excitement of the intense,

complementary colors.

The picture is mainly a wash painting, but it was done with such verve that stroke marks remain embedded in the washes, recording the vibrancy of its execution over the entire surface. This liveliness informs the whole scene and lets the viewer see it as perennially filled with light and life. It radiates affirmation.

Finally, let's compare two paintings that in a terse catalogue description might seem to have exactly the same subject: a girl lying down, reading. A quick glance at Sidney Goodman's *Eileen Reading* (figure 112) and DeWitt Hardy's *Studio Interior, Fall* (figure 113) shows that the pictures could not possibly be confused, an observation that dramatizes the fact that paintings are couched in terms of *visual* not verbal, organization. They are self-defining and, ultimately, self-sufficient.

But how different *are* they? And *how* are they different? Here we want to articulate as completely as possible the reasons for the distinctive expression projected by each of these pictures in order to help you with an example as you try to analyze the unique qualities of your own work.

First, Goodman puts strokes on a fairly smooth paper, whereas Hardy puts washes on a moderately rough one. Goodman softens most edges and achieves surface textures through modulation of his strokes, whereas Hardy creates delicate but wiry edges and achieves texture through pigment granulation. Both artists place the paper or magazine at the center of the picture, together with the head and hand of the reader, and the whole of Goodman's figure is there, too. Beyond this, the two artists develop their compositions very differently.

Goodman emphasizes strong diffuse light to model forms and bleach away the reader's exterior world. Hardy's light is very gentle; even the direct sunlight coming through the window is muted. Form is softly rendered and the exterior world is not only visible through the window but brought within through the vase of flowers.

Goodman looks perpendicularly toward the room's back wall and lets the sofa push directly into his vigorously created space. The arrangement creates strong vertical/horizontal contrasts on the two-dimensional surface. Hardy's space is less emphatic, stressing a very different two-dimensional pattern. Vertical and horizontal here form a contrapuntal theme played against two interlocked arcs in illusory depth. One is relatively light, moving from the reader's feet, along her body and left arm, out through the light of the window. The other, darker, extends from the table and books at foreground right and along the blanket to the books and shaft of sunlight at left. Just above the intersection of these arcs is the reader's head, magazine, and hand. Light, reflecting from the page she holds, illumines her face—symbolic of the mind's illumination from reading (a device Rembrandt used). To the far left is the edge of a mirror, also symbolic of reflection and the private life of the mind. Notice, too, that the rectangular shapes of the closed books echo the magazine's shape and relate to the vision through the window panes as well—another way of stating visually the fruits of understanding.

The vanishing point in Goodman's picture comes behind the center of the newspaper (also a device as old as Masaccio), which further emphasizes the newspaper and the part of the reader's face that we can see. Notice that Eileen's face, too, is illuminated by light reflected from her paper. The circular shapes that Goodman plays against his architectonic structure are emphasized by the strong lateral verticals. The primary curve of the sofa support relates to the more open reverse curve below; it is modified by the shape of the girl's hips and changed again to the shape framed by her legs. This is picked up and inverted in the table legs at right. As we study these changing shape relations, we see how the reader's head also inverts the sofa arm curve and how her head is picked up by the mirror above. As in Hardy's painting, it is not the overt subject, but the interplay of these shapes and their meanings, that provides the artist's expression.

Both pictures are about introspection and reflection and about privacy and the weakness of one's defenses against invasion of it. Both express this in terms of woman's vulnerability and hence both carry erotic overtones. Because of the painters' very different approaches and their distinctive selection of artistic options, however, our response to each picture, each coherent within itself, is quite singular. Goodman's picture is assertive but tender; Hardy's evokes a more pastoral mood of innocence.

As you become more and more yourself as a painter, your pictures will speak through their visible order more and more clearly of the worlds that only you can see.

Summary

What I have tried to do in this book is provide suggestions about some of the kinds of decisions you can and should make. Please don't take anything I've said as a Rule—except one: your picture world must have a coherent order. It's your creation, you're its boss. You owe it form, clarity, and structure. Only then can it aspire to meaning or beauty. And on the way remember: nothing that works is wrong! Good luck.

Bibliography

Albers, Joseph. *Interaction of Color.* New Haven and London: Yale University Press, 1971. Examples and discussion of relationships among pure colors, size, and shape.

Evans, Ralph M. *An Introduction to Color.* New York: John Wiley & Sons, 1948. A thorough discussion of optics and the physical behavior of light, with good material on vision.

Fisher, Howard T., and Carpenter, James M. *Color in Art: A Tribute to Arthur Pope.* Exhibition Catalogue, Fogg Museum, Harvard University, Cambridge: 1974. A complete presentation of the Pope color theory, with examples of its use in analyzing works of art.

Gettens, Rutherford J., and Stout, George L. *Painting Materials.* New York: D. Van Nostrand Co., Inc., 1942. London: Dover, 1966. An especially thorough treatment of pigments and supports.

Gombrich, Ernst. *Art and Illusion.* Bollingen Series XXXV 5. New York: Pantheon Books, 1960. An interesting discussion of the process of picture-making from the point of view of both history and the psychology of perception.

Gregory, R. L. *Eye and Brain, The Psychology of Seeing.* 2d ed., New York and Toronto: McGraw-Hill Book Company, 1963. A history, and discussion of the present understanding, of human visual perception.

Grumbacher, M. *Color Compass.* New York: M. Grumbacher, Inc., 1972. A concise summary of color as it affects the artist.

Hill, Edward. *The Language of Drawing.* Englewood Cliffs, N.J.: Prentice-Hall, Inc., 1966. A provocative and illuminating analysis of drawing.

Land, Edwin H. "Experiments in Color Vision." *Scientific American*, May, 1959. (Available in separate reprints.) A report on some interesting possibilities regarding human color vision.

Mayer, Ralph. *The Artist's Handbook of Materials and Techniques.* 3d ed., New York: Viking Press, 1970. London: Faber and Faber, 1964. A complete compendium of materials and their uses.

Pope, Arthur. *The Language of Drawing and Painting.* New York: Russell and Russell, 1968. An excellent introduction to drawing, painting and color.

Ross, Denman W. *A Theory of Pure Design.* Boston: Houghton Mifflin Co., 1907. An early publication, outlining an analytic theory of design.

————*On Drawing and Painting.* Boston: Houghton Mifflin Co., 1912. An introduction to the principles of design and their application to representational art.

Shahn, Ben. *The Shape of Content.* Cambridge: Harvard University Press, 1957. A description by an artist of an artist's working process as well as other thoughts on the artist's place in society.

Index